The politics of focus

MANCHESTER
UNIVERSITY PRESS

THE CRITICAL IMAGE

'From today painting is dead': a remark made by the French artist Paul Delaroche on first seeing a daguerreotype in 1839.

'I can see it's the end of chemical photography': a remark made by the British artist David Hockney in 1990 on the likely effect of computer-generated imagery.

The 'Critical Image' series aims to develop the subject area of photographic history, theory and criticism. It explores the historical and contemporary uses of photography in sustaining particular ideological positions. Photography is never a straightforward 'window on the world'; the meanings of photographs remain unstable, depending always on usage. Chemical and lens-based photographs are now antique forms of image production, while pictures made in computers are not strictly photographic since there is no necessary link between images and what-has-been. The series engages with both chemical and digital imagery, though new forms of representation do not obliterate older forms and ways of looking that persist through custom and practice. The term 'representation' is not simply another word for picture or depiction, but hints at the management of vision. Representation is not just a matter of what is shown but who has permission to look at whom, and to what effect. The series looks beyond the smooth narratives of selected 'masters', styles and movements. It aims to discuss photographic meanings produced within the complex social formation of knowledge. To situate photography in its intellectual context, the series cuts across disciplinary boundaries and draws on methods widely used in art history, literature, film and cultural studies.

SERIES EDITOR

John Taylor
Department of History of Art and Design, Manchester Metropolitan University

Already published

Jane Brettle and Sally Rice (eds) *Public bodies – private states: new views on photography, representaion and gender*

Sarah Kember *Virtual anxiety: photography, new technologies and subjectivity*

John Roberts *The art of interruption: realism, photography and the everyday*

John Taylor *Body horror: photojournalism, catastrophe and war*

John Taylor *A dream of England: landscape, photography and the tourist's imagination*

The politics of focus

women, children and nineteenth-century photography

LINDSAY SMITH

MANCHESTER UNIVERSITY PRESS
Manchester and New York

distributed exclusively in the USA by
St. Martin's Press

Published by Manchester University Press
Oxford Road, Manchester M13 9NR, UK
and Room 400, 175 Fifth Avenue, New York, NY 10010, USA

Distributed exclusively in the USA by
St. Martin's Press, Inc, 175 Fifth Avenue, New York,
NY 10010, USA

Distributed exclusively in Canada by
UBC Press, University of British Columbia, 6344 Memorial Road,
Vancouver, BC, Canada V6T 1Z2

British Library Cataloguing-in-Publication Data
A catalogue record for this book is available from the British Library

Library of Congress Cataloging-in-Publication Data
Smith, Lindsay.
 The politics of focus: women, children, and nineteenth-century
 photography / Lindsay Smith.
 p. cm. – (The critical image)
 Includes bibliographical references and index.
 ISBN 0-7190-4260-7 (cloth). – ISBN 0-7190-4261-5 (pbk.)
 1. Photography of women–History–19th century. 2. Photography of
 children–History–19th century. I. Title. II. Series.
 TR681.W6S63 1998
 778.9'24–dc21 98-17825

ISBN 0 7190 4260 7 *hardback*
ISBN 0 7190 4261 5 *paperback*

First published 1998
05 04 03 02 01 00 99 98 10 9 8 7 6 5 4 3 2 1

Designed and typeset by Lionart, Birmingham
Printed in Great Britain
by Redwood Books, Trowbridge

For David, Joe and Lily

Yet, how difficult it is to avoid substituting the sign for the thing; how difficult to keep the essential quality still living before us, and not kill it with the word

(Goethe, *Theory of Colours*)

Contents

List of figures viii

Acknowledgements 1

Introduction 'That Old Black Magic': exorcising photography's histories 2

1 The politics of focus: feminism and photography theory 13

2 'This Old House': Julia Margaret Cameron and Lady Clementina Hawarden 35

3 'Lady Sings the Blues': the woman amateur and the album 52

4 'Me and My Shadow': the double in nineteenth-century photography 74

5 'Take Back Your Mink': Lewis Carroll, child masquerade and the age of consent 95

6 The shoe-black to the crossing sweeper: Victorian street Arabs and photography 111

Index 133

List of figures

page

1 Henry Peach Robinson, *Sleep* (1867), The Royal Photographic Society Collection, Bath, England. 22

2 Lewis Carroll (C.L. Dodgson) *Xie Kitchin Playing the Violin* (1876), Gernsheim Collection, Harry Ransom Humanities Research Center, University of Texas, Austin. 29

3 Lewis Carroll (C.L. Dodgson) *Xie Kitchin as Penelope Boothby* (1875), Gernsheim Collection, Harry Ransom Humanities Research Center, University of Texas, Austin. 29

4 Julia Margaret Cameron, *Annie, 'My First Success'* (1864), Science and Society Picture Library. 31

5 Lady Clementina Hawarden, *Untitled* (1860s), Victoria and Albert Museum. 38

6 Lady Clementina Hawarden, *Untitled* (1860s), Victoria and Albert Museum. 40

7 Lady Clementina Hawarden, *Untitled* (1860s), Victoria and Albert Museum. 41

8 Lady Clementina Hawarden, *Clementina in Fancy Dress* (1860s), Victoria and Albert Museum. 43

9 Lewis Carroll (C.L. Dodgson), *Xie in Greek Dress* (June 1873), Gernsheim Collection, Harry Ransom Humanities Research Center, University of Texas, Austin. 44

10 Lewis Carroll (C.L. Dodgson), *Xie Kitchin Standing in a Nightdress and Crown* (1874), Gernsheim Collection, Harry Ransom Humanities Research Center, University of Texas, Austin. 44

11 Julia Margaret Cameron, *My Grandchild Aged 2 Years and 3 Months* (August 1865), Gernsheim Collection, Harry Ransom Humanities Research Center, University of Texas, Austin. 45

12 Lewis Carroll (C.L. Dodgson), *Xie Kitchin Lying on a Sofa* (1875), Gernsheim Collection,

Harry Ransom Humanities Research Center, University of Texas, Austin. 46

13 Julia Margaret Cameron, *Florence* (August 1872), Gernsheim Collection,
Harry Ransom Humanities Research Center, University of Texas, Austin. 47

14 Julia Margaret Cameron, *All Her Paths are Peace* (June 1866), Gernsheim Collection,
Harry Ransom Humanities Research Center, University of Texas, Austin. 48

15 Julia Margaret Cameron, *Eleanor Locker* (July 1869), Gernsheim Collection,
Harry Ransom Humanities Research Center, University of Texas, Austin. 48

16 Julia Margaret Cameron, *The Red and White Roses* (1865), Gernsheim Collection,
Harry Ransom Humanities Research Center, University of Texas, Austin. 50

17 Lady Charlotte Milles, *Fanny Stracey* (1860s), Milles Album, Gernsheim Collection,
Harry Ransom Humanities Research Center, University of Texas, Austin. 62

18 Lady Charlotte Milles, *The Honourable Lewis and Harry Milles* (1860s), Milles
Album, Gernsheim Collection, Harry Ransom Humanities Research Center,
University of Texas, Austin. 63

19 Lady Charlotte Milles, *Queen Victoria, the Prince and Princess of Wales and their
Children* (1860s), Gernsheim Collection, Harry Ransom Humanities Research Center,
University of Texas, Austin. 65

20 Lady Charlotte Milles, *Collection of Figures in Interior Setting* (1860s), Milles Album,
Gernsheim Collection, Harry Ransom Humanities Research Center, University of Texas,
Austin. 66

21 Henry Peach Robinson, *The Photographer Catching Up on His Reading* (1862),
carte-de-visite, Gernsheim Collection, Harry Ransom Humanities Research Center,
University of Texas, Austin. 80

22 Benjamin Robert Dancer, *Self-Portrait* (1854), Gernsheim Collection, Harry Ransom
Humanities Research Center, University of Texas, Austin. 82

23 Henry Peach Robinson, *Photo Sketch for a Holiday in the Wood* (1860), Gernsheim
Collection, Harry Ransom Humanities Research Center, University of Texas, Austin. 83

24 Henry Peach Robinson, *Fading Away* (1858), The Royal Photographic Society
Collection, Bath, England. 84

25 Henry Peach Robinson, *She Never Told Her Love* (1857) The Royal Photographic
Society Collection, Bath, England. 85

26 Oscar Gustav Rejlander, *The Artist Introduces O.G. Rejlander the Volunteer* (1871),
The Royal Photographic Society Collection, Bath, England. 87

27 Julia Margaret Cameron, *Cupid's Pencil of Light* (1870), The Royal Photographic
Society Collection, Bath, England. 89

28 Lewis Carroll (C.L. Dodgson), *Gertrude Chataway Lying on a Sofa* (1870s), Gernsheim
Collection, Harry Ransom Humanities Research Center, University of Texas, Austin. 103

29 Lewis Carroll (C.L. Dodgson), *Irene MacDonald, Autographed* (July 1863). 104

30 Lewis Carroll, *C.L. Dodgson to Xie Kitchin* (15 February 1880) pen and ink, Berg

Collection of English and American Literature, The New York Public Library, Astor, Lenox and Tilden Foundations. 107

31 Oscar Gustav Rejlander, *Insult Added to Injury* (1866–68), Gernsheim Collection, Harry Ransom Humanities Research Center, University of Texas, Austin. 112

32 *'Before' and 'After' Cards* (1870s), Barnardo's Photographic and Film Archive. 116

33 *Florence Holder* (1870s), Barnardo's Photographic and Film Archive. 117

34 *William Fletcher* (1870s), Barnardo's Photographic and Film Archive. 118

35 Oscar Gustav Rejlander, *Night in Town* (1860), The Royal Photographic Society, Bath, England. 119

36 *The Williams Children* (1870s), Barnardo's Photographic and Film Archive. 121

The author and publisher are grateful to those institutions above who have kindly granted permission to reproduce photographs.

Acknowledgements

I would like to thank John Taylor, the series editor, for his detailed comments and his encouragement, and Matthew Frost and Stephanie Sloan at Manchester University Press. In particular, staff at the Photography Collections of the Harry Ransom Humanities Research Center and at the V. & A. made archival research a real pleasure.

An earlier version of chapter 1, 'The politics of focus: feminism and photography theory', appeared in Isobel Armstrong, (ed.) *New Feminist Discourses* (London: Routledge, 1992). A version of chapter 5, 'Take Back Your Mink': Lewis Carroll, child masquerade and the age of consent', was published in *Art History* (September 1993). In its early stages, chapter 6, 'The shoe-black to the crossing sweeper: Victorian street Arabs and photography', was given as a paper at the University of Oxford and at the V. & A., and I would like to thank Kate Flint and Tim Barringer for their generous comments. Chapter 6 subsequently appeared in *Photography and Cultural Representation* a special edition of *Textual Practice* 10:1 (Spring 1996).

My special thanks to David Rogers for his support with this and in everything else.

Introduction

'That Old Black Magic': exorcising photography's histories

From its inception, photography held a connection with magic. The 'black', which associates that 'black art from France' with magic, is apparent both in the literal chemical stains upon the body of the photographer and in the 'negative' status of the photographic medium, which quickly became known for its inauthenticity in its sovereign ability to deceive. For child subjects of nineteenth-century photographers, such as Julia Margaret Cameron, some of the most powerful memories of the business of being photographed hinge upon the smell of collodion potions and images of the blackened hands of the photographer as she performs her magical act of conjuring. Passionately present to control sittings, and then absent for long periods during the process of development, the photographer appears to subsist, like the proverbial chameleon, on air; she produces something out of nothing. For Lewis Carroll's child friends 'the tiny darkroom' itself, with its 'strong-smelling bottles' was, like the photographer, the locus of a profound mystery.

The analogy of photography with magic is one that has been retained, in various incarnations, since the nineteenth century. It has served both as a reductive generalisation and as a theoretically enabling pairing, but the former reading of the analogy in photographic history has tended to dominate the theory of photography. The correlation of photography, as a sophisticated technology, with magic, as a metaphysical condition, has worked all too easily to mystify photographic operations and to circumvent difficult questions about the politics and the aesthetics of the medium. But, I hope to show, there are ways of exorcising the one without sacrificing the other; ways, that is, of historicising the connections between those correlations with magic and photographic technology in order to re-examine the cultural and philosophical status of the medium in the nineteenth century and in recent theoretical accounts. The wide-reaching conceptual possibilities of the subject are perhaps most interestingly exposed by Walter Benjamin's reference to magic in his seminal essay 'A Small History of Photography'.[1] To equate photography with magic is especially productive for Benjamin because it encapsulates 'lessons inherent in the authenticity' of the medium which he believes are still being circumvented in

photographic history. In this context, Benjamin draws upon the work of Heinrich Schwarz whose essays persuasively address the fact that such questions were still not being adequately addressed by the 1930s. For as Schwarz points out, even though at no period other than the nineteenth century, ' – not even during the Renaissance – was artistic evolution so closely linked to the scientific', the route to 'the historicism and realism' of the nineteenth century still lay 'in a certain darkness'.[2]

The concept of photographic 'authenticity' to which Benjamin refers is inseparable from notions of magic: 'the most precise technology can give its products a magical value, such as a painted picture can never again have for us'.[3] He uses the term 'magic' both to suggest the discovery of the unexpected in the obvious, rather like the Renaissance reaction to the previously hidden visual wonders of the microscope, and to evoke photography's complex relation to other mediums. The contiguity of magic with technological precision, the seemingly contradictory condition that photography realises, incites Benjamin's desire to fundamentally re-conceptualise the relationship of the medium to history:

> No matter how artful the photographer, no matter how carefully posed his subject, the beholder feels an irresistible urge to search such a picture for the tiny spark of contingency, of the Here and Now, with which reality has so to speak seared the subject, to find the inconspicuous spot where in the immediacy of that long-forgotten moment the future subsists so eloquently that we, looking back, may rediscover it. For it is another nature that speaks to the camera than to the eye: other in the sense that a space informed by human consciousness gives way to a space informed by the unconscious.[4]

For Benjamin, the necessity for such re-conceptualisation is further encapsulated in the beholder's urge to locate in the representation of a past moment the present of what was at that point future. Benjamin's 'inconspicuous spot' – later transformed by Roland Barthes into the concept of the 'punctum'[5] – manifests a gap between 'human consciousness' and the 'unconscious'. Experienced as a temporal dislocation, the 'eloquent' existence of the future in a present always already past, this sense of a gap crystallises the type of experience of simultaneity that photography also articulates at the spatial level. Moreover, of considerable importance is the agency of the subject who, Benjamin believes, feels empowered by the medium itself to take on that search for 'that long-forgotten moment'. Exploring the sense that it is 'another nature that speaks to the camera than to the eye' – a space of consciousness 'giving way' to one informed by the unconscious – the search itself assumes, in the language of psychoanalysis, the quality of 'repression'. Benjamin's concept of that which is 'forgotten' represents, as in the nature of a repetition, something not lost but merely hidden. By extension, he expresses particular interest in the way in which the apparently radical empiricism of the camera, which makes it more akin to 'technology and medicine than to painting,' reveals, through its enlargement of minutiae, the very 'difference between technology and magic' as 'a thoroughly historical variable'.[6] Dispelling any notion of an absolute difference between the two, Benjamin cites the example of Blossfeldt's plant photographs which manifest 'the forms of ancient columns in horse willow, a bishop's crosier in the ostrich fern, totem poles in tenfold enlargements of chestnut and maple shoots, and gothic tracery in the fuller's thistle'.[7] The transformative power of such images, in which the vast is contained invisibly in the minute, recalls Gaston Bachelard's later formulation, made in the context

of the viewing experience required by the artistic form of the miniature, that 'a bit of moss may well be a pine, but a pine will never be a bit of moss.'[8] Moreover, such transformation, reminds us as does William Morris so memorably, in 'Shadows of Amiens', that the photograph invariably miniaturises that which it represents.[9]

Not only do Blossfeldt's photographs render for Benjamin 'magic' and 'technology' as historically contingent – the difference between 'magic' and 'technology' becomes an historical variable and a source of Benjamin's recognition of a need to historicise photography as magic and photography as technology – but they also invoke the magic/technology coupling as part of a larger debate upon the relation of the transcendental to the empirical in the nineteenth century. As I have shown elsewhere, the invention of photography blurs fundamental distinctions between the nineteenth-century philosophical positions of empiricism and transcendentalism and in so doing transforms in various ways the relationship between large and small, fragment and whole.[10] Following the public announcement of the daguerreotype in Paris in 1839 debates around the ontological status of photography are rooted in its indexical link to a referent, its radical empiricism together with its analogous authority on deception: the camera will always lie, and the magical status of its deception is different from that of previous mediums.

Taking up Benjamin's magic/technology coupling as part of a larger transcendental and empirical dualism, this book examines the politics of focus in nineteenth-century photographic culture. It is concerned with 'focus' both in the sense of a photographic condition – very simply that focus which photographs can be said to be 'in' and 'out' of, together with the reasons for, and variations within, qualities of depth of field – and in terms of those larger questions of historical periodisation and cultural emphasis in photographic discourse. The first chapter addresses the split that persists in work on nineteenth-century photography between discussions of the technicalities and masters of photographic processes on the one hand and, on the other, those theoretical and cultural discussions which have frequently regarded themselves as estranged from such 'specialist' concerns. As an identifiable discipline, photography was slower than film in establishing for itself a body of theory. The relatively late recognition of the cultural importance of an historical and theoretical re-examination of the medium stemmed somewhat from the unattractiveness to 'theory' of such a rigid division of work on photography into the history of process and invention, and a discussion of the aesthetic and 'masters' of those processes. In a sense, photography occupied too rigid a categorisation owing to its historical rootedness in the Victorian period; it was easier for theorists to mobilise around cinema, whose moving pictures had somewhat forgotten their origins in the 'still' photograph. Yet, as understandable as it might be for exponents of more sophisticated methods of critical theory to want to dissociate themselves from such unreconstructed approaches, this disassociation has been sustained at a price. This book recognises the nature of that price and attempts to address it as part of a re-assessment of the present significance of photography in visual culture.

A re-evaluation of photographic focus and political struggles over its status, both at the level of theory and practice, has led me to approach nineteenth-century photography from a radically inter-disciplinary position which attends to photographic discourse in its verbal as well as in its more obvious visual manifestations. From the perspective of such an inter-disciplinary bias, of foremost importance to the present study are the related areas of the position of the child in photographic discourse, and the question of gender

politics in work by women. This book attempts to re-think nineteenth-century photography by newly considering the investment of its history and theorisation both in the figure of the child and in particular photographic practices of Victorian women. As chapter 1 testifies, my interest in photographic 'focus' in general, and as a condition of theoretical contention in particular, developed in the context of viewing Julia Margaret Cameron's photographs of children juxtaposed with those of her contemporary, the amateur photographer Charles Dodgson. I do not believe it is coincidental that it was in the act of photographing children that Cameron questioned and challenged accepted contemporary assumptions about so-called 'correct' degrees of focus. Nor, indeed, did my subsequent writing on Cameron and Carroll lead accidentally to a recognition of the need to address nineteenth-century cultural constructions of the child as inseparable from debates upon the nature of photographic practice in its early decades.[11]

In the light of these considerations and by attending to the centrality of figures of children in those debates, several chapters approach questions of the cultural investment in issues of focus in the Victorian period as brought to light in Benjamin's reassessment of the relevance to photographic discourse of the coupling of technology with magic. As part of his call for us to reconsider such a coupling as historically determined, and in a discussion of what he believes to be a 'sharp decline' in taste in photography in the nineteenth century coterminous with the vogue in photograph albums, Benjamin himself draws upon the figure of a child exemplified in a photograph of Franz Kafka. Benjamin satirises the conspicuous artificiality of such studio portraits which for him are poles apart from those slightly earlier portraits which retain, in the disposition and look of the sitter, the endurance of a long exposure out of doors; photographs, that is, that still had 'an aura about them, an atmospheric medium, that lent fullness and security to their gaze even as it penetrated that medium'.[12] Approaching the thick leaves of the photograph album from the position of uncomfortable, displayed child subject, Benjamin identifies with the humiliation he sees manifest in the photographed countenance of the child Kafka:

> There the boy stands, perhaps six years old, dressed up in a humiliatingly tight children's suit overloaded with trimming, in a sort of conservatory landscape. The background is thick with palm fronds. And as if to make these upholstered tropics even stuffier and more oppressive, the subject holds in his left hand an inordinately large broad-brimmed hat, such as Spaniards wear. He would surely be lost in his setting were it not for the immensely sad eyes, which dominate this landscape predestined for them.[13]

Such a straight photographic display of disempowerment in the photographic portrait becomes for Benjamin tantamount to the humiliation of child subjects. For the child's relation to the album, in which is compounded his or her lack of agency, is not only one of powerlessness but of a new brand of humiliation inherent in the lack of control in having one's likeness 'taken' in order for it to be displayed: 'this was the period of those studios … which occupied so ambiguous a place between execution and representation, between torture chamber and throne room'.[14] Moreover, the rigid form of the photograph album itself commemorates the falsity and stiffness of the occasion of photographic exposure. Kafka, as here described by Benjamin, prefigures those descriptions by Barthes of child subjects and points up, as a fundamental concern of this book, the adult's identification with the position of the photographed child. The

photograph is uniquely able to facilitate such an identification most obviously through the links with death, mortality and loss; the absence or death of a loved one. More specifically, the adult subject's identification with him or herself as a child involves a kind of infantalisation, before the photograph, to which Barthes refers as the lot or domain of the lover.

A photograph, such as that of the young Kafka, appears to facilitate a persistent analogy of the state of the lover with that of a child wanting to delay the slippage of the mother's absence into death. The adult's desire to identify with the position of the child as whole, as yet sustaining an interval between 'the time during which the child still believes his mother absent and the time during which he already believes her to be dead,'[15] resonates in those descriptions of child photographic subjects by Benjamin and Barthes. Moreover, the photograph's irrefutable insistence upon absence as 'death' is more keenly expressed in the photographic child portrait. The 'power' of a photograph – such as that described above by Benjamin – lies in the virtual impossibility of the viewer's not identifying, in some sense, with a child subject. It resides too in an awareness of the simultaneously current, and yet in the photograph still prospective, knowledge that enables and accompanies such identification. For the adult relates to the child subject as an other, but also as 'self'. Re-living the moment when the 'staging of language postpones the other's death,'[16] the adult viewer witnesses retrospectively that point at which he or she as a child was fervently caught up in the manipulation of absence to ward off as long as possible the mother's absence as death. In larger terms, such a form of identification illuminates the centrality of the figure of the child to Benjamin's and Barthes's analyses of the medium of photography, and explains why for Barthes, in the process of mourning as an adult the loss of the mother, it is a photograph of his mother as a child which, more than any other, conjures his mother for him as he knew her.

At the beginning of *Camera Lucida*, Barthes, stumbles upon a photograph of Napolean's youngest brother and registers the fact that he is 'looking at the eyes that looked at the Emperor'. Barthes is not simply declaring that the photographed subject, long since dead, is captured at a particular moment in time. Instead, he is suggesting that the photographed child subject elicits a particular form of identification on the part of the adult viewer which recreates that loss experienced at the point of entry into language; a response perhaps more overtly expressed in his reaction to Kertész's *Ernest* (1931), ('it is possible that Ernest is still alive today: but where? how?').[17] Such investment in the photographed child involves a conception of the present as always confirming the past as prophetic (Benjamin's search for the spark of contingency), together with a desire to identify with the child subject depicted, a desire which does not apply in the same way with photographs of adults. Barthes identifies with the mother as child in order to live that loss of her, that he now experiences, as a form of the child's loss of the mother in absence:

> By giving me the absolute past of the pose (aorist), the photograph tells me death in the future. What *pricks* me is the discovery of this equivalence. In front of the photograph of my mother as a child, I tell myself: she is going to die: I shudder, like Winnicott's psychotic patient, *over a catastrophe which has already occurred*. Whether or not the subject is already dead, every photograph is this catastrophe.[18]

While all photographs are 'this catastrophe,' the photograph of the child, more than any

other, makes us aware of this death that 'has already occurred' but yet remains to occur because on the surface that which it depicts is so far from death. Of the photograph of his mother as a child Barthes further writes:

> I arrived, traversing three-quarters of a century, at the image of a child: I stare intensely at the Sovereign Good of childhood, of the mother, of the mother-as-child. Of course I was then losing her twice over, in her final fatigue and in her first photograph, for me the last; but it was also at this moment that everything turned around and I discovered her *as into herself*.[19]

What strikes him most of all here is the temporal disruption of the present caused by the temporal rootedness of the photograph in the past. In the image, 'the sovereign good of childhood' and 'of the mother' come together in 'the mother-as-child'.[20] Forging an equivalence between childhood and motherhood, Barthes reads the good of childhood in the unknown mother as child.

This book shows how in a fundamental sense, as a medium, photography makes it impossible to refuse such identification with the position of the child, while demonstrating how theoretical recourse to the figure of the child must be read in the context of the wider appropriation of that figure in recent and contemporary nineteenth-century theorisations of photography. In other words, I do not simply throw out the professed essentialist project of *Camera Lucida*. The amount of critical work dedicated to Barthes volume on photography testifies to the inherent difficulties of so doing, especially when the author himself pre-empts such an easy response among his critics.[21] Rather, we can locate the impetus of Barthes's book as part of an historical drive to unpack an 'essence' for the photograph specifically as evidenced in photographs of children. Far from being unprecedented, Barthes's response to the Winter Garden photograph of his mother has its origins in nineteenth-century photographic constructions of children and discourses on childhood.[22] The types of associations with photographic images of children with which I am concerned not only recall the centrality of issues of childhood to the Victorians, they further stress the link between such images and the adult's relations to death and absence as ones re-configured by the medium of photography itself.

A pervasive, though very different use of the figure of the child, from that of the textual dramatisation of direct adult identification, in nineteenth- and twentieth-century writing on photography, hinges upon, in various contexts, the child's own perception of the medium. As a supposedly naïve vision which stands outside a recognition of those conditions of historical variability exposed by Benjamin, the child's view, or conception, of photography, has served in photographic theory both as a model for what has been considered the Victorians' naïve interest in the medium following its inception, and as a means of obscuring those very historical questions that Benjamin raises. Recourse to the figure of 'the child' is commonplace in recent theory dealing with visual culture. It should perhaps not surprise us in this context that post-modern critiques of modernism, especially those concerned with issues of periodisation, construct nineteenth-century visual culture as being marked by a child-like 'innocence' of the look. Photography appears to offer a cardinal point of reference in visual representation of that period because its invention most conspicuously exposes contemporary reactions of fascination and credulity, all too easily translatable into naïveté and unquestioning faith. The credulity of the nineteenth-century child upon seeing its own image reproduced has

become, in photographic theory, a prototype for what has endured as a predominant historical construction: the photograph as primarily guaranteeing a centred subjectivity for a Victorian viewer. As we shall find, however, such a construction of the child subject in relationship to the medium is not separable from the adult's manufacture of the child as object of the photographic lens, and all that such manufacture implies about concepts of agency and those of majority and minority.

It is with these considerations in mind that I wish to question what might be implied by a continuing investment in such credulity, and relatedly to examine how the model of the child operates in both nineteenth-century and contemporary discourses of photography.

Rosalind Krauss's *The Optical Unconscious* (the title of which of course invokes Benjamin's concept) seeks to trace an alternative history of modern art.[23] In order to establish a genealogy running from the Victorian period through to the work of Michael Fried, Krauss uses the nineteenth-century *child* John Ruskin. Her choice of the child Ruskin is curious and, according to Stephen Bann her attempt to 'vindicate "the optical unconscious" as a domain which eludes and at the same time underlies the conditions of normalised vision,' a mode of seeing which disassociates 'the visual from the corporeal, fails' because 'she attempts to locate the ... child Ruskin as one of its unlikely predecessors'.[24] As Bann further points out in his review of Krauss's book, 'Ruskin and Fry become pioneers of the "evangelical Christian's" disincarnated look' when in fact 'there can hardly be a less satisfactory candidate than Ruskin for the establishment of "an autonomous field of the visual"'.[25] For Ruskin 'was fully aware that the act of painting involved the body in an intimate relationship to the scene which was to be depicted'.[26] For our purposes, Ruskin is an aptly inappropriate choice by Krauss. It is not simply a question of Ruskin's exceptional childhood; his compulsion to draw type-face, for example, in the place of those dogs and horses which tended to occupy other children of his age. Ruskin's failure to occupy that place of disembodied vision that Krauss would prefer for him not only stands in a direct relation to photography's inability to guarantee mimesis as unquestionably purveyed through Western systems of geometrical perspective, but it also reveals by what customary legerdemain the child crops up as an almost invisible figure of cultural investment.

Krauss is purposely interested in the child Ruskin's relationship to the stare (a physical passivity) as anticipating for example a modernist relation to the sea which owing to 'its detachment from the social' is regarded as a medium of 'perfect isolation'.[27] She is not interested in the nuances of an undeniably culturally problematic empirical/transcendental dichotomy in Ruskin as manifest in his simultaneous praise of the radically different styles of Turner and the Pre-Raphaelites. Krauss uses the child-figure of Ruskin, then, in order to establish a pre-twentieth-century model of perception outside of purpose, outside of the social. But how far removed is this version of the child-figure from the archetypal version of the adult Victorian's naive perception? Given the highly self-conscious critical writing throughout *The Optical Unconscious* ('it's easy enough to laugh at Ruskin' she writes) it seems all the more surprising that Krauss should draw upon a figure of the child as naïve perceiver in this way. It is a move which, by implication, keeps the technology and magic dichotomy intact and uncontested.

It is crucial to realise ways in which in Western culture, since the invention of the medium, concepts of the child and photography have been linked. Recent post-modern theory seems not to have been alert to the fact that Victorian culture primarily uses

representations of child readers of photographs when questions other than those concerning simply the medium of photography or spectatorship are at stake. Such theory fails to realise, for example, that the child's relation to the photograph has larger ramifications for contentious debates upon constructions of childhood in the nineteenth century. Those debates centre upon questions about agency, identity, majority and consent. In chapter 5, we discover how such questions are uniquely negotiated in Charles Dodgson's (Lewis Carroll's) photographic practices and in the elaborate narratives he constructs in order to legitimate them. Much of Carroll's own discourse around photography, the many notebooks and letters dealing with the subject, constituted a means of accounting for a visual compulsion (to photograph 'little girls') within the loaded contemporary social and legal discourses of age of consent and child prostitution. For Carroll, the legitimacy of his compulsion turned upon his ability to read, or determine visually through size, a child's age and her consequent positioning as major or minor. Far from constituting the self-contained hobby of an amateur, otherwise teacher of mathematics, Carroll's photographic practices are intricately located within popular legal and social discourses of the day. In his desire to photograph little girls repeatedly he has to negotiate boundaries and limits and his practices themselves become intricately bound up with the rhetorical schemes for their legitimation.

In a related manner chapter 6 deals with adult constructions of a child's reading of a photograph. It examines, in the Victorian philanthroper Thomas Barnardo's evangelical pamphlets, narratives of the reform of street Arabs in which the reluctance of a raggedly dressed and destitute child to leave the streets for a children's home is instantly transformed by the sight of a photograph of another child in the smart garb of a domestic servant. In one of Barnardo's texts a photograph is constructed as having a power to incite desire in the child subject far beyond that of words or any other medium, to elicit a wish on the part of the child to be *the* one imaged. I show how such a relation of the child to the photograph continues to stand in for the way in which we construct the Victorians' relationship to photographic representation. That recent photographic theory should retain such a model of spectatorship for nineteenth-century viewing subjects is all the more troubling because it replicates a prevalent, but recently widely contested construction of the child in Victorian culture. Simple recourse to a child viewer is all too easy a means by which to avoid thinking about our historical constructions of nineteenth-century photography.

Barthes's passing comment upon the etymology of the word 'innocence' as 'I do no harm'[28] is productive in this regard since it shifts the parameters of the debate. To restore 'innocence' to a neutral – as that which does not 'do' rather than to construct it as a positive nostalgically longed-for term, offers a way of re-conceptualising what is being 'longed for', together with our investment in the Victorians' construction of childhood innocence. The concept of innocence is read off nineteenth-century photographs of children as a positive 'lost' quality precisely by masking the etymology of the term. For, in longing for a return to childhood it is not a state of being incapable of doing harm that an adult viewer aspires to regain. By shifting the register in this way, we compound the absence of agency on the part of the child, that which precisely distinguishes the child's position as attractive to the fantasy of the adult. The fantasy of being in the position of the child (as he or she who 'does no harm') is a fantasy of a return to a pre-linguistic self; the silenced, awkward homeless figure of the young Kafka or of Barthes's mother as child. 'Innocent' in the sense of 'I do no harm' is reciprocally 'I to which harm may be

done without my knowledge'. To rethink what is involved in a desire to retrieve a condition of lost 'innocence' requires us to shift the term from a positive condition to an absence of the ability to harm, which is concomitantly to a condition of receiving harm without knowledge of it.

A reconsideration of the uses of the child as a naïve perceiver in the nineteenth-century enables us to interrogate a strict retention of the magic and technology dualism that Benjamin brings to our attention, along with those accompanying, equally generative categories of the visible and invisible, empirical and transcendental. So too does a re-assessment of constructions of gender, which occupy the remaining chapters of this book. I am especially concerned with the ways in which matters of gender inflect, and still further, determine, 'unorthodox' photographic practices. Cameron's use of focus, Lady Clementina Hawarden's lighting and distribution of female figures in interiors, and Lady Charlotte Milles's little-known activities in photo-collage in the amateur domain all bring to the fore as inseparable complex considerations of photographic process and gender. Chapter 2 contextualises Hawarden's work, together with that of Cameron, according to its reliance upon the domestic and all that that implies. By reconsidering the pursuits of amateur women within the context of 'home', I question the way in which such photographic work has been simultaneously marginalised and aestheticised. Both Cameron and Hawarden have been regarded as exceptional and idiosyncratic women photographers, rather than as practitioners who challenged, in different ways, constructions of photographic discourse in its early decades.

The cultural positioning of the technique of combination printing, the production of a photographic print from more than one negative, inflects my reading of Lady Charlotte Milles's album of photo-collages, not only in terms of our understanding of the Victorian album, but with regard to larger questions about memory. In chapter 3, I am particularly concerned to chart the relationship of the subject to photographs as altering a previous allegiance to objects of sentiment such as mementoes and keepsakes. I begin in this context with a consideration of John Herschel's cyanotype process, and the way in which it was taken up by Anna Atkins for the depiction of botanical specimens as a means by which to rethink the status of photographic monochrome within those abstract conditions of absence and presence. We find that by radically cutting up treasured photographs and re-fashioning them among incongruous water-colour settings, Milles precisely tampers with that straight narrative of display that for Benjamin characterises the photograph of the child Kafka. Analyses of Milles's images must be situated within the context of debates on combination printing and 'unorthodox' practice of the 1860s and 1870s. The album pages bring to the fore the relation of the album as domestic object to questions of the gendering of absence and the articulation of loss.

Collectively, by performing a type of exorcism on established histories of the medium, which have required the maintenance of discrete disciplinary separations, I hope that the chapters will allow us to begin to interrogate, as historically variable, those differences as manifest in Benjamin's deceptively complex opposition of technology and magic. With current developments in information technology, such as digital manipulation and computer simulation of 'photographic' images, together with a newly emerging language of interactivity, discourses are being generated which compound the radically inter-disciplinary nature of the medium itself. Yet photography, as understood in its nineteenth-century incarnations, remains somewhat uncritically located in these debates as a means of measuring, as repeatedly lost, an investment in realism.[29] While

invariably early photography has to provide a certain yardstick for cultural understanding of these later developments, hence the recourse of contemporary image-making technologies to versions of nineteenth-century theory and practice as stable anchor-points, I hope that this book will demonstrate to what extent only particular versions of Victorian photography can, and have ever, been able to offer such forms of normative realism. Our understanding of nineteenth-century photography as a welcome foothold must radically change along with contemporary developments in the medium.

Notes

1 Walter Benjamin, 'A Small History of Photography', *One Way Street and Other Writings,* trans. Edmund Jephcott and Kingsley Shorter (London: Verso, 1985) pp. 240–57.

2 Heinrich Schwarz, *Art and Photography: Forerunners and Influences,* ed. William E. Parker (Chicago and London: University of Chicago Press, 1987), p. 85. Heinrich Schwarz, *David Octavius Hill. Der Meister der Photographie*, Mit 80 Bildtafilm (Leipzig, 1931); *David Octavius Hill: Master of Photography*, with 80 reproductions made from original photographs and printed in Germany, is the English translation of Schwarz by Helen E. Fraenkel (London: George C. Harrap and Co, 1932).

3 Benjamin, 'A Small History of Photography', p. 243.

4 *Ibid.*

5 Roland Barthes, *Camera Lucida: Reflections on Photography* (New York: Hill and Wang, 1981), p. 27

6 Benjamin, 'A Small History of Photography', p. 243.

7 *Ibid.* p. 244.

8 Gaston Bachelard, *The Poetics of Space,* trans. Maria Jolas (Boston: Beacon Press, 1969) p. 163.

9 See William Morris, 'Shadows of Amiens', *Collected Works of William Morris,* ed. May Morris, 12 vols (London: Longmans Green & Co., 1910), in particular vol 1 pp. 350–60.

10 Lindsay Smith, *Victorian Photography, Painting and Poetry: The Enigma of Visibility in Ruskin, Morris and the Pre-Raphaelites* (Cambridge: Cambridge University Press, 1995).

11 Lindsay Smith, 'The Politics of Focus: Feminism and Photography Theory' in Isobel Armstrong ed. *New Feminist Discourses* (London: Routledge, 1992).

12 Benjamin, 'A Small History of Photography', p. 247.

13 *Ibid.*

14 *Ibid.*

15 Roland Barthes, *A Lover's Discourse: Fragments,* trans. Richard Howard (New York: Hill and Wang, 1984), p. 16.

16 *Ibid.*

17 Barthes, *Camera Lucida,* p. 83.

18 *Ibid.* p. 96.

19 *Ibid.* p. 71

20 *Ibid.*

21 See for example Sarah Kember's recent discussion of Barthes's text in terms of the affective capacity of the photograph in relationship to recent debates on digital imaging: '"The Shadow of the Object": Photography and Realism', *Textual Practice* 'Special Issue: Photography and Cultural Representation', 10:1 (1996), pp. 145–63.

22 I discuss these issues more fully in chapter 5. For discussions of childhood in the period, see in particular: Philippe Ariès, *Centuries of Childhood: A History of Family Life,* trans. Robert Baldick (New York: Vintage Books, 1962); James Kincaid, *Child Loving: The Erotic Child and Victorian Culture* (London: Routledge, 1992). For discussions of age-of-consent legislation and definitions of 'adolescence' see Deborah Gorham, '"The Maiden Tribute of Babylon" Re-examined: Child Prostitution and the Idea of Childhood in Late Victorian England', *Victorian Studies* (Spring, 1978); Judith Walkowitz, *City of Dreadful Delight: Narratives of Sexual Danger in Late Victorian London* (Chicago: Chicago University Press, 1992), chapters 2 and 3; Michael Pearson, *The Age of Consent* (London: David and Charles,

1972); Jo-Ann Wallace, 'Technologies of "the Child": Towards a Theory of the Child-Subject', *Textual Practice* 9:2 (1995), pp. 285–302.

23 Rosalind Krauss, *The Optical Unconscious* (Cambridge, Mass: MIT Press, 1993).

24 Stephen Bann, 'Greenberg's Team', *Raritan* 13: 4 (Spring 1994), pp. 146–59, p. 150.

25 *Ibid.* p. 153.

26 *Ibid.*

27 Krauss, *The Optical Unconscious*, p. 12.

28 Barthes, *Camera Lucida*, p. 69.

29 See for example, Fred Ritchin, *In Our Own Image: The Coming Revolution in Photography* (Aperture: New York, 1990).

1

The politics of focus:
feminism and photography theory

'Focus' or its synonym 'depth of field' is a crucial term in photography history. For histories of photography have assumed as authoritative a link between the photograph and a fine-art tradition, in part, through a conception of photographic focus as correlative with 'style' in painting. More particularly, in histories of documentary photography, 'focus' has been instrumental in confirming a belief in the sovereignty of geometrical perspective as one of documentary photography's key enabling factors. Geometrical perspective, the dominant Western system for articulating three-dimensional space as two-dimensional, assumes an established linear relationship between a vantage-point (the eye of a subject looking) and a vanishing-point (the culmination of the look upon an object) according to the eventual convergence of lines of geometrical projection. Since the function of documentary as photographic genre has relied upon a translation of geometrical perspective – originally used by the discourse of painting – into photographic depth of field, it has thereby seemed to confirm documentary photography as a similarly authoritative mapping of the visual. These appropriations of photographic 'focus', both to 'style' in painting and to the authority of a geometrical model in documentary, are, however, highly problematic and, as I hope to demonstrate, crucial to any debate upon gender within photographic discourse.

As a consequence of these appropriations, depth of field has occupied a significant place in recent photography theory, especially that which has challenged the very mystificatory model upon which documentary photographic practice relies.[1] A deconstruction of the 'truth' of documentary and the self-sustaining rhetoric of its images has grown out of a recognition of the historical, material, ideological and psychic complexities implicit in Barthes's now familiar coinage, 'the evidential force of the photograph'. Yet attempts by photographic theorists to address in these terms the politics of the photograph, particularly documentary and how it relates to a politics of gender, have to some extent still required for their persuasiveness a construction of nineteenth-century photography theory and practice as unproblematic at its inception. This version, characteristically, represents nineteenth-century photography as that which is understood

to 'conform' a centred subjectivity prior to 'the militant avant-gardism of the post-World War I period'.[2] Such an extreme simplification of photography at its inception has made it possible for theorists to locate the first 'real' questioning of the ideological functioning of photography in the 1920s and to reiterate a stable nineteenth-century model in which gender politics are also elided. Even some of the most radical and important work in photography theory replicates a version of nineteenth-century photography as occupying an unproblematic historical juncture against which to posit subsequent deviations primarily in order to enable the radicality of a modernist avant-garde to emerge against a foil of normative realism.[3]

This use of nineteenth-century photography as an enabling historical generalisation has been written into photography's history by a variety of methods. I do not mean here to refer simply to a rhetorical habit or to develop a retrospective attribution of ignorance to a previous era – another version of that which the nineteenth century did to the eighteenth and the eighteenth to the seventeenth and so forth. For there is something much more troubling at stake in theoretical approaches that ultimately sanction the reproduction of a stable and essentially simplistic nineteenth-century discourse of photography. Such approaches, in their proposition that nineteenth-century subjects believed photographic reproduction to be unquestionably 'true', assume as a priori a nineteenth-century blind spot to the workings of photographic representation and fail therefore to allow for any contestation of dominant ideological modes. Furthermore, this misrepresentation of nineteenth-century photographic discourse ignores those disruptions of the geometrical monopoly on the visual field, those interventions which photography courts from its inception. In fact, since conversely nineteenth-century discourses of vision and visuality are themselves intrinsically disrupted by the photographic medium, an allegedly stable and totalising model of nineteenth-century theory and practice occludes a complex politics of focus and gender as they come together and are played out in the early decades of photography. With these previous occlusions taken into account, nineteenth-century photographic practice can no longer comfortably provide a foil of stability against which to posit twentieth-century 'radical' practice.

In order to address further questions of precisely what is eclipsed by an erroneously stable nineteenth-century model that ultimately refutes difference in vision – those contestatory debates in optics and visual theory – and simplifies constructions of subjectivity and photographic representation, we can turn to important recent photography theory. Allan Sekula and John Tagg among others have reread the history of nineteenth-century photography in terms of disciplinary institutions, engaging discourses of surveillance, the body and institutions of social control.[4] Foucault's two 'Birth' books, and especially his work on Bentham's conception of the panopticon (as an unprecedented means of surveillance and optical mastery) have provided one of the most significant and widely used paradigms in this area of debate.[5] However, in many ways such attempts by materialist work on surveillance and the body to re-assess those old linear histories, as characterised by the domino-like progression of optical invention, have re-introduced a unifying myth of a nineteenth-century photographic unity by ascribing an historical monopoly to surveillance. There was a sense in which surveillance threatened to become the new unifying agency in photography history that was previously occupied by geometrical 'truth'. In other words, a reductive model of nineteenth-century photography may persist in part as a result of an overstatement of a

thesis of social control that only transfers a version of photography's 'inherent coherence' to the operations of 'the social formation itself'. For in Tagg's account the 'nature' of photographic practice (its implicit unity) is displaced to the 'agents and institutions which set it to work'. But these institutions themselves are brought together under the umbrella term of surveillance, the unifying project of which is subjection.[6] And even if we accept that his project is designed only to extend to particular nineteenth-century institutions, this does not account for the fact that he completely disregards a politics of gender. In this sense Tagg does not fully allow for the production of counter-tendencies to the dominant; he underplays, in other words, spaces of contestation. The cameo's ability to resolve itself into an intaglio, to take a favourite nineteenth-century optical metaphor, goes unrecognised. The logic of Tagg's approach is therefore in many ways at odds with the existence of multiple scopic regimes, totalising them all ultimately to the panoptic stare. He may rightly pre-empt the possibility of such an overstatement in the introduction of *The Burden of Representation*, but he fails to predict the possible consequences of his own position for photography theory. We are left, consequently, to wonder why and how a division of gender, for example, demarcates to quite an extent a division between historical materialist work in photography theory and that work which situates its origins in psychoanalysis and film theory. And, in this respect, we are reminded of the way in which Victor Burgin rationalised an absence of essays by women in *Thinking Photography* with the statement that women are working in another field, one more clearly aligned to developments in feminist film theory.[7]

It is important, then, that theorists of the photographic medium be conscious of the dilemma we find in Tagg. Difference in vision needs to be recognised as occurring at photography's inception, as we can detect, for example, in the nineteenth-century theorisation and construction of multiple photographic practices – such as combination printing – as both endorsing and contesting various modes of seeing. But in fact such an inherently problematic nineteenth-century practice as combination printing (the construction of a photographic image from more than one negative) is still primarily regarded as an uncomplex stylistic gesture in the direction of a fine-art tradition, in spite of the fact that combination printing brings to the fore competing ideological positions and is a structural antecedent of radical photo-montage in the twentieth century. Perhaps most troubling, dramatised by this example, is that the original appropriation by traditional photographic histories of certain nineteenth-century practices as akin to fine art has thus consigned those nineteenth-century practices to a position of relatively minor interest as compared to the more overtly political status of nineteenth-century photography as an instrument of surveillance and social control. Thus, although recent photography theory has demystified certain aspects and functions of nineteenth-century practice, it has not been entirely resistant to one of the dominant strategies of those 'traditional' histories it has sought to subvert, namely the privileging, to the exclusion of many other discourses, of a kinship between photography and painting. In many ways theory has left the problematic of so-called nineteenth-century 'fine art' photography untouched.

While, on the one hand, successfully undermining the authority and coherence of previous unproblematic photography histories and dramatically opening up critical debate, recent theory has retained, on the other, a ghost history, that of nineteenth-century photographic discourse as confirming a centred subject. The direction of future development for photography theory remains then a matter of history, involving

questions of periodisation and of renegotiating the relationship of theory to photographic history. Exorcism of its residual ghost is only possible if theorists engage more willingly and extensively the discourses of optics and visual theory that attend the invention of photography and out of which it is produced. But, we must not only refuse to dismiss those early and apparently unproblematic instances of photographic practice, we must reread and utilise differently those photographic historians and collectors (such as Helmut Gernsheim) if we are to rethink the interplay between that which is historicised and that which is omitted.[8] For it is with such rethinking that areas of dispute in early nineteenth-century photographic practice emerge as ones acutely inflected by matters of gender. It may be, in fact, the seemingly dispensable bath water and not the baby that we need to retrieve in order to address those means by which difference in vision, gender difference and a politics of focus have been written out of seminal histories of photography to obscure particular areas of theoretical unease, areas already written out when photography was detached from discourses of optics and visual theory.

Just how productive such a retrieval of these seminal histories can be becomes apparent when we compare the work of Lewis Carroll with that of his contemporary, the Victorian woman photographer Julia Margaret Cameron, whose politics of focus inscribes an overt sexual politics in a critique and refusal of the brand of perceptual mastery that geometrical perspective is designed to guarantee. But before examining Gernsheim's histories and charting a politics of focus as manifest in the photographs of Cameron and Carroll, let us contextualise further the agency of 'focus' in nineteenth-century discourses of photography and visual theory.

The politics of focus as sexual politics

Focus, in the photographic sense, derives from the Latin 'focus', meaning 'hearth'. The etymology of the term incorporates the origins of photography in fire (light), as in the optical sense of a 'burning point of a lens or a mirror', and in the meaning of centredness, implied in the centring function of hearth, and by extension, in the centring function of photography. Moreover, as the centre of the home, the private domestic space with all its symbolic and much rehearsed iconographic import, focus thereby brings to the fore this other much contested Victorian domain. As Rosalind Krauss reminds us, 'it is not surprising that the camera and photography have been placed within the ritualised cult of domesticity,' for the photographic record 'is an agent in the collective fantasy of family cohesion,' while similarly the camera is 'part of the theater that the family constructs to convince itself that it is together and whole'.[9]

Interestingly, in a now obsolete sense 'focus' also connotes theatre in its meaning of 'the best illuminated part of the stage', and it is not much of a shift from this sense to that of 'the best articulated part of a photographic image'. Of a lens, then, focus is 'the power of giving a "sharp" image of objects not in the same plane, now usually expressed as a distance, and used as a synonym of "depth of field"'. Thus, 'focus' is that which confers intelligibility upon objects in spite of their planar disparity and further implies centredness in its signification of 'a centre of activity'.[10] The cultural and conceptual possibilities that are opened up by this generative connection of focus to literal and figurative hearths would be worthy of exploration in greater detail, and while in the next chapter we will consider the centredness of hearth, for the moment let us concentrate upon their relation to a politics of focus in specific nineteenth-century photographic

practices, and particularly in those of Cameron and Carroll.

A concept of photographic 'focus' is politicised in nineteenth-century visual theory precisely in the sense that from the announcement of the invention of the daguerreotype in 1839, the professed superiority of photography in delineation of the visible is predicated upon the newly discovered ability to harness (chemically) the *focused* images in the camera obscura. Photographic meanings of the term 'focus' immediately imply therefore a new potentiality in visual representation since photography recreates a scale upon which are situated literal and metaphorical calibrations of being 'in' and 'out' of this state. The new 'sun pictures' revealed the variability of focus together with the fact that it was contingent upon particular conditions. Thus, William Henry Fox Talbot's *Pencil of Nature* was from the first a sharp one in more than one sense of the word. By introducing as variable the focal lengths that could be (re)produced in photographic representation, the sun pictures inevitably stressed or presupposed an absolute state of 'in focus' against which to measure deviations. By definition, a knowledge or demonstration of variables of focus functioned in relation to and thereby ratified an unwritten consensus upon an absolute state. From the beginning, the photographic definition of focus was made to serve existing systems of visual representation, and in particular to conspire with the dominance of geometrical perspective, thus further confirming the sovereignty of the latter in various media. In one fundamental and immediate sense, photography could appear to guarantee the continued ubiquity of geometrical accounts of space by seeming to represent geometrical spatial mapping in the greatest degree of verisimilitude experienced in visual perception up to that time. For the function of a photographic lens in recording depth of field could be read as confirming the desired ubiquity of this particular system of representing space by further attributing to it that which was eclipsed by the geometrical model, the sovereign agency of light.

Reactions to early photography as the independent work of the sun have been extensively recorded, and interpretations of photography as 'fairy' work suggest ways in which the new sun pictures could be thought to resolve or simplify agency. Talbot pinpoints a primary difference between the camera obscura and the camera lucida (as aids to drawing) and the new invention of photography. Whereas the former 'do not work for' the artist because 'the actual performance of the drawing must be his own', the latter negates the agency of the photographer since 'the picture', Talbot writes, 'makes ITSELF'.[11] Talbot thus raises the potentiality of photography as a technology for reducing human labour in modes of representation. In addition, however, his notion of auto-mimetic agency (the ability of representations to 'make' themselves), when set in relation to an ideology of mastery, links significantly with a newly defined photographic condition of focus. Indeed, the way in which the sun is thought to be able to 'naturalise' photographic representation, in early accounts of the medium, is analogous to the manner in which a photographic conception of absolute focus is apparently able to sanction the continued sovereignty of geometrical perspective by appearing to naturalise it further. Moreover, the application of photography to a visual representational realm dominated by geometrical perspective may appear to give to that perspectival system the power to reproduce itself as seemingly available in reality, by conferring a sense that the image was 'out there' in reality, able to imprint itself as it was (geometrically mapped) by way of a photograph. Preserved in such a primarily scenic representational model is that crucial Cartesian duality of vantage-point and vanishing-point without which the authoritative geometrical threads unravel.

However, from its very inception photography did not simply appear to ratify such a model but instead dramatised the existence of a variety of ways of seeing and enacted a critique of the ahistorical, 'disembodied' subject perpetuated by 'Cartesian Perspectivalism'.[12] Yet, this questioning by photography in the nineteenth century of the status and function of geometrical perspective has, as I have implied, been repeatedly overlooked, in spite of the fact that the shared ubiquity of the geometrical model in painting and of the photograph in mechanical reproduction invited interrogation of their interrelationship. By questioning the relationship of agency to focus, photography actually problematises and re-configures in the first decades a critique of the ideology of perceptual mastery as that which geometrical perspective appeared to ensure. In other words, it does not simply confirm, in 'focus', the sanctity and centredness of hearth that its etymology seems to promise.

In fact, a twinning of photographic focus and geometrical perspective as authoritative visual mapping was systematically subverted from photography's inception by radical manipulation of both the concept of focus and the concept of agency. Just as a demystification of geometrical authority in painting has since the Renaissance been repeatedly performed in the oblique constructions of anamorphosis, as the frequent and continued recourse to the suspended skull of Holbein's *Ambassadors* bears witness, so too in photography attempts to fly the nets of geometrical authority masquerading as retinal authority have been made continuously. Anamorphosis, the Renaissance fascination with the so-called 'right view' viewed 'awry', is the de-centring visual rupture in the seemingly snag-free net of geometrical optics. In nineteenth-century photography a similar disruption that foregrounds multiple scopic regimes occurs in the mid-century technique of combination printing in which, as we shall see, there is a significant coming together of focus with questions of agency in an assault upon geometrical authority.

In the 1850s and 1860s, combination printing emerges as a new process that intervenes radically at the level of depth of field. A wilful manipulation of the photograph occurs initially as a means of controlling technical weakness. Early lenses had a relatively narrow depth of field and lengthy exposures necessary for recording objects occupying different spatial planes tended to bleach out areas such as the surrounding sky for example; photographic depth of field was at once determined by technical and aesthetic considerations. One of the earliest records of combination printing is Hippolyte Bayard's description of his method of adding clouds to landscapes in the 23 February 1851 issue of *La Lumière*. The method involved cutting the print of a landscape along the line where sky and horizon met, making another print from the negative, then covering 'the lower portion of the new print with the same portion cut from the first print, leaving the sky area exposed. He placed a paper mask cut in the shape of a cloud over the sky area and printed again. During the second stage of printing in order to avoid a sharp outline Bayard continually shifted the cloud mask.'[13] Related attempts at resolving the bleaching-out of skies resulted, in many instances, in uncanny images marked by a degree of anti-realism. The half-and-half prints of landscapes by Gustave Le Gray are a case in point, in which the density of sky in relation to sea disrupts any assurance of a unitary image. Le Gray's *The Sun at Zenith, Normandy* (1850s) for example, demonstrates the effect of a seascape in which a potential bleaching-out of the sky has been averted. The photograph, which shows horses and carts on the edge of the sea with sailing boats in the distance, is distinguished by the reflection of the sun which creates a burnt-out patch on the water. Owing to the extreme tonal similarity of sea and sky, together with the fact

that each occupies almost exactly half of the composition, there is a curious appearance along the horizon line. The equality of density between the sky and the sea defies visual credibility.

Combination printing aimed to resolve limitations in focal length by combining and arranging on different focal planes separate negatives of objects taken at the required focal lengths to guarantee 'sharpness' in an eventual composition. Thus, by extension, the technique aimed to produce and confirm a consensus upon 'sharpness', upon that condition of being 'in' focus as an unhesitant and irrefutable signature of the photographic medium. But, in fact, the effect of combination printing repeatedly frustrates this strategy as is evident in adverse contemporary reaction to what it regarded as the 'patchwork quilt school of photography'.[14] Significantly, a technique (thought to be instigated by Bayard in France and developed most substantially in Britain by Henry Peach Robinson) becomes highly polemical in its deployment, not only because it is understood to assault photographic 'naturalism' in terms of subject matter, but also because it is considered by some to violate the uniqueness of the claim of photography upon the mechanical reproduction of the visual.

The Swedish artist Oscar Rejlander, a portrait painter before learning photography at the beginning of the 1850s, was one of the earliest exponents of the process to develop it to significant extremes. Rejlander made his first combination print in 1855 in a desire to maintain uniformity of focus across a photographic print, and it is clear from his remarks upon photographic techniques that such a quality of focus, as an aesthetic requirement of photography of the period, fuelled his wish to develop the process of combination printing. He notes that of his photograph entitled *Charity* (1854–56), a composition of a group of children receiving fruit from a woman in a doorway, photographers complained that all the heads were not equally sharp, nor too were some of the accessories: 'they think that the head of the broom yonder ought to challenge attention as readily as the head of my principal model'.[15] Rejlander's point in this context is that the photographer manipulates 'focus' precisely in order to throw certain important elements of a composition into relief in the same way that a painter would. The rationale for such a method of combination printing, he maintains, finds sanction in fine-art practices:

> The same way a painter goes if he wishes to paint, a photographer must go if he wishes to make a composition photograph. The two go together, part here to meet again. Fine art consists of many parts, and a photographic composition commenced in this manner must contain many parts in common with art; and even where they part company, photographic art does not stand still, but proceeds and gathers other merits on another road, which, though a more humble one, is yet full of difficulties, requiring much thought and skill up to the last moment, when [art and photography] again converge in the production of the light, shade, and reflected light which have been predetermined (in the sketch) all in general keeping, and (with) aerial perspective.[16]

A kinship between art and photography here is not simply determined by related compositional methods but by correlative levels of difficulty. While Rejlander concedes that photography is 'a more humble' practice than painting, he maintains that a combined photograph is closer to a painting than a unitary photograph because its method of production involves a similar laboriousness. Freed in this way from a relatively

instantaneous origin, and like a painting, 'requiring much thought and skill up to the last moment', the combined photograph testifies to the labour of an individual photographer.

Rejlander produced his most well-known combination print *The Two Ways of Life* in 1857 specifically for The Art Treasures Exhibition in Manchester. Printed from more than thirty negatives the final composition, thirty-six inches wide by sixteen inches high, appeared on two pieces of albumen paper joined together. In making such an ambitious combined photograph, Rejlander aimed to display the multiple compositional possibilities of the photographic medium in general. In order to do so, he chose to violate a geometrical model of visual perception and its so-called naturalness in pictorial representation. He introduced 'figures draped and nude, some clear and rounded in the light, others transparent in the shade' to demonstrate 'the plasticity of photography' and 'to prove' that a photographer is not 'confined to one plane, but may place figures and objects at any distances, as clear and distinct as they relatively ought to be'.[17] Rejlander's consideration of the relative positions of figures raises the question of whether those figures are subject to a relativism determined by contemporary developments in the understanding of the way the eye sees or, alternatively, by one authorised by the age-old perspectival model of vision. Significantly, Rejlander articulates here a split between these two, a split which fundamentally informs his work in the medium. On a practical level Rejlander used combination printing to achieve focus in the background as well as in the foreground of *The Two Ways of Life*. As William Crawford points out, not only would it have been impossible for Rejlander to have had both the foreground and background figures in focus at the same time, but it would also have been equally impossible for him to have photographed 'the figures in direct light and figures in shadow on one plate and maintain control over the tones in each'.[18] To overcome this limitation therefore he printed the various figures to different depths. His practice raises the general issue of the origin of uniformity of focus across a depth of field, a condition which does not occur in so-called 'normal' vision. As a means of deviating attention from such an issue, Rejlander emphasises the metaphysical nature of his methods as 'sun-painting', together with his ultimate subservience to the agency of the sun by 'thanking it when it had done its job'.

Contemporary critics both praised and denounced *The Two Ways of Life* which, following the Manchester exhibition, was displayed at the South Kensington Museum. One writer commented:

> the quasi-sentimentalism about the indelicacy of the picture, we have no patience to discuss; it would seem that anything which bears with it the impress of antiquity, however lewd or indelicate, is idealised into classicism, whilst anything like an attempt to elucidate an idea in the present *moral* age, if only bordering on the nude, is at once condemned as indelicate. But to the consideration of this class of art, we think that those photographers who are capable of producing such ingenious things by the camera – those who have such a power of composition, are mistaken in their vocation.[19]

Somewhat paradoxically, the tenor of criticism which centres on the practitioner's misplaced talents indicates to what extent Rejlander had been successful in his aim of applying to the medium of photography compositional processes peculiar to painting. Such reaction to his picture prompted Rejlander to write to Henry Peach Robinson: 'I am tired of photography for the public – particularly composite photos, for there can be no gain and there is no honour, but cavil and misrepresentation. The next exhibition must

then only contain ivied ruins and landscapes for ever – beside portraits – and then stop.'[20] In thus remarking upon the public's preference for predictably picturesque subjects, Rejlander captures the extent to which popular taste resisted experimentation within the photographic medium and the way in which it regarded, as straightforward, a transposition of the subject matter of painting to that of photography. As long as photography was content to present the types of subjects to which the public had grown accustomed through genres of fine art, it could be seen to complement rather than to directly threaten painting. But as Rejlander realised, soon after becoming acquainted with photography, to impose such a limitation upon the medium denied its difference from painting while at the same time undermining that denial by directly exposing the difference in seemingly unproblematic juxtapositions of the two mediums.

Nineteenth-century critics of combination printing read the technique as an ostensible denial of that agency singularly intrinsic to photography, the chemical harnessing of solar conditions at particular moments in time. Crucially, however, a theoretical positioning of an early technique together with a rhetoric of its legitimation arises as inseparable from a complex and strategic inscription of gender. Robinson locates the legitimation of combination printing in classical ideals of the female body. There can, indeed, be little danger of overstating Robinson's links between the claim of photography to a status equal with that of painting and with constructions of femininity. Robinson cites a familiar classical anecdote, illustrative of the ideal, and popular in painting, by which to authorise the technique:

> Rather more than two thousand years ago Zeuxis, of Heraclea, painted his famous picture of Helena for the people of Crotona, in the composition of which he selected, from five of the most beautiful girls the town could produce, whatever he observed nature had formed most perfect in each, and united them all in one single figure. A reference to the dim traditions of antiquity might perhaps be considered out of date in treating of an art which was discovered only a few years since; but the purpose ... is to induce you to do in photography something similar to that which the old Greek did in painting, that is, to take the best and most beautiful parts you can obtain suitable for your picture, and join them together into one perfect whole.[21]

Rather than elucidating Greek methodology, Robinson locates justification for composite printing in a version of a dismembered female subject. The female body, as model of classical 'perfection', becomes a gauge by which to measure transgressions which photographers may legitimately perform. That is to say, he legitimates a cropping and realignment of photographic negatives by a parallel dismemberment and realignment of the female body, such that the feminine becomes synonymous here with both the subject matter of the photographer and the photographic process and with the fetishism of an absolute focus. More tellingly still, for Robinson the female body as composite of male perception – a visual dismantling of the female subject in order to reconfigure it – works strategically to reconfirm a particular structuring of the male gaze as that which is rooted in geometrical authority. Robinson's impetus to solve failures of vision entails this particular appropriation of femininity to his composite theory and establishes an initial problematic identification between photographic process and the feminine.

Clearly, Robinson implicates a politics of gender in relation to questions of representation in order to argue access for photography into fine-art at the highest point

in the hierarchy. Paradoxically, however, the effect of combination printing is such that it subverts one of the main tenets of that fine-art tradition, the authority of geometrical laws of composition. For Robinson's technique works, in spite of his conscious claims to the contrary, as a critique of the perspectival model, precisely that which the initial 'scissors and paste' were brought in to preserve. Recent theory has, however, overlooked this crucial aspect of combination printing, as expressed in its uncomfortable relationship to geometrical perspective. It has therefore failed to recognise how nineteenth-century combination printing implicates geometrical perspective in two distinct ways. First, it reconfigures it, a fact which might initially appear to reconfirm geometrical authority, with an irreconcilable unease. Second, the combination print harbours, structurally, a singular potential splitting apart – the means for its own dismantlement.

Nineteenth-century photographers, such as Robinson, regarded combination printing as the type of concession that photographic composition was obliged to make if photography were to be able to replicate the geometrical perspective of Victorian genre and narrative painting. Paradoxically, however, it did not ensure this. The 'look' of combination photographs, the appearance of their readiness to 'fly apart' (together with their cultural positioning) indicates that they did not function simply to sanction the type of perceptual mastery that a replication of geometrical perspective seemed to offer. Moreover, combination printing complicates, in structural and theoretical terms during the mid-nineteenth century, the concept of such visual mastery. The labour of photographers to conceal completely the seams joining multiple negatives is crucial to the actual compositional effects because even in the most technically 'accomplished' photographs by Robinson in which one cannot find actual seams, phantom seams appear

Fig 1
Henry Peach Robinson, *Sleep* (1867)

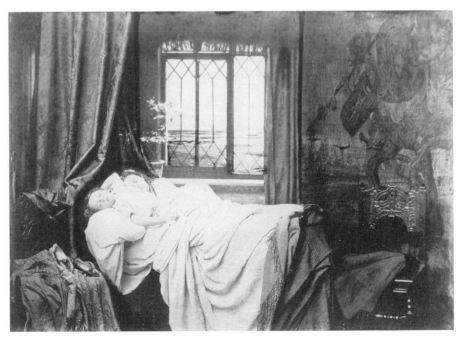

to unsettle the eye, and precisely because their multiple compositional vanishing-points, as irrefutable signature of the technique, prohibit the eye from settling into the familiar spatial certainties of geometrical perspective. Thus, in Robinson's *Sleep* (figure 1) (1867), for example, oddly apparent are those additional disjunctions characteristic of combination printing's uncanny assault on the visual (as geometrically represented). It is an assault created in many composites by the mismatched directions and functions of the represented looks, which suggest 'referred cuts' in addition to those actual structural cuts in the combined image.

Sleep made from four negatives depicting Robinson's children Edith and Ralph, and based upon a verse from Matthew Arnold's *Tristan and Iseult*, presents a composite whole in which there is envisaged not a realist sense of totality, but a sort of stereoscopic one. The reduction in size that occurs in the photo-duplication of this image fails to register the tonal dissimilarity and the compositional disjunction of the whole. Extremely pallid child figures are set against variously textured fabrics: silk brocade to the left, embroidered clothing, shiny leather shoes and slippers, together with the intermediate tones of a candlewick bedspread, are read alongside the checked cotton over-cover which spills off the end of the bed. The chair on the left of the composition, though identical to the one on the right with its intricate Gothic carving, appears distinctive through its incongruous lighting. The overall oddity of the composition is compounded by the appearance of the window in the central portion of the print, where a curtain takes on a transparent quality as it passes before a plant pot (which has become solarised), and in which the most highly lit section of the sea outside appears to project furthest into the room. More fundamentally, there is a sense in which simply too much sea is visible from the perspective created.

In the context of the structural and atmospheric oddity of combined photographs, a later combination print such as Robinson's *When the Day's Work is Done* (1877) that represents the happy domesticity of hearth becomes almost a parodic version of the origins of photographic focus itself. The photograph, made from six negatives, shows an old man and woman engaged in the activities of reading the Bible and darning, sharing the hearth which, although not particularly prominent in the composition, is indicated by the kettle which hangs above it. More emphatically, *Dawn and Sunset* (1885) combines from three negatives the figure of an old man with a mother and child seated at the hearth. Again, an uncanny perspective is created especially around the crowded left-hand foreground and the hearth, as focal point, is here centralised compositionally as a semi-obscured glow.

It is all too easy to dismiss combination printing as aesthetic whim or as an unreliable pretension of photographers towards painting, and to fail to question just what it means to cut up a photograph in 1860, what it means, that is, to tamper with the newly articulated negative/positive process. We neglect to ask what it means, in other words, to deny the single take, the unitary image, and to manipulate its temporality. Indeed, in Robinson's combination prints and photographic collages one is struck by the numbers of compositions in which a disparity between objects in terms of geometrical perspective is so great and geometrical relations so disrupted that one feels that something else is going on. For a controlling desire to preserve an even and geometrically controlled level of focus frequently creates uncannily mismatched gazes and lines of sight between subjects. It is a disjunction not only created by the composite physical distribution of figures (and combination prints nearly always contain figures) but in the

look itself. Combination prints, it must be said, create a radical disjunction in the direction and the function of the look. And this, in addition to the 'joins' frequently 'gives them away', and troubled nineteenth-century critics.

But, the look of the viewer from vantage-point to vanishing-point is also that which geometrical vision articulates as an uninterrupted and centring distance, a Cartesian relationship of exchange. And this uninterrupted linear relation, crucial to documentary, is what combination printing destabilises. The disrupted look – eye contact in combination prints – disturbs the engendering relation, expressed as a look to a vanishing-point, of a viewer. Viewing the image becomes newly problematic. Focus – as centring 'hearth' – is no longer such a stable place to define. It is precisely then within the context of nineteenth-century debates on combination printing that Cameron's photographs, read alongside those of Carroll, provide a different theoretical and ideological function.

Retrieving the bath water not the baby: Gernsheim's Cameron/Gernsheim's Carroll

In his book *Julia Margaret Cameron. Her Life and Photographic Work*, Helmut Gernsheim cites a letter of 1864 from Cameron to Sir John Herschel in which she discusses her singular photographic style:

> [I] believe in other than mere conventional topographic photography – map-making and skeleton rendering of feature and form without that roundness and fullness of force and feature, that modelling of flesh and limb, *which the focus I use only can give, tho' called and condemned as 'out of focus'. What is focus – and who has a right to say what focus is the legitimate focus?*[22]

Gernsheim cites part of the same quotation again in an attempt to shed 'light' on what he believes to be Cameron's haphazard technical methods:

> Mrs Cameron was so obsessed by the spiritual quality of her pictures that she paid too little attention to whether the image was sharp or not, whether the sitter had moved, or whether the plate was covered in blemishes … Lacking training, she had a complete disregard for technical perfection. Exactly one year after taking up photography she asked Sir John Herschel in a letter: '*What is focus – and who has a right to say what focus is the legitimate focus?*'[23]

In the shift from Gernsheim's first to his second usage of the quote we witness a particular and now familiar positioning of Cameron, the Victorian woman photographer as technically inept. In fact, in the interplay between these two quotations Gernsheim reverses the motivation for and the tone of Cameron's discourse with Herschel. Instead of a questioning of a photographic 'law' of focus (in an optical hierarchy), Cameron's communication with Herschel is made by Gernsheim into one in which she is primarily situated as incompetent regarding technical details. This creation occurs in a transference from the first to the second quotation in which Gernsheim obscures the rhetorical nature of Cameron's question, 'What is focus?' For Gernsheim chooses to render Cameron's remark as if it were a literal enquiry when it is clear from the original context, from the

dash and the deferral of the question mark in her use of the compound interrogative, that the remark is a rhetorical statement and one that does not correlate with an inability to understand the relatively simple procedure of stopping down a lens to achieve variables of focus. For Cameron is raising with Herschel, a scientist well-versed in optics and visual theory and her long-term friend and coiner of several photographic terms, including the word 'photography' itself, the issue of a politics of focus by contesting the authority of focus as law in the discourse of photography. In so doing, she is questioning the very roots of that chief tenet of photography's authority in the realm of the visual.

To support his contention, however, Gernsheim strategically slices Cameron's syntax, effectively inverting its meaning and silencing the rhetorical move that articulates 'focus' as a potential subject of nineteenth-century debate, as a contested domain in the fields of vision and visuality, and, by implication, the Victorian hearth and home. Focus becomes emphatically gendered territory.

That Gernsheim is charging a woman with the inability to grasp no more than how to stop down a lens appears to him to be sufficiently credible. For when the case of gender on one particular side of the camera is at issue then a mystification of technical knowledge serves conveniently to contain a potentially disruptive questioning of photographic authority, and by extension, as I have shown, a questioning of the ideology of perceptual mastery along geometrical lines. Thus, while Gernsheim maintains that Cameron 'paid too little attention to whether the image was *sharp or not*', it is conversely evident that that is what she in fact paid a great deal of attention to – a refutation of 'sharpness' by means of a photographic method which is, as she writes, 'called and condemned as out of focus'. Moreover, by taking a stand upon an already established commonplace, Cameron implicitly undermines the dominance of geometrical perspective in Western systems of visual representation. In the sense that the ubiquity of such a representational system in the nineteenth century (as discussed above) would appear to be further guaranteed by photographic reproduction, Cameron shakes even more implicitly, as I will show, the foundations of the nineteenth-century hearth.[24]

Influential photo-historians such as Gernsheim have forged as 'natural' and inevitable a relationship between Cameron's photographs and a fine-art tradition, in part through an approximation of photographic focus to style in painting. Indeed, there has occurred a simplistic mediation of the one discourse through the other together with a dehistoricisation of focus into the bargain. Gernsheim typifies a dominant strategy to appropriate Victorian photographers to an art history predicated upon matters of 'style' in which gender is deeply implicated. In such a scheme Cameron's photographs are said to display a style, roughly categorised as 'soft' focus, which comes to stand for a type of optimum aesthetic value in photography owing to a supposed contiguity of 'focus' to 'style' in painting. But this construction is a dehistoricised version of Cameron's theory and practice, and it succeeds essentially in detaching Victorian photography from the multiple discourses that attend and participate in its invention in order to leave a single discourse as *the* naturalised discourse for correlation and comparison. More crucially still, it repeatedly conceals precisely those stages required to arrive at a neat equation whereby 'soft' focus equals a greater aesthetic value than does 'sharp' focus in Cameron's portrait photography. Gernsheim's account of Cameron fails to acknowledge that 'soft' focus is a relatively new construction, that the term refers, in fact, to the aestheticisation of focus. Such a construction also obscures the fact that focus or its synonym 'depth of field' operates primarily in nineteenth-century photography as a mark of, or signature

for, the mechanics of the medium whose meanings are invariably different from its pre-photographic ones. In one important sense, then, a concept of focus, deriving from the discourses of geometry and optics, becomes that which is singularly intrinsic to photographic reproduction. In this way, instead of aligning photography with painting, 'focus' is that which elicits a conception of photography at its farthest remove from painting.

Thus, what has occurred in photography history to make us read Cameron's unfocused images as 'soft' focus images (notice what a considerable shift in signification is implicit here) is an aestheticisation of focus as popularised by Gernsheim's history. To continue to read simply as 'style' the problematic concept of focus in nineteenth-century photography theory and practice is to continue to privilege the relationship of photography to painting to the exclusion of all other discourses. Furthermore, it is to write out of history, as does Gernsheim in his omission of the counter-tendency from Cameron's syntax, primarily on the grounds of gender, a questioning and critique of the ideology of perceptual mastery. Most importantly, as I will go on to demonstrate, when read contextually, Cameron's decision not to approximate a focused image, together with her questioning of focus as photographic law, constitutes a critique of the ideology of perceptual mastery as that which is continually affirmed in the notion of a stable relationship of subject to visual field along the lines of a geometrical grid. Contextually, Cameron's photographs have to be read as problematising photographic discourse, by employing it to challenge one of the most dominant paradigms in Western modes of visual representation. By subverting a photographic law of focus close to photography's inception, Cameron destabilises the assurance of hearth, both in its technical and its social senses.

A second reference to Gernsheim and his highly influential book, *Lewis Carroll, Photographer* allows us to examine even more explicitly the problematic of a relationship between nineteenth-century visual theory and gender difference as enacted in a politics of focus.[25] As with his work on Cameron, Gernsheim was the first critic to devote a book-length study to Carroll as photographer, and in particular to Carroll's portraits of children. As Gernsheim notes, Carroll, like Cameron, was a self-taught amateur. However, while the myth of Cameron as technical incompetent has to some extent endured, variously translated as a condition of chronic myopia, Carroll is mythologised, beginning with Gernsheim, as a master of composition. As part of his strategy of lionising Carroll, Gernsheim compares the two contemporaneous photographers in a way that genders their photographic styles according to an inversion of their gendered positions:

> Mrs Cameron was urged on by great ambition, and her work is the expression
> of an ardent temperament. Lewis Carroll had no ambition; *his art springs from*
> *delight in the beautiful; he is feminine and light-hearted in his approach to*
> *photography, whereas she is masculine and intellectual.*[26]

The conscious sexual inversion here operates to indicate ultimately a preference for the 'feminine and light-hearted' in a man with 'no ambition' over the 'masculine and intellectual' in a woman 'urged on by great ambition'. In this sense the gender disruption that each photographer suggests does not involve a strict motility between these two positions. That is to say, it is more admirable to be a nineteenth-century male photographer with no ambition than a female photographer with a great deal of it. Ambition for a woman is invariably equivalent to a surfeit of it. Such interrelations of

gender and focus become more acute when Gernsheim brings questions of composition into his comparison of the two photographers. But, as we shall see, there is a problem with reading the two photographers as straightforwardly gendered 'masculine' and 'feminine', for Gernsheim disrupts the opposition when he finds it expedient to do so. He cites a comment by Carroll on the relationship of his photographic 'style' to that of Cameron which further dramatises complex ways in which focus and gender are here each implicated in the other. In referring to an evening in August 1864, spent in looking at Cameron's photographs at her house, Freshwater, Isle of Wight, Carroll writes of them: 'some are very picturesque, some merely hideous. *She* wished she could have some of *my* subjects to do *out* of focus – and I expressed an analogous wish with regard to some of *her* subjects', a statement that Gernsheim annotates then as implying that Carroll wished to do some of her subjects 'in focus'.[27]

We have here a fantasy hinged upon substitution in which the photographic 'subjects' of each photographer are articulated as a theoretical visual antithesis, that of being 'in' or 'out' of focus. But what then is the status of this type of fetishism of focus – and by extension a fetishisation of its absence – in nineteenth-century photographic discourse and those discourses with which it intersects? What is articulated at this stage in Victorian photography in the passage or potential slippage between these two newly photographically inscribed extremes of being 'in' and 'out'?

In/out, in/out, shake it all about

We have, then, a hokey-cokey situation; to be alternately 'in' and 'out' is the legacy of photographic focus. Such a legacy becomes evident in comparisons of photographs by Cameron and Carroll in which we find difference articulated at the level of depth of field. Quite simply, the comparison shows that where Cameron largely refuses to produce a highly focused picture-plane, Carroll in his portraits of 'child friends' preserves above all else a centrally focused object. Indeed, in Carroll *all* represented space leads ultimately to a focused region, that of a child's body. The ramifications of Carroll's obsession with focus is demonstrated by the extraordinary portraits in the Gernsheim Collection of one of his favourite models, Alexandra Kitchin, nicknamed Xie. The photographs represent a repetition of the 'set-up', highly staged portrait. In them we find Xie in Greek dress in 1873, wearing a crown in 1874, sleeping in ragged dress in 1875, as a China man, in white hat and coat, playing the violin, and as Reynolds's 'Penelope Boothby' among others in 1876. Not only in these photographs do we repeatedly encounter the same persistently makeshift studio interior, the same properties (Chinese boxes and crown for example) but we find that the articulation of space surrounding the subject remains the same. However, what becomes most troubling is the articulation of the centrally focused and elaborately clothed body of the child. For the look is repeatedly stopped upon the child's body. But this literal and abrupt stopping is created as such by the inclusion of the photographer/viewer's route to it. In other words, it is created by the depth of field that intervenes between vantage-point and vanishing-point and secures their interdependent relation.

Rather tellingly, Gernsheim dismisses wholesale Carroll's 'costume portraits' by condemning them as artistically inferior and as 'errors of taste'. But in fact more than any other of his photographs these 'set-ups' of Xie enact the obsessional repetitive methods of the photographic entries in Carroll's diaries, those elaborately circuitous schemes for

securing an infinite supply of child subjects for the lens, those processes by which Carroll's literary authority precedes and sanctions his photographic identity and practices.[28] Nevertheless, Gernsheim makes the following distinction:

> Whereas Lewis Carroll's other photographic work shows a remarkable independence of contemporary photography, the sentiment of these pictures is a lamentable concession to Victorian taste. As a producer of costume pictures Lewis Carroll is almost always banal; as a photographer of children he achieves an excellence which in its way can find no peer.[29]

There is a striking paradox here, an imbalance in this perfectly parallel sentence. For surely the point is that Carroll's 'costume pictures' are *always children* in costume. Yet when is a child portrait not a child portrait? Gernsheim seems to imply – 'When it's in costume!' His attempt to make a distinction here unwittingly further complicates Carroll's portraits of children – children standing in here of course for girls ('I am fond of children', Carroll once wrote, 'except boys'). If we extend this point to the controversial case of the lost but now retrieved though tampered-with images of naked children, together with those negatives that Carroll is known to have destroyed himself, we are reminded of how questions of sexuality in Carroll always hinge upon these images. Perhaps not surprisingly, we discover that the clothed ones are the most troubling, especially those that enact various cultural and national fantasies – the Indian, the Greek, the Turk, the directly theatrical guises, or Carroll's unrealised lifelong desire to create a 'gypsy'.[30] In other words the most complex of Carroll's photographs are those which Gernsheim directs us away from – those of children repeatedly clothed and set-up against a blank studio wall, undressed, only to be reclothed in the garb of various cultural fantasies. The manner in which these portraits articulate gender in terms of a politics of focus therefore makes them central to a comparison with Cameron.

The intrusiveness of photographer and viewer in these portraits of Xie Kitchin is dramatised by the repeated inscription of wide expanses of floor area in front of the subject which creates an odd effect rendered all the more oddly pervasive by the inclusion of tatty sections of carpet that cover or uncover the floorboards. In many of these portraits of Xie particularly there is a missing piece to the left foreground. Carroll's missing carpet square, in the end, becomes a haunting aspect of these photographs. The presence of the absent piece is emphasised by the fact that the piece behind the exposed boards is kinked up slightly to give the further impression of our viewing the scene from a low point of view. We might even suggest that this missing square of carpet in Carroll's photographs of Xie serves as a tawdry inscription of the ideology of perceptual mastery. Yet no one has ever, as far as I know, remarked upon its blatant presence, nor (not wishing to expose emperors) has anyone chosen to see its persistence in the work of a 'master' of composition.

The photographs *Xie Kitchin Playing the Violin* and *Xie Kitchin as Penelope Boothby* (figures 2 and 3) may demonstrate my point. *Xie Kitchin Playing the Violin* shows the model posed in the balletic third position to appear as if playing the instrument. But it would be impossible for her to do so from where she is standing, since the bow is pressed right up against the wall. Xie stands, off-centre to the right, with her heels up against the skirting-board, her back against the wall with a large expanse of foreground space and the ever-present, though here somewhat obscured by damage to the negative, signatory carpet. She is wearing a heavy velvet dress with white sash and

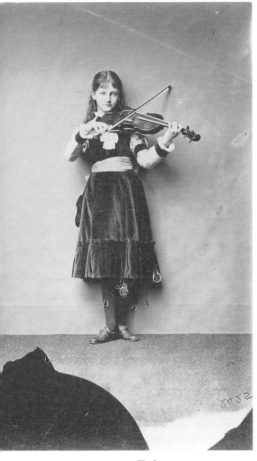

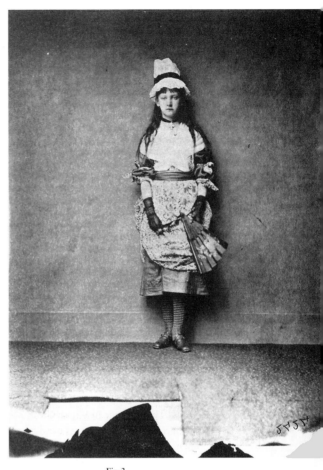

Fig 2
Lewis Carroll (C.L. Dodgson) *Xie Kitchin Playing
the Violin* (1876)

Fig 3
Lewis Carroll (C.L. Dodgson) *Xie Kitchin as
Penelope Boothby* (1875)

sleeves, and she looks out towards the camera with a slight smile. Dressed as 'Penelope
Boothby' (the standing rather than recumbent pose) Xie is captured in the same interior,
centrally located up against the wall with the same absent piece of carpet to the left
foreground. She wears striped stockings, transparent fingerless gloves, and around her
neck hangs a black choker with heavy metal cross. This time her look is directed slightly
off to the left. Again, what is disturbing here is the foreground space which precisely
suggests the encroachment of the point of view, of the photographer's vantage-point. In
other words, the location of the figure beyond empty foreground space itself signals that
she has been set up to view in geometrical terms. The vantage-point of the
photographer/viewer is extremely uncanny in both of these and various other portraits
by Carroll. He appears, in effect, to be toying with geometrical mastery in more ways
than one. The object of the look/lens is literally mastered here optically, displayed for
view before a blank ground, somewhat in the manner of a projection, located at the
vanishing-point of our look. This is why the inclusion of the foreground space is so
crucial and the persistently absent carpet square so troubling. The set-up in terms of
depth of field, as much as the child portrayed, inscribes Carroll's irrefutable forge-proof

signature with the agency of invisible ink.

In this context, Gernsheim's reading of Carroll as master of composition might be rephrased as a 'master' of successfully replicating the type of visual mastery articulated or exercised by geometrical perspective. Significantly, nothing like this mastery is present in Cameron, and therefore it should not surprise us that Gernsheim labels her 'weak' at composition. This point of comparison does not of course make Cameron, for Gernsheim, a less successful photographer, but it keeps her in her gendered place in a fine-art tradition, as more interested in representing the 'souls' of her sitters as opposed to Carroll's largely pragmatic interest in 'laws' of composition.

Thus we can ascertain more clearly the relationship between a politics of gender in photographs and photographic histories of Cameron and Carroll with a politics of focus. The oddly repetitive depth of field in Carroll, culminating in a captive displayed literally up against a wall, represents a space assumed necessary to mobilise that geometrical binary relation, which is also a space of male fantasy. In Carroll this intervening space is in focus indicating the sovereignty of hearth. And he is called a master of composition in Gernsheim's history because his photographs more nearly approximate the colonising gaze of documentary practice, that which requires geometrical mapping for its intelligibility.

But such so-called mastery also has direct implications for the roles of gender as they are established in and by the relationship of focus to hearth and home, that bastion of patriarchal power. As Christian Metz reminds us, the intrinsic link between photography and the fetish occurs with the home, the 'birthplace of the Freudian fetish'.[31] While Metz addresses the fetish in order to determine some of 'the basic differences between photography and film' I am here concerned with the way in which photographic focus in Carroll mobilises processes of fetishism. Freud in his essay 'Fetishism' (1927), defines the fetish as 'a substitute for the woman's (the mother's) penis that the little boy once believed in and – for reasons familiar to us – does not want to give up'.[32] Thus, fetishism occurs in the boy's disavowal of the woman's lack of penis as a means of displacing his own fear of castration. Carroll, in these portraits of Xie Kitchin seeks to 'stop' the look 'half-way' as it were, to arrest it with fetishised articles of clothing (upon those 'India shawls' for example).[33] Focus as photographic state may thus in a sense be read as fetishised with its antithesis 'out of focus' thereby becoming commensurate with a fear of castration (or with 'the unwelcome fact of woman's castration') symbolised in the loss of patriarchal power in the home. We can further rewrite this formation as the fetishism that *is* focus in the sense that focus in photographic representation newly mobilises the fetish. Moreover, returning to the substitutive relationship of 'in' to 'out' of focus, for a subject to be 'out' of focus for Carroll becomes an issue because of the relationship of photographic focus to the institution of the fetish, because to deny focus is to deny the institution of the fetish as a displacement of loss. Carroll approximates this position when articulating his lack of aesthetic interest in the bodies of young boys, for he maintains they always give the impression of needing to be covered up. Yet, to put it simply, for Carroll, the bodies of boys are still not worth dressing up to be photographed. To dress up boys would not constitute an attempt to ward off this loss, for they are always already redundant with regard to fetishism since it is not the sight of the phallus that the voyeur seeks to ward off but rather the sight of its absence.

Cameron, however, unlike Carroll, does not stop the look. With an absence of 'sharp' focus, her photography cannot therefore in the same way serve fetishism. In

Fig 4
Julia Margaret Cameron, *Annie, 'My First Success'* (1864)

subverting photography's authoritative self-defining law of absolute focus Cameron effectively denies the phallocentricism of geometrical perspective and rewrites the contingency of depth as her subject. Consequently, Cameron typically situates the subjects of her portraits, including those of children, close to the picture-plane. She does not invite the eye into the recessional certainties of geometrical perspective; she removes the intervening distance between vantage-point and vanishing-point. Her portrait, of the child Annie Philpot, *Annie, 'My First Success'* (figure 4) (1864), shows the subject without sharp focus in a three-quarter left profile. Her clothing is detectable only as a dark coat with large buttons. The image is devoid of props and since the subject occupies virtually the whole space of the picture-plane, the small proportion of background works against a recessional register; the female subject is newly realised. This portrait has been described as 'unusually modern by virtue of its informality';[34] in fact its effect of 'informality' derives as much from a denial of Cartesian perspectivalism as from an absence of the staging characteristic of Carroll. Similarly, *Daisy* (1864) a portrait of Daisy Bradley, shows the subject, close to the picture-plane, occupying virtually the entire

image and again without sharp focus. The child looks directly out, with hand held to her collar and the representation disrupts conventional modes of identification (voyeurism and narcissism) for the viewer through its reformation of the agency of focus.

By definition, then, Cameron's politics of focus also denies the fetish. Since a condition of 'in' focus becomes fetishised (as a displacement of loss) then her denial of focus conversely prevents the look from being blocked or displaced, by the 'pre-eminence of certain forms as the objects of its search',[35] and thus condemns it to perpetual unease, to the relative 'blur' of its mobilisation. Constructed in such a way, Cameron's contestation of focus contains clearly wider historical and cultural ramifications. In other words, Cameron threatens more than merely an aesthetic principle. She represents the possibility of demobilising the whole mechanism of fetishism in the field of vision, and all that demobilisation clearly implies for the Victorian patriarchal sanctity of home and hearth. As we are reminded by Lacan, Freud singles out the scopic drive as 'not homologous with the others' precisely because it is 'this drive that most completely eludes the term castration'.[36]

Thus, to read nineteenth-century debates upon photographic focus is to confront a primary identification of contestatory photographic practice with problematic constructions of gender; it is the ideology of perceptual mastery (as exemplified by geometrical perspective) laid bare in a simultaneous problematisation of photographic agency and a politics of gender. Furthermore, Cameron specifically threatens the most reliable means by which for the male the castration complex may be disavowed: the scopic realm. Moreover, since psychoanalytic theory has appropriated from visual culture the geometrical as a model for the psychic apparatus, the potential displacement of such a model in nineteenth-century photography also suggests new ways in which to think about the relationship of sexual difference to photographic representation. In this way, Cameron's politics of focus should be read as undermining dominant modes of seeing, and theories of representation that underpin the whole patriarchal structure of Victorian society.

Notes

1 See in particular Andrea Fisher, *Let Us Now Praise Famous Women* (London: Pandora, 1987).

2 Abigail Solomon Godeau, 'Reconstructing Documentary: Connie Hatch's Representational Resistance', *Camera Obscura* 13/14, 1985, p. 116: 'Not before, however, the militant avant-gardism of the post-World War I period was it possible to at least partially address some of the underpinnings of photography's ideological functioning.' See also her *Photography at the Dock: Essays on Photographic History, Institutions, and Practices* (Minnesota: University of Minnesota Press, 1991).

3 Solomon Godeau, 'Reconstructing Documentary', p. 116.

4 John Tagg, *The Burden of Representation, Essays on Photographies and Histories* (London: Macmillan, 1988); Allan Sekula, 'The Body and the Archive', *October* 39 (Winter 1986), pp. 4–64.

5 Michel Foucault, *The Birth of the Clinic: An Archaeology of Medical Perception* (London: Tavistock, 1973) and *Discipline and Punish: The Birth of the Prison* (London: Allen Lane, 1977).

6 Tagg, *The Burden of Representation*, p. 118.

7 Victor Burgin, ed. *Thinking Photography* (London: Macmillan, 1982), p. 114.

8 Helmut Gernsheim together with his wife Alison Eames Gernsheim amassed numerous holdings of photo-historical images and literature and began the Gernsheim Collection in

London in 1945. Over the next two decades they published twenty books and over two hundred journal articles on photography and photography history. When the University of Texas acquired the Gernsheim Collection in 1964, it was the largest photo-historical archive in private hands.

9 Rosalind Krauss, 'Photography and the Simulacral', *October* 31 (Winter 1984), p. 57.

10 The Latin *focus* was first used in plane geometry by Johannes Kepler in 1604 to simplify 'one of the points from which the distances to any point of a given curve are connected by a linear relation'. In optical discourse, 'focus' describes 'the position at which an object must be situated in order that the image produced by the lens may be clear and well-defined'.

11 William Henry Fox Talbot, *Literary Gazette* 1150 (2 February 1839), p. 73.

12 The de-mystification of geometrical or Cartesian perspective, together with a critique of the mastery inherent in its disruption, has been addressed – in relation to painting – by Norman Bryson and Martin Jay in one of a series of talks at the Dia Art Foundation; see *Vision and Visuality*, ed. Hal Foster, *Dia Art Foundation Discussions in Contemporary Culture*, no. 2 (Seattle: Bay Press, 1988). Whereas Bryson locates a critique of geometrical perspective in the work of Erwin Panofsky, Jay argues that although geometrical perspective has been 'the target of a widespread philosophical critique', owing to its dependency upon an ahistorical 'disembodied' subject, this does not mean that as a representational system, 'it was quite as uniformly coercive as it is sometimes assumed'. And Jay cites the position of Michael Kubovy, *The Psychology of Perspective and Renaissance Art* (Cambridge: Cambridge University Press, 1986) to argue that we cannot identify the theoretical rules of perspective 'with the actual practice of the artists themselves'. However, absent from the Dia lectures is a recognition of the way in which nineteenth-century photography complicates the status and functioning of geometrical perspective.

13 Hippolyte Bayard, *La Lumière* 23 February 1851.

14 *The British Journal of Photography* contained an ongoing debate upon combination printing during 1860. See in particular: 2 April, 15 June, 2 July. I hope to suggest here and in chapter 4 some of the reasons for combination printing's having remained an 'unhomely' technique in photography theory .

15 Oscar Rejlander, cited in Edgar Yoxall Jones, *Father of Art Photography Oscar Rejlander 1813–1875* (Newton Abbot: David and Charles, 1973).

16 *Ibid*.

17 Oscar Rejlander, 'On Photographic Composition with a Description of *The Two Ways of Life*', *Journal of the Photographic Society*, 21 April, 1858, pp. 191–6.

18 William Crawford, *The Keepers of Light*: *A History and Working Guide to Early Photographic Processes* (Dobbs Ferry, New York: Morgan and Morgan, 1979), p. 53.

19 *Journal of the Photographic Society*, 21 April, 1858, p. 193.

20 Rejlander to Robinson, *Practical Photography*, March 1895, p. 65.

21 Henry Peach Robinson, *The British Journal of Photography*, 2 April 1860, p. 94. Robinson is in many ways unabashedly disrespectful of 'naturalism'; moreover he is not very good at foreseeing the logical extensions of his theoretical strategies, thus opening himself to the accusations of second-rate 'patchwork'. It is further significant that in the debates, in this journal, on combination printing, the critic A.H. Wall opposes Robinson to Rejlander, allegedly to demonstrate Rejlander's greater respect for 'composition' as evidenced in his never overlooking 'the superiority of painting over photography' (A.H. Wall, *The British Journal of Photography*, 2 July 1860). However, in fact, Rejlander turned to combination printing for a reason that systematically brings together a politics of focus and gender: in order to reproduce a gendered spatial ordering. Rejlander describes his first use of the technique as a means of reconfirming a particular structuring of the male gaze. As William Crawford remarks, 'vexed and despairing, he found that, after arranging three figures in a portrait group, his lens would not give sufficient sharpness to the male subject who stood behind a couch, on which two ladies were seated' (*The Keepers of Light*, p. 53). Thus, in order not to disrupt traditionally gendered relations in portrait photography, not to allow the man to drift out of focus, Rejlander adopted combination printing.

22 Helmut Gernsheim, *Julia Margaret Cameron. Her Life and Photographic Work* (London: Aperture, 1948), rev. edn (London: Aperture, 1975), p. 14 (my emphasis).

23 *Ibid*. p. 70.

24 The claim that Cameron's photographs may be read as engaging a critique of dominant nineteenth-century representational theories and practices might initially seem incompatible with her claim that part of her project is an attempt to secure for photography 'the character and uses of High Art'. Cameron's above aim is not so unquestionably at odds with a politics of focus if we read her phrase as more commensurate with pre-Renaissance art, or at least with the versions of medievalism that she explores in her Tennysonian subjects. Nor is it so if we take into account her recognition of the inherent problematic of a desire to position her own discourse in relationship to that of painting.

25 Helmut Gernsheim, *Lewis Carroll, Photographer* (New York: Dover, 1969). In the preface to the first edition, 1949, Gernsheim explains how, while collecting material for his biography of Cameron, his attention was first drawn to one of Carroll's albums.

26 *Ibid*. p. 29 (my emphasis).

27 Quoted in Gernsheim, *Lewis Carroll*, p. 30.

28 Gernsheim chooses to refer to Carroll by his literary name, even though Carroll used C.L. Dodgson for his photographic identity. This point would be interesting in itself even if it did not relate to Gernsheim's dismissal of Carroll's costume pieces. While I do not wish to join the Jekyll and Hyde debate, I would like to point out the manner in which, in practice, Carroll's literary identity fronted the photographic one. The author of *Alice in Wonderland* usually procured photographic 'victims' by first sending them a copy of his book. The book as gift was generally followed by a letter to the parents asking permission to 'borrow' their child.

29 Gernsheim, *Lewis Carroll*, pp. 20–1.

30 For plates of the four surviving 'nude' studies, see Morton N. Cohen, *Lewis Carroll, Photographer of Children: Four Nude Studies* (New York: Potter, 1979).

31 Christian Metz, 'Photography and Fetish', *October* 34 (Fall 1985), pp. 81–90, p. 82: 'Photography enjoys a high degree of social recognition in another domain: that of the presumed real, of life, mostly private and family life, birthplace of the Freudian fetish.'

32 Sigmund Freud, 'Fetishism', 1927, *The Standard Edition of the Complete Psychological Works of Sigmund Freud*, eds James Strachey and Anna Freud, 24 vols (London: Hogarth Press, 1953–66), vol 21, pp. 147–57, pp. 152–3. Freud also writes:
 In the situation we are considering ... we see that the perception has persisted, and that a very energetic action has been undertaken to maintain the disavowal ... But this interest suffers an extraordinary increase as well, because the horror of castration has set up a memorial to itself in the creation of the substitute. (p. 154).
 But later he further adds: 'In very subtle instances both the disavowal and the affirmation of castration have found their way into the construction of the fetish' (p. 156).

33 On the question of the relationship of fetishism to Orientalism see David Simpson, *Fetishism and Imagination* (Baltimore: Johns Hopkins University Press, 1982), p. iv. There is not space here to discuss at length the question of fetishism as 'anthropological concept' in the work of Carroll, but Simpson discusses Melville and Conrad as demonstrating the 'exporting of the fetishised imagination from one's own society to distant places; the very places from which, ironically enough, the first accounts of fetishistic practices had originally been taken'.

34 Amanda Hopkinson, *Julia Margaret Cameron* (London: Virago, 1986), p. 106.

35 Jacques Lacan, *The Four Fundamental Concepts of Psycho-Analysis*, trans. Alan Sheridan (London: Penguin, 1977), p. 182.

36 *Ibid*. p. 78.

2

'This Old House': Julia Margaret Cameron and Lady Clementina Hawarden

Confronting the materiality of individual photographs invites a consideration of the predilections and compulsions of their maker: in the case of Lewis Carroll, the compulsion to repeat a particular staging of little girls for the lens; in that of Julia Margaret Cameron, the drive towards a condition of 'unfocus' or a less than absolute focus. In the previous chapter, I attempted to show that these two desires (compulsions) were intimately related. Carroll's fixing of the female minor time and again in 'fancy' dress and tawdry studio-setting – in which desire is played out in the display of the body of the child – and Cameron's positioning of the female subject close to the picture-plane dramatise a particular gendering of 'focus' or photographic depth of field. At photography's inception, and in its early decades when the medium's aesthetic and scientific status were still primarily provisional, it was more likely than at any subsequent moment that conditions of focus would be subject to questioning. The case of Cameron reinforces this point. A predominant critical reading of nineteenth-century photography that valorised 'sharp' focus (over a lack of focus) demoted Cameron's photographic images to unsuccessful attempts to 'master' the photographic medium. At the same time however, her contemporary photographer Lewis Carroll was singled out as achieving compositional mastery. Such 'mastery', it followed, meant aspiring to sharp focus and it meant distributing the elements of a composition in such a way as to allow the eye the recessional register (distance) necessary to read the subject depicted in the manner of a projection. The question that especially concerns me is why at this juncture in the nineteenth century, when the status of the photographic medium was by no means determinate, should we be required to privilege these particular qualities of the medium?

As we found in chapter 1, such a correspondence between mastery and photographic depth of field to some extent stems from the fact that compositional 'regularity' in photography has a direct correlative with the dominance of geometrical perspective in Western art. Quite simply, focus in photography was seen as analogous with perspective in painting, and seemed to offer confirmation of the ubiquity of that dominant Western system of articulating three dimensional space in two dimensions.

While the inability of a painter to depict a retiring plane in 'correct' perspective was considered a sign of inferiority in the nineteenth-century, 'correct' perspective, as Ruskin pointed out in his defence of the Pre-Raphaelites, was routinely over-valued in art criticism at the expense of more fundamental structural qualities. Moreover, for Ruskin, such over-valuation of perspective indicated precisely that painting had lost its root in visual perception to be determined instead by its depiction of what one knew to be present rather than by what one actually perceived.[1] For, as he argued persuasively, Cartesian perspectivalism allowed that which was peculiar to the visual sense to escape; it was a system of describing space by mathematical calculation. It did not articulate sight, since it could be taught to the blind, and it eluded light itself.

Aligned with such perspectivalism, the equation of so-called 'mastery' with photographic depth of field is fundamentally gendered. At its invention, photography, heralded by some as the sovereign realist mode, appeared to guarantee the utmost geometrical accuracy to date. If it failed to do this, or was wilfully prevented from achieving such legitimising 'accuracy' by a photographer such as Cameron, not only was there an assault on the integrity of the photographic process as coterminous with geometrical perspective, but a questioning of those qualities of enlightenment and rationalism, and of all that such a perspectival system stood for. An aversion to a less than absolute focus (Carroll's to Cameron's for instance) or a critical reduction to a condition of myopia of Cameron's resistance to sharp focus reveals differences of gender as prime motivating factors.

A gendering of photographic 'focus', present first and foremost in the etymology of the Latin word 'focus' meaning 'hearth', brings to the fore that much contested private space in the separate spheres ideology of nineteenth-century culture, together with its profound resonances for visual and gender politics. Although in the period one tends to associate woman with the private domestic space and often finds the controlling man of the public sphere exerting an influence on that space, for example in Victorian narrative paintings which anticipate his return home from work, it is clear from a study of nineteenth-century women's painting and photography that the domestic context offered all sorts of possibilities for women practitioners that could not simply be absorbed into that neat bipolarity as implied by the ideology of separate spheres. Clearly, women worked from within the private, if not to overturn its controlling rationales then to significantly disrupt and alter them. In representing seemingly innocuous domestic acts and scenarios, or by transforming everyday contexts into studio spaces, women artists were able to question accepted hierarchies and begin to erode those fixed structures upon which they were based.[2] Paintings of the domestic bliss of hearth which show women and children alone suggest a particular kind of monopoly on, rather than a simple powerlessness within, that domestic space. Jane Bowkett's painting *Preparing Tea* (1860s) for example depicts the spell of hearth in its representation of the pleasure of a mother and child as not reducible to, or primarily confirming, a pre-determinate concept of masculinity.[3] In many images, especially present is an interest in the psychic realms of represented figures; psychic realms as uncontainable in contrast with those seemingly circumscribed private spaces.

In a sense then photography within the domestic context, like the genre of 'still life' painting for women all too often read as simply indicative of female artists' non-intervention in the more 'interesting' male genres, allowed women a place from which to explore important psychic and social questions without having to negotiate problems of

chaperonage and travel. It is in the light of these considerations that I want to question, not simply the politics implicit in the condition of focused and unfocused photographic images, but also more extensively the domestic context as depicted without the 'sharp' focus of geometrical authority. I am interested in those points at which a manipulation of focus in the domestic realm coincides with the origin of the term 'focus' itself. The gendering at the level of depth of field which, as I have argued, may be read in the Freudian symbolic terms of castration, fetishism, and of a stopping of the look 'half-way' requires further analysis in the gendered context of hearth.[4] In addition to stressing the links between focus and fetishism, it is crucial to consider ways in which the connections between them emerge in particular photographic contexts such as that of the domestic. In the previous chapter I noted that the generative connections between literal and figurative hearths, as implicit in the photographic term 'focus,' were worthy of greater attention, and it is to these connections that I wish to turn.

That woman is required to occupy the position of guardian of the province of hearth in nineteenth-century culture testifies to the importance of that domestic centre in constructions of masculinity; but it does not thereby negate the possibilities of the context of hearth for women themselves. Cameron's work embodies a particular spatial intervention in the representation of the domestic. Her use of 'hearth' as a point of political redefinition (in its broadest sense as a locus of her interest in those women and children close at hand who regularly served as her models), demonstrates its centrality to various discourses of the period. Cameron's photographs redefine the literal space of hearth by manipulation of photographic focus. In Cameron there is not a sense that the private (as depicted photographically) is unquestionably defined by the public. There is a celebration of hearth inseparable from a contestation of photographic focus which cannot be read as complicitous with a division of spheres, with a polarity in which one term is invariably and unproblematically privileged over the other. Cameron as a woman photographer redefines that supposedly 'feminine' domain.

For Cameron, the assault on the domestic comes in a self-conscious refusal of the brand of perceptual mastery implicit in the concept of 'focus'. By refusing to focus her images, preferring instead a look aesthetically pleasing to her own eye, Cameron undermines the sovereignty of hearth as a stable place underpinning the foundations of Victorian culture based upon a privileging of public (male civic subject position) over private (domestic female) space. As we found, Cameron's rhetorical question 'and who has a right to say what focus is the legitimate focus?'[5] introduces a relativism into the realm of photographic authority which makes the traditional space of hearth contingent and refuses the brand of perceptual mastery implicit in a concept of 'sharp' focus. As explored by Cameron, 'focus' generates a radical questioning of the space of 'hearth' (the domestic) in all its mythology. The domestic represents a domain which, in its emphasis upon the psychic as essential to social definitions of gender and subjectivity, operates to undermine dominant cultural definitions. Importantly, during the mid-nineteenth century we find women intervening in the establishment of a fantasy of familial and social cohesion. At this historical moment, what we have come to accept as the photograph's naturalised place in the promotion of the family was not yet firmly established and the photographic medium was opening up other fantasies enacted within the domestic space.

The photographs of Lady Clementina Hawarden are particularly apt in this respect since they chart various aspects of that private realm. An amateur photographer contemporary with Cameron and Carroll, Hawarden repeatedly photographed her own

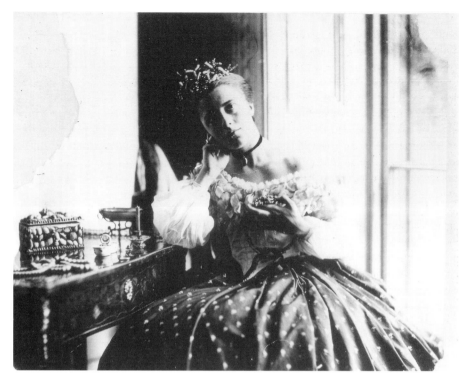

Fig 5
Lady Clementina Hawarden, *Untitled* (1860s)

children and young women, often in lavish historical costume, in interiors transformed by natural light and by the reflective mediums of windows and mirrors. In a photographic career of about seven years Lady Clementina Hawarden (1822–65) produced around eight hundred and fifty photographs. The main body of her work is held by the Victoria and Albert Museum. Seven hundred and seventy-five Hawarden photographs were given to the V. & A. by Hawarden's granddaughter in the late 1930s or early 1940s. Hawarden first exhibited her photographs at the 1863 Photographic Society of London exhibition at which she gained a silver medal for the best contribution by an amateur, and was elected to the Society. At the 1864 show she was awarded a silver medal for the 'best group or groups, or composition or compositions, each from a single negative'.[6]

In Hawarden, the insularity of the domestic (private) is shown to be distinct from the public, but it is ambiguously defined as a region in which all sorts of intimate interactions are staged. Staging is a predominant quality of Hawarden's photographs; many are reminiscent of the fashionable Victorian genre of the tableau vivant with its self-consciously stiff poses. But her photographs are different; they avoid the compositional symmetry and distanced theatricality endemic to the tableau vivant and move instead to a sense of a set-up of spatial compositional irregularity. Vast expanses of light and shadow characteristically achieve emphasis equal to that of human figures; so too do props and objects, particularly jewellery and objects of adornment.[7] I am particularly interested in those photographs in which two women are acting out theatrical scenes, and in those images of single women in their own interiors in which

'women's objects' figure predominantly. The depiction of such personal objects distinguishes Hawarden's photographs (that use props) from those of Carroll. *Untitled*, for example, shows a three-quarter length pose of a woman in what looks to be a bridal gown. She sits by a window on an upright chair wearing a highly ornate bodice, with sleeves and a veil of net, together with an ornate necklace and tiara. There is a head-dress of flowers, and a jewellery box, on the table to the left upon which she rests her arm. The mood of this photograph (the woman has downcast eyes, though a fraction of each eye is visible) is one of pensiveness. One feels that it shows a woman relating to highly personal objects in the intimacy of her boudoir, or the equivalent of the seventeenth-century closet in which a woman could seek solace. But the photograph depicts a private 'womanly' space by stressing its ordinariness or its virtual innocuousness. It is as if in presenting a woman at home in contemplation in this way Hawarden is situating the female subject at a far remove from that role of female producer as artist or photographer.

The photograph opposite (figure 5) may be twinned with the one discussed above in which the same one of Hawarden's daughters is similarly posed with her right elbow leaning upon the same highly decorated chest. More of the chest is clearly visible in this photograph, as are the objects lying upon it: a small vase; a jewellery box with shell work in front of which lies a snaked string of beads, a small china ornament, and a candle. The woman wears an ornate head-dress, a gown which slips from her shoulder as before, the same bodice as in the previous photograph with a dark skirt bearing a simple sprig motif, and a dark choker around her neck. Since she clasps a garland of flowers to her breast, the one previously displayed on the table, one is tempted to read these two photographs as subtle permeations in a private narrative. The woman directs her look outward to a point above the viewer; she is depicted among secretly meaningful mementoes at a moment of contemplation. The viewer is made to confront the female figure at close range in a privately resonant space, not unlike that domestic space described in Mary Elizabeth Braddon's novel *Lady Audley's Secret* (1862) when the 'hero' having negotiated a narrow secret passage enters the bigamous heroine Lady Audley's boudoir to encounter its private and highly emotive 'womanly luxuries': 'the atmosphere of the room was almost oppressive from the rich odours of perfume bottles whose gold stoppers had not been replaced … jewellery, ivory-backed hair-brushes, and exquisite china were scattered here and there'.[8] In this novel which is contemporary with Hawarden's work, male protagonists are shown violating specifically 'female' space in order to view a portrait of the heroine so as to gain mastery over her. In a fictional text concerned with contemporary social questions, such as the categorisation of female insanity as either inherited or socially produced, Braddon makes central to her narrative questions concerning the possession and control of the female domestic context. Relatedly, not only do these photographs lack male figures entirely in their compositions, but they also suggest points of identification between, and among, women in terms of the viewpoints they invite.

Both of the above photographs by Hawarden offer rich possibilities for re-conceptualising women's stake, and the stake attributed to them in the domestic in the manner of paintings by women contemporary with them that show female figures somewhat innocuously doing nothing in the home. To be shown in the process of being a dutiful wife or mother, or as a contemplative woman at leisure, is to be far removed from the actual practice of the woman photographer as cultural producer. The going

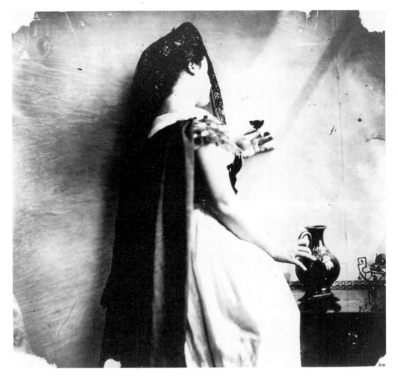

Fig 6
Lady Clementina Hawarden, *Untitled* (1860s)

against type that is necessary in order to produce the photograph is patently evident in the woman rendered as cultural observer or, as depicted in many paintings of the period, as cultural consumer. The position of women as producers in a material sense is both revealed and obscured in their depiction of themselves primarily as cultural observers or consumers.

In these photographs of lone women, Hawarden does not attempt complex narratives, but nor does she appear to be interested principally in arresting specific or discrete moments in time. Gestures of figures seem far too ordinary and relaxed to sustain such a reading. Rather, Hawarden is concerned to image the connectedness of aspects of women's psychic life with seemingly innocuous material objects, which acquire significance within the compositional realm of the photograph. She aspires to photograph the physicality of private objects in the same way that she renders the physical presence of her female models by emphasising the luxury and texture of their clothing through harnessing particular conditions of light. We find in this context (figure 6), *Untitled* one of Hawarden's daughters photographed from behind turning to right profile. She leans away from the viewer, her left hand holding a glass of red wine, while her right hand leans on the handle of a jug from which she has poured it. She wears a dark bodice, a dark-toned cloak and a black lace-edged mantilla which falls to the waist. When read in relation to the previous two images which suggest bridal display, the effect is one of exoticism, of the suggestion of a non-British southern context. More than this though, one is struck by the apparent simplicity of the photograph, and of Hawarden's body of work in its entirety, by the way in which household objects, both decorative and

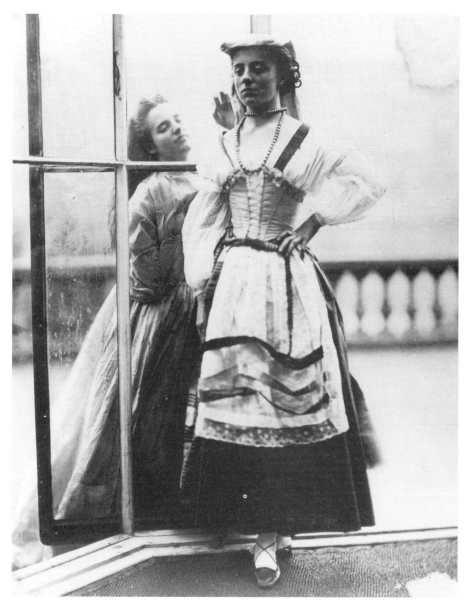

Fig 7
Lady Clementina Hawarden, *Untitled* (1860s)

functional, assume a highly charged status within the confines of a composition. In this photograph for example, one's eye is drawn especially to an ornate fruit bowl next to the jug; the every-day object has the effect of exceeding its significance in the subtle narrative coherence of the whole.

The use of mirrors, in particular, heightens Hawarden's assault on and transformation of private ('female') space. Mirrors not only suggest an outlet in their most obvious compositional and traditionally symbolic functions, but they also insist upon fragmentation by presenting different facets of the subject depicted and by altering

the viewer's relationship to that subject, perhaps most obviously by making one more acutely aware of the process of identification itself. One is prevented in Hawarden's work from taking up easy positions of identification such as straightforwardly narcissistic or voyeuristic ones.[9] Windows serve similar functions in Hawarden's photographs; she interposes the medium of a window between two female figures. Another untitled image dramatises a look between a woman on the inside (standing in three-quarter length profile) and a hatted woman on the outside of a window peering through at her. The looks exchanged here open up all sorts of questions about specularity and sexual sameness, about the interaction of women inside and beyond the domestic space. So too does the photograph *Untitled* (figure 7) which shows two women, one inside and one outside a French window, posing as if taking on the appearance of a modified mirror image. The figure inside the room wears a national costume with apron, white head-dress, laced bodice, and cross-strapped shoes. The figure outside leans against the window, looking longingly with left hand raised, emotively crushing the sleeve of her candy-striped dress against the pane, thus alluding to the surface quality of the glass as well as to its transparent reflective status. The woman within stands with her left hand on her hip, looking out with a sombre expression. Rosary beads which hang from her waist are interestingly emphasised by a string of beads doubled around her neck. There is a certain inscrutability about such an image which suggests an interaction across the medium of a window. We are invited to read each figure as a type of double of the other; there is a self-referentiality that renders the threshold space ambiguous. The window as aperture, as a means of outlet, returns the image of the woman within to herself.

The stress upon intimate interactions between women also figures in those of Hawarden's photographs that include cross-dressed figures. Unlike Cameron, Hawarden does not secure eminent Victorian men to occupy bit-parts or central roles in her theatrical photographs; women play all the parts. Consequently, the predominant sense of specularity that these photographs convey goes unchecked. In a further photograph the daughter appearing in the photograph discussed above features in the same dark bodice, with mantilla, offering a purse, or some sort of token to a cross-dressed figure on the left who registers a look of shock and leans three-quarters away from the viewer, head resting against the wall, with downcast eyes. We witness an enactment of female supplicance which hinges upon the staging of an unexplained economic encounter.

An apparent reversal of the power relation here depicted, as embodied in the gesture, appears in another image of cross-dressing, *Untitled*, in which the male figure poses on bended knee, offering his left profile to the viewer, with outstretched arm touching the hem of the dress of the woman figure who looks down at him with disdain. The dramatic cameo takes place by a wall lit from a window to the left. The effect, as when men playing women's parts in Shakespearean drama additionally cross-dress as male, is to introduce a heightened awareness of the constructedness of gender difference and of gendered roles according to the codes of clothing and gesture. It is to make the viewer or reader aware of the inseparability of codes of gender from those of formalised behaviour, but also to display intimate interaction between women as played out in articles of dress and among the objects of a closed domestic milieu.

It is significant that gestures between figures, although frequently dramatic or overstated, remain difficult to decipher in Hawarden's photographs which include pairs of women; difficulty in reading them is generated by the total effect of a composition. Hawarden questions the mythologised sanctity of hearth by complicating its

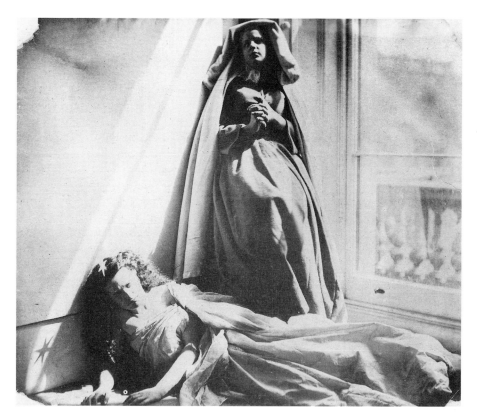

Fig 8
Lady Clementina Hawarden, *Clementina in Fancy Dress* (1860s)

representation as an easily knowable territory of nurturing and regeneration. Such complication is evident, for example, in Hawarden's photograph *Clementina in Fancy Dress* (figure 8) which shows two women figures (her daughters) heavily draped, against windows with a faint view of a balcony and buildings beyond. One figure is prostrate; the other stands, hands clasped, her attitude resembling that of a sculpted saint in a niche. The recumbent figure has an ornate star in her hair which is interestingly doubled, thrown onto the wall as a shadow by a shaft of light. A very self-conscious use of space creates formal arrangements in which human figures and effects of light and shadow acquire equal priority. There is a sense in which no distinction is made between the substance of the female figures and their billowing, tonally modulated clothing. Positioned in the corner of a room against a deep skirting board, the figures themselves command the physical area depicted to such an extent that they work against the sense of claustrophobic space, or projection against a blank wall, we so often find in Carroll. In part such an effect is owing to the inclusion of the window itself which serves as an outlet, signalling a hazy scene beyond, and as a source of dramatic and visible light effects, especially that of the shadow of the star to which the eye is repeatedly drawn back.

The dramatic scenarios of Hawarden's photographs force a reconsideration of private spatial realms. Such a formal emphasis relates most obviously to Cameron's photographs which make the viewer confront her figures at close and intimate range.

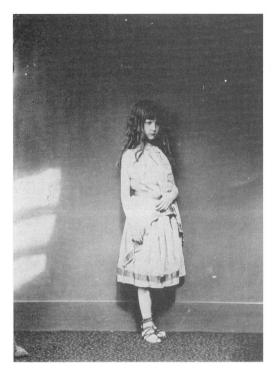

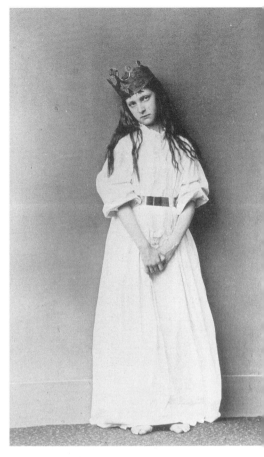

Fig 9
Lewis Carroll (C.L. Dodgson), *Xie in Greek Dress*
(12 June 1873)

Fig 10
Lewis Carroll (C.L. Dodgson), *Xie Kitchin Standing
in a Night-dress and Crown*, (1874)

Though their styles are obviously very different, and Hawarden does not undermine 'sharp' focus in the manner of Cameron, both photographers frequently set up women and girls as dominating space, and in this respect the photographic subjects of both are distinct from those of Carroll. In *Clementina in Fancy Dress* the women are so arranged and flooded by light as to almost cancel out the relatively bare interior context; not the context *per se* but the context as 'empty' space. The reclining figure is right before us; we are not presented with the inclusion of a gentle spatial route to her body.

Although Hawarden frequently photographs young women in relatively bare interiors, which I have identified as a feature of Carroll's photography, there is more of a sense in Hawarden that the interiors are crucial to the composition; great aesthetic interest is demonstrated in the distribution of light for example and in the record of combined reflections, say of architectural elements and costumes. Not only is her work different from Carroll's in its entire treatment of objects, but Hawarden does not situate her figures in isolation. Shadows and light patches are equally focused, and not all represented space is subordinate to the display of a central child. It is in such a comparative context that one feels that Carroll's eye is unaware of intervening space, that he is unconscious of the ways in which it reproduces photographically – he doesn't care so long as it does not detract from a central focal point. Where much could be made of viewpoint, nothing is made of it by Carroll. It is as if he feels that there is no choice; a

sense most clearly evident in the many photographic studies of Xie Kitchin in the dress of various cultural fantasies. In Carroll's photographs *Xie Playing the Violin* (figure 2), which we considered in the previous chapter, and *Xie in Greek Dress* (figure 9) (June 1873) there occurs a subtle degree of difference. The difference amounts to a shift to a three-quarter profile. But in both photographs Carroll is interested in the figure in isolation, not the figure as located in a *defining* space; it is the figure dressed and displayed against a blank wall in the manner of a projection.

For me, one of the key issues to arise from such equations is the way in which children (little girls) are set in context. On the face of it, Carroll's images frequently include more space surrounding a figure, but there is less of a context consciously evoked, and little or no interaction between figures and their locales. If we take Carroll's photograph of *Xie Kitchin Standing in a Nightdress and Crown* (figure 10) (1874), we find displayed in the image the impetus to secure the child against a blank wall in an undifferentiated context. Indeed, it is highly unusual in Carroll to find variations in light effects purposely captured in a photographic print. Where they do appear, as in the shafts of light cast upon the wall beside the figure in *Xie in Greek Dress*, one feels that their presence is entirely incidental. Cameron, by distinction, in denying obvious compositional structures based on a depiction of recessional space, creates as a consequence much more complex forms of identification for the viewer than does Carroll. In Cameron's *My Grandchild Aged 2 Years and 3 Months* (August 1865) (figure 11), the sleeping baby is presented beneath the adoring look of the mother/Madonna figure. The juxtaposition of soft focus on the baby's face with the sharp, highly lit profile

Fig 11
Julia Margaret Cameron, *My Grandchild Aged 2 Years and 3 Months* (August 1865)

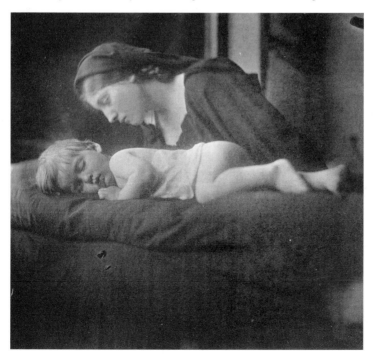

of the mother defies a perception of depth. The mother's dark dress fails to recede but registers instead as a continuum of the dark foreground drapery. The infant's hand, comfortingly cramped beside his chin, is read alongside the relaxed positioning of his legs. His body is subject to the mother's gaze. A relatively short depth of field together with an arrangement of the figures at eye level exaggerates the representation of the power of maternal adoration. By comparison, in Carroll's *Xie Kitchin Standing in a Nightdress and Crown*, in which the girl is shown as perceived, as espied, the photographer's and viewer's route to the object of his gaze is captured irrefutably. The awkwardness with which the child appears, read in the uneven distribution of her body weight, comes not from having to hold an awkward theatrical pose, but rather, one feels, from her projected sense of being the only point of emphasis in a very empty and undemarcated space. In Cameron there is not the same sense of mediation. The opportunity for fetishisation is not presented to us ready-made; there is a much more subtle manipulation of the viewer's identification. This point of my argument is not, I believe, altered by the consideration that Cameron sometimes focused her images, for the case at issue is variability of focus and the fact that Cameron is so interested in defending her idiosyncratic use of it. In Cameron and Hawarden the human figure is important as a contextualised figure; in Carroll context is largely disregarded.

The differences that I am identifying are not ones at the level of subject matter: Cameron as a woman photographs young women and girls and Carroll as a man does the same. They are rather differences enacted in the methods by which girls are offered to the lens. Cameron, Hawarden, and Carroll all use dressing-up and, as we have found, Hawarden has young women cross-dressing, but the contexts of the dressing-up are

Fig 12
Lewis Carroll (C.L. Dodgson), *Xie Kitchin Lying on a Sofa* (1875)

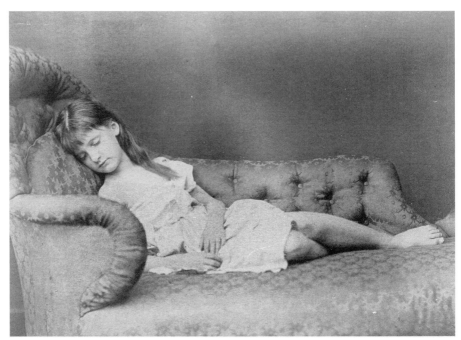

radically different; so too are the purposes that they serve. Frequently, Carroll photographs little girls in nightdresses, aspiring to what he believes to be a condition of 'naturalness'. In this context, while *Xie Kitchin Lying on a Sofa* (figure 12) is compositionally different from most of the photographs by Carroll that we have discussed so far in that it situates the child fairly close to the picture plane, the edge of the *chaise-longue* occupying the entire bottom portion of the image, it registers a characteristic awkwardness in the rather indeterminate torn garment which leaves bare the little girl's right shoulder and much of her chest. In an overtly voyeuristic fashion, a sleeping girl is captured for our view. While Cameron and Hawarden often create narratives in their photographs, Carroll rarely does so. When he attempts to tell a story, as in *St George and the Dragon* or in *The Elopement*, in which Alice Jane Donkin balances perilously out of a window, it fails to convince the viewer because the narrative content is subordinate to a 'straight' depiction of individual elements.[10] The figure of Xie Kitchin dominates *St George and the Dragon* in which she poses with her brothers. She wears the same crown and nightgown as in the portrait *Xie Kitchin Standing in a Nightdress and Crown*, and, hands clasped in front of her, she looks out directly at the viewer. The three boys engaged in simulated action appear as mere accessories. The one assuming the part of St George sits, with sword, astride a rocking horse; another serves as the dragon somewhat inadequately obscured by a leopard skin; a third lies on the ground as if wounded. The effect of the whole is an odd sense of dislocation. Carroll doesn't manipulate space, or situate the figures in order that they make sense. There is too much space – there is always a sense of retaining a distance necessary for fetishisation.

Cameron has been accused of being sloppy in her process, of printing from cracked plates, of including finger prints, hair and other debris in her images, but for me these characteristics are different from Carroll's 'faults'. In Cameron the faults seem to testify to an ease, an intimacy not only with her subjects but with the process of wet-plate collodion photography itself. Whereas in Carroll, the faults smack of a blindness to anything other than the little girl captured (it is as if there is nothing else to be seen), in Cameron, there is an awareness of errors and, one feels, a simultaneous disregard for them. In Carroll, they are simply not seen – it is not that the photographer's eye is simply comfortable with them. One feels it does not notice them.

By typically situating the subjects of her portraits, including those of children, close to the picture-plane Cameron overtly denies the recessional certainties of geometrical perspective; she removes the intervening distance between vantage-point and vanishing-point. In this context, we noted her portrait of Annie Philpot, *Annie, 'My First Success'* (figure 4) (1864), for the way in which it shows the subject without sharp focus, in a three-quarter left profile, as an image devoid of props.[11] The compositional dominance of the child, occupying more or less the whole space of the picture-plane, works against a recessional register and allows the female subject to be newly photographically realised. Similarly, in a portrait of Florence Fisher (figure 13) (1872), the child subject, depicted without sharp focus, occupies virtually the entire image. The child's hair, almost indistinguishable from the background, frames the whole. Any sense of clothing is obliterated by the vegetation that encloses the bottom edge of the image. As the little girl looks out directly, the softly focused whiteness of her skin, exaggerated by her dark eyes, disrupts voyeuristic and narcissistic modes of identification for the viewer through its reformation of the agency of focus. She is situated at the distance of a self-reflection in a

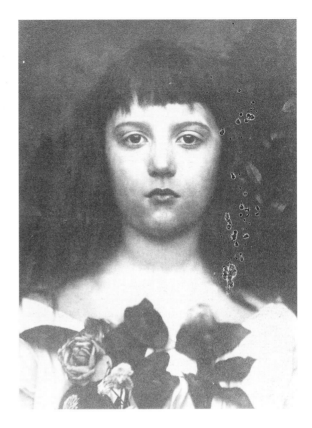

Fig 13
Julia Margaret Cameron, *Florence*
(August 1872)

Fig 14
Julia Margaret Cameron, *All Her
Paths are Peace* (June 1866)

Fig 15
Julia Margaret Cameron, *Eleanor
Locker* (July 1869)

looking glass.

In *All Her Paths are Peace* (figure 14) (1866), the frontal aspect of the portrait, the cropping of the young woman's hair and neckline, and the practical inability on the part of the viewer to separate figure from ground, create what is in many ways Cameron's most emphatic representation of 'the look'. One confronts the subject in the manner of a mirror-image (as oneself seeing oneself). The full-frontal aspect gives rise to that particular transparency of light eyes that only uncoloured photographs can convey. While it is possible to seek out some depth within the image in the tonal contrasts, in the interplay of white face and darkened hair, for example, the photograph frustrates such a search. Indeed, the image blocks any attempt by the viewer to set it at such a distance to enable a conception of a whole or complete subject. In this photograph, even the eyes refuse to offer depth, and with their light transparency – suggestive primarily of surface – they confront the viewer without betraying any sense of a submissive relationship of the subject to the camera. In a related manner, the emanation of the figure from the bottom of the composition in the portrait, *Eleanor Locker* (figure 15) (1869) – whereby the hair of the subject assumes the shape of a pyramid and entirely frames the image – prevents the eye from seeking out background recessional space, and makes the contingency of focus a fundamental concern. For in this photograph, long flowing hair, one of the most conventionally symbolic attributes of feminine sexuality, is presented compositionally so as not to allow that intervening space, between viewer and object of the lens, necessary for a fetishisation of the subject as I have described its occurrence in

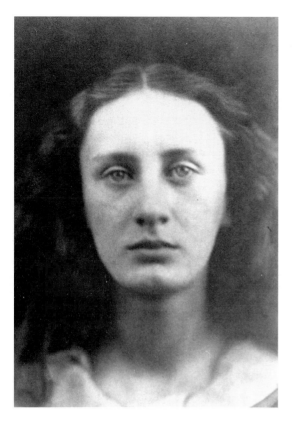
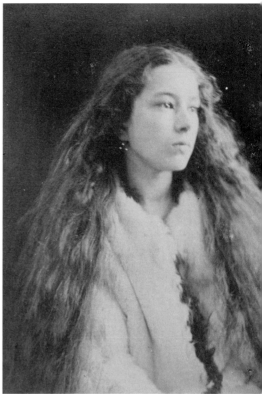

Carroll. The spatial location of Cameron's figure, whereby hair circumscribes and extends beyond the woman at the bottom edge of the picture-plane, recalls the compositional dominance of hair in J.E. Millais's painting *The Bridesmaid* (1851), and transforms the metaphoric connotations of hair into a newly realised structural element. Hair and clothing are fused around a subject who emerges from the bottom right of the picture plane with reflected light in her eyes. In both photographs clothing is attributed little importance; it is present as a vague accessory to the figure, as drapery rather than as a point of interest in its own right as it tends to be in Carroll.

But it is not simply Cameron's portraits that unsettle spatial relations in this way and disallow the type of distance necessary for a photographic image to be perceived in the manner of a projection. In a more directly allegorical photograph such as *The Red and White Roses* (figure 16) (1865), one does not so much encounter a complete absence of focus as a redefinition, by degrees, of a less than sharply focused image. Cameron achieves such a range of focus and of tonal gradations in this image that, in a sense, the photograph replaces 'focus' as an indisputable photographic condition with a relativism of focus. Although she creates great variety of focus in this photograph, even the most highly focused areas – those that fall along the line of the rose branch, the knuckles on the left hand of the girl and the fingernails of the child on the right, which share approximately the same focal plane – are still comparatively blurred if one refers them to an authoritative quality of 'focus'. The photograph registers, however, in such a way that one does not require the yardstick of an absolute condition of focus against which to

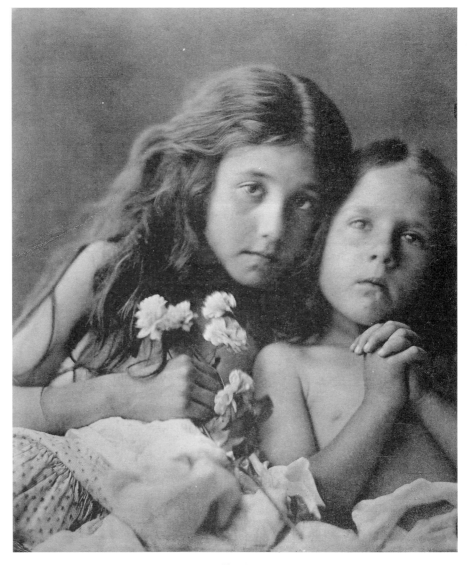

Fig 16
Julia Margaret Cameron, *The Red and White Roses* (1865)

measure a shortfall, so to speak. Rather, the distribution of focus within the print radically redefines the appearance of objects according to such a photographic code.

By redefining the seemingly familiar contexts of the domestic, by repeatedly photographing women and children with newly realised depths of field, women photographers, most notably Hawarden and Cameron, bring to the fore the cardinal function of hearth (as the linchpin of separate spheres) in gender politics of the period. Their representation of subtle permutations from within the domestic realm indicates that a discussion of nineteenth-century women's photography in the context of its production should not simply begin from the premise that these women photographers wished to overthrow the tyranny of the domestic by aspiring themselves to a more

'significant' civic persona. The realm of the hearth itself, as locus of the identity of the medium of photography, offered all sorts of opportunities for Victorian women practitioners that may easily go unnoticed in discussions that begin from the assumption of an ideology of rigidly separate spheres. Cameron's and Hawarden's photographs testify to a sustained intervention into such theoretical paradigms. Cameron's interest in women and children (implicitly occupying that private space of hearth) and her depiction of it by way of her idiosyncratic technique, and Hawarden's concentration upon melodramatic staging and innocuous scenes of domestic contemplation represent a profound questioning of all that the seemingly knowable domestic sphere stands for in Victorian culture.

Notes

1 For a discussion of Ruskin's attitudes to Cartesian perspectivalism see my *Victorian Photography, Painting and Poetry: The Enigma of Visibility in Ruskin, Morris and the Pre-Raphaelites* (Cambridge: Cambridge University Press, 1995).

2 I am particularly concerned with those representations by women painters which show women at leisure, interacting within the domestic realm. See for example works by Joanna Wells, Jane Bowkett, Rebecca Solomon and Louise Jopling.

3 Deborah Cherry reproduces and discusses Bowkett's *Preparing Tea* in relation to the ideology of separate spheres, *Painting Women: Victorian Women Artists* (London: Routledge, 1993), pp. 134–5. See also my discussion of the painting in 'Polly Put the Kettle On', review of *Painting Women*, Art History 17:3 (September 1994), pp. 464–9.

4 See Freud's essay 'Fetishism' 1927 (*The Standard Edition of the Complete Psychological Works of Sigmund Freud*, eds James Strachey and Anna Freud, 24 vols (London: Hogarth Press, 1953–66), vol. 21, pp. 147–57, pp. 152–3).

5 Cameron, cited in Helmut Gernsheim, *Julia Margaret Cameron. Her Life and Photographic Work* (London: Aperture, 1948), rev. edn (London: Aperture, 1975) p. 14 and p. 70.

6 Lewis Carroll's comment on seeing the 1864 exhibition is highly significant: 'I did *not* admire Mrs Cameron's large heads, taken out of focus. The best of the life ones were Lady Hawarden's.' (*The Diaries of Lewis Carroll*, ed. R.L. Green, 2 vols (New York: Oxford University Press, 1954), vol. 1: pp. 217–18). For further biographical information see: Virginia Dodier, 'Clementina, Viscountess Hawarden: Studies from Life', Mike Weaver, ed. *British Photography in the Nineteenth Century: The Fine Art Tradition* (Cambridge: Cambridge University Press, 1989), pp. 141–50, and Virginia Dodier, *Domestic Idylls: Photographs By Clementina Hawarden* (Malibu, California: John Paul Getty Museum, 1990).

7 See for example Hawarden's untitled photograph in which a woman at a window creates a strong diagonal composition with her gown flowing and tumbling off the left-hand side of the print. Shadows on the floor and on the moulding of the table are as equally focused as the human figure (V. & A., XVII, D627).

8 Mary Elizabeth Braddon, *Lady Audley's Secret* (1862) (Oxford: Oxford University Press, 1987), p. 69.

9 John Pultz in *Photography and the Body* (London: Weidenfeld and Nicolson, 1995), p. 41 remarks, in relation to Hawarden's use of mirrors: 'Mirrors not only restate the process of photography; they also have a psycho sexual power of their own ... The reflected images also suggest the role played in sexual fulfilment by vision and visuality, points at which photography and the body intersect'.

10 Lewis Carroll, *Alice Jane Donkin* (1862), entitled by Carroll *The Elopement* and Lewis Carroll, *St George and the Dragon*. Characteristically, in the latter photograph, there is a significant amount of foreground space in which the eye may wander.

11 Amanda Hopkinson, *Julia Margaret Cameron* (London: Virago, 1986), p. 106.

3

'Lady Sings the Blues': the women amateur and the album

> A picture in black and white seldom makes its appearance; some works of
> Polidoro are examples of this kind of art. Such works, inasmuch as they can
> attain form and keeping, are estimable, but they have little attraction for the
> eye, since their existence supposes a violent abstraction.
>
> (Goethe, *Theory of Colours.*)

I want to consider further the context of the domestic in photographic work by
nineteenth-century women, but more specifically in relation to theoretical questions
about photographic process; those places where scientific experiment and unorthodox
amateur practice come together. In his Royal Society essay of 1842, Sir John Herschel,
celebrated scientist and coiner of many photographic nomenclatures, outlined his
discovery of the cyanotype process, a culmination of considerable chemical research.[1]
The process which used iron salts sent to him by the contemporary young chemist, Alfred
Smee, was distinguished by its blue colouring. 'To paper washed with a solution of salt
is deposited Prussian blue' writes Herschel:

> after half an hour's exposure to sunshine, a very beautiful negative photograph
> is the result, to fix which all that is necessary is to soak it in water, in which a
> little sulphate of soda is dissolved, to ensure the fixity of the Prussian blue
> deposited … After washing, the ground colour disappears, and the photograph
> becomes bright blue on a white ground.[2]

Struck especially by the distinctive colour of this direct positive process, by which
Prussian blue was formed in the paper, Herschel named it the cyanotype, explaining
further that since the varieties of the process 'seem to be innumerable' 'the whole class of
processes in which cyanogen and its combinations with iron performs a leading part, and
in which the resulting pictures are blue, may be designated by this epithet'.[3] The
cyanotype was one of many processes and striking effects to result from early photo-
chemical experiments, reminding us that early experimentation with colour formed an

integral part of the pre-history of the photographic medium. As the emergence of the colour peculiar to the cyanotype bears witness, early photographic processes give rise to multiple monochrome schemes which are not simply reducible to the 'black and white' used to describe pre-polychromatic photography. We recognise, in Herschel's comments, not only the legacy in colour of the black-and-white photograph, but also the fact that when colour was invented it had the quality of a return to what had been regarded as those early potentialities of the medium. Indeed, as Herschel's research demonstrates, the possibility of photography had been conceptualised first of all in colour. We find many experiments by Herschel, predating those with Prussian blue, which suggest an avid quest for colour in early photography.[4] In his correspondence with William Henry Fox Talbot (10 September 1840), the scientist reiterates the dependence of his research into the possibility of colour photography upon the sun itself which, as is characteristic in the early stages of the medium, is routinely anthropomorphised:

> The sun has been so dreadfully niggard of his beams that I have been unable duly to follow up the very curious train of enquiry about the peculiar efforts of the spectrum-rays. The white spot corresponds strictly to the extreme red. And the whitening power is transmitted through cobalt blue glass. But the most curious thing is the effect on paper already tinted by a pure violet ray. On such paper the extreme rays develop a red of surprising richness and intensity of which I enclose you a specimen. I should observe that the prism used for the enclosed is a *water* prism.[5]

While the development under particular conditions of red spectrum rays is a source of fascination for Herschel, it is the blueness of the cyanotype – and those particular theoretical issues it raises – that I want to focus on as a means of relocating the amateur practices of nineteenth-century women within those philosophical debates around photography's invention. For a consideration of the cyanotype signals an intersection of issues of gender, and the minutiae of early experiments in the chemistry and optics of photography at its inception, with the larger cultural and material circumstances of amateur practice. In addition, a reading of the cyanotype process alongside techniques of photo-collage raises fundamental questions in the nineteenth century about the relationship of photography to memory and to abstract concepts of absence and presence.

'Blue, Blue, My World is Blue'

I begin with the genesis of Herschel's incredible blue process because, as several commentators have indicated, not only did it provide the means by which the first photographically illustrated book was produced but, pre-dating Fox Talbot's celebrated *The Pencil of Nature* which began to appear in instalments in June 1844, it was made by a woman.[6] In October 1843 Anna Atkins (1799–1871) published *Part I* of *Photographs of British Algae; Cyanotype Impressions* which ran to a ten-year span, thereby applying Herschel's process to scientific book illustrations.[7] The only daughter of the scientist John George Children, Atkins had been a friend of the Herschel family since her childhood, and in 1823 she had illustrated her father's translation of Lamarck's *Genera of Shells*.[8] A keen botanist, she took up the cyanotype process specifically in order to document specimens of algae she had collected. As Larry Schaaf informs us, 'each part [of the book]

contained a number of plates that were contact prints from specimens of algae',[9] and her motivation for using Herschel's process resulted from a desire to record minutiae which might be missed by other mediums. Atkins writes, 'the difficulty of making accurate drawings of objects as minute as the Algae and Confervae, has induced me to avail myself of Sir John Herschel's beautiful process of Cyanotype, to obtain impressions of the plants themselves, which I have much pleasure in offering to my botanical friends'.[10]

Atkins's methods of producing cyanotypes from her seaweeds were, in their own ways, as painstaking as Herschel's chemical researches. She had to prepare thousands of sheets of cyanotype paper by hand, and 'hundreds of various and delicate specimens of algae had to be made ready, washed and arranged and dried. Each sheet took its turn in the sun, was washed, dried and flattened. Then the plates had to be collated and sewn together'.[11] Atkins combined recording with collecting, the legitimate mid-nineteenth activity for women, and the resulting images derive from a desire to provide a reliable means of identification. Scientific rationalisation and faithful reproduction are at the heart of the project. While those photograms provided by the cyanotype give silhouettes, they also lend an incomparable transparency to objects reproduced. That is why tender plants, stems, and petals are rendered particularly well because the photographic process itself facilitates a sort of seeing through the object, bestowing upon the observer an extra dimension to the visual sense. Like single-cell thick specimens prepared for microscopic slides, cyanotypes invite a correspondence between the revelatory eye of a microscope and that of the camera, for the fragility of the seaweed, and especially its different levels of thickness, are rendered as indelible as the creases in the clothing of a human photographic subject. The text accompanying the images was 'either in Atkins's hand or in title letters composed of strands of seaweed,'[12] forging a continuity between impressions from nature and a writing produced from the 'seaweed' itself. It is as if the photographer wants to stress elemental aspects of the process by fixing chemically both the linguistic and the pictorial.

In histories of photography Anna Atkins has been classified as a straightforward amateur woman practitioner, largely because she holds the distinction of having made that 'first' photographically illustrated book.[13] But Atkins's algae and their critical acclaim occupy a more complex role in photographic discourse. Not only do they provide a means of introducing larger issues of the status of women in the amateur photographic domain, but they require us to rethink particular conceptualisations of the medium of photography at its inception specifically in relation to questions of gender. Atkins's cyanotypes prevent us from easily homogenising early photographic processes. What is more, they make us address the question of what is both gained and lost in photographic monochrome. It is by no means accidental, I will argue, that women practitioners (and compositors) bring to the fore such hermeneutical issues. Atkins's work highlights the congruence of the domestic with the world of the natural sciences, as characterised by its practices of collecting and cataloguing, and with the medium of photography itself. In considering the nature of Atkins's project to reproduce those exquisite seaweeds, critics such as Larry Schaaf and Constance Sullivan[14] have remarked upon the peculiar aptness to a book on algae of Herschel's intense blue process which eventually became known in the familiar modified form of the architectural 'blueprint':

> Cyanotypes were cheap, easily processed, and were amongst the most
> permanent of all photographic processes. The most severe drawback of the

cyanotype was that the inescapable color was a deep, rich blue. Its application to portraits of people was thereby limited, but what could have been more appropriate as a background to the 'flowers of the sea'.[15]

Taking up his distinctions here, I want to question fundamentally why Schaaf considers an intense Prussian blue less appropriate than black and white (in reality a range of sepia tones rendered by other photographic processes) to represent human figures. We cannot simply take as read such an assertion. We have to consider the means by which 'blueness' comes to be interpreted as a representational 'drawback'. By reading unquestioningly the now familiar monochrome of 'black and white' as the signature of the photographic medium, commentators are likely to gloss over vexed issues of conceptualisation attendant upon the invention and circulation of a process such as the cyanotype. Why not substitute 'blue and white' for 'black and white' in the monochromatic schema? We must consider why it is that 'blue' is read as representative of particular qualities of objects in a way that 'black and white' is not. Is it because blue is considered incapable of achieving a quality of abstraction? There are of course historical precedents for such reactions; but equally, there are precedents for obverse interpretations. For Ruskin, for example, of all the colours in the spectrum blue is the most suggestive of liquid infinity and, following Goethe, he believes that 'we love to contemplate "blue"' not because 'it advances to us, but because it draws us after it'.[16] Relatedly, Ludwig Wittgenstein, in his *Remarks on Colour* – which by detailed aphoristic method examines the intricacies of colour perception – settles, in passing, upon this very question of the differences between 'black and white' and other monochromatic schemas: 'Let us now suppose that people didn't contrast coloured pictures with black-and-white ones, but rather with blue-and-white ones. I.e.: couldn't blue too be felt (and that is to say, used) as not being an actual colour.'[17] Using the example of 'blue', Wittgenstein points up the operation of 'black' and 'white' as sorts of non-colours, the way in which (post photography), they constitute vehicles for the conjuring of actual colours by providing what amounts to a state of transparency through which to perceive those colours. Wittgenstein ponders such a notion in his reference to the photographic image of a boy with 'blond' hair. It is an example to which he returns at particular points throughout his text:

> I saw in a photograph a boy with slicked-back blond hair and a dirty light-coloured jacket, and a man with dark hair, standing in front of a machine which was made in part of castings painted black, and in part of finished, smooth axles, gears, etc., and next to it a grating made of light galvanized wire. The finished iron parts were iron coloured, the boy's hair was blond, the castings black, the grating zinc-coloured, despite the fact that everything was depicted simply in lighter and darker shades of the photographic paper.[18]

For Wittgenstein, the crucial question is: 'do I actually see the boy's hair blond in the photograph?! – Do I see it grey? Do I only *infer* that whatever looks *this way* in the picture, must in reality be blond? The resolution to his question is suitably equivocal: 'in one sense I see it blond, in another I see it lighter or darker grey'.[19]

The photographic medium facilitates such an oscillation between a perception of 'blond' and a 'lighter or darker grey'. Moreover, it is such a view of the boy's hair (indeed, as Wittgenstein suggests, why not grey?) as 'blond' here that the blue of the cyanotype would be thought to block, such is the implied assumption of those critics who claim that Herschel's process is supremely appropriate to algae but not to people. Monochromatic

blue, the argument goes, would stand in our way of reading skin tones. But the question remains, is not such a perception of the cyanotype's distinctive colouring perhaps differently defined prior to the ubiquitous presence of photographic representations as more uniformly black and white? In the context of such philosophical questions, are we not retrospectively attributing a kind of appropriateness to the colour of the cyanotype process over and above the one that Atkins envisaged for it? Schaaf is implying that the blue characteristic of the cyanotype is not read abstractly, or would not have been regarded in such a way, but we must question this assumption as characteristic of the 1840s.

If we concede that 'blue' is not the colour of portraits, might it not be the colour of absence? By shifting the question randomly in this way from one of the representation of an actual referent to that of an abstract concept, we can alter the terms of the debate by positing the blue of the cyanotype as an apposite colour by which to communicate the loss of presence most of all conveyed by such direct contact prints. It is a woman who first sings the praises of the blue, realising its potential for botanical specimens, but, there is more to Atkins's use of the cyanotype than a happy coalescence of marine vegetation with its most appropriate colour. If we simply accept that Atkins is offering the most adequate match of subject to medium, what we occlude is the production by photographic representation of a specific relation to an absent object, a relation which, by definition, involves a particular condition of 'dissimilarity' to a referent.

Stephen Bann, in *The True Vine*, refers to Roger Fenton's photographic still lifes in terms of their 'comparative failure', recalling Georges Didi-Huberman's 'inventive use of the theological notion of the "figure dissemblable" – that is to say, the figure which, in the special circumstances of Christian art, is acclaimed as an adequate representation precisely because of its dissimilarity to its referent'.[20] Bann uses Didi-Huberman to point up that larger failure of 'writing about painting' with which his own book is concerned, a writing which likewise invariably constitutes 'a figure of dissimilarity in which adequacy to an object must always be supported by the prior test of adequacy to conditions of the text itself'.[21] By extension, it would be precisely early photography's absolute representational inadequacy with regard to colour that would make it a consummate representer of the human figure and of absent ones. While a type of unconscious rootedness of the colour 'blue' in a history or a pre-history of colour symbolism might be thought to prevent it from attaining the abstraction or the inadequacy borne out of a dissimilarity to a referent, following this argument, any monochromatic scheme would thereby constitute 'a figure dissemblable' or this type of failure. In the event, when referring to the congruence with their subject matter of Atkins's cyanotypes, critics neglect that fundamental incongruence out of which photographic meaning is generated, precisely that condition – pinpointed by Wittgenstein in the blue/white, black/white analogy and by Bann in the 'comparative failure' of Fenton's still lifes – and the way in which it may be read through the theological notion of the 'figure dissemblable' ('though without the same connotations of negative theology'). The type of distinction that Schaaf draws can only be made post-colour photography; prior to the invention of colour, 'blue and white' and 'black and white' would both equally constitute 'figures dissemblable' since both would equally elicit a dissimilarity to a referent.

Questions of such representational incongruity are correspondingly, though differently expressed, by Fox Talbot in *The Pencil of Nature* when he discusses the

example of *Lace* as a negative image, 'that is to say, directly taken from the lace itself', from which positives may be produced.[22] Talbot ends his account of his 'photogenic drawing' developed in the 1830s by maintaining that although it is necessary to obtain a positive image of buildings, human figures, and of various objects because they would not be intelligible in the form of negative images ('substituting light for shade and vice versa') in the instance of the reproduction of lace, a negative image is highly satisfactory since 'black lace' is 'as familiar to the eye as white lace, and the object being only to exhibit the pattern with accuracy'.[23] In a sense, Talbot's 'original' take here on the issue, determines the position that Schaaf, and other recent critics adopt, for Talbot is drawing a distinction between the photographic depiction of objects in which a certain degree of abstraction is regarded as untenable and others in which such abstraction would be highly acceptable. Potential intelligibility here rests upon the example, as in the case of the lace, of a knowledge of both black and white varieties, of the subject having experienced both; the implication being that a positive image of black lace would not be too abstract, would not require any great leap of association, whereas 'in taking views of statues [and] portraits'[24] the negative would not grant sufficient information to prevent misreading. Talbot's rationale for the negative/positive opposition here shares aspects of the above debate around black and white, and blue and white. For Talbot, a certain negative image of 'lace' is recognisable because a viewer can easily take in the distance from its referent whereas, in the instance of a human figure, a reversed image would be too distant to be intelligible.

As well as rendering a particular visual luminosity, photograms (such as those direct contact prints of objects by Fox Talbot) produce an uncanny order of presence in the object as pressed, as touched by the photographic paper and placed in the sunshine. Atkins's images read as much if not more in the sense of pressed-flower arrangements, or wreaths of seaweed, than as photographic representations. Becoming physical traces of their referents, they suggest an emphatic presence and are close to the constituents of the eighteenth-century sentiment album, as antecedent of the Victorian photograph album. In the emergence of the photograph album from the sentiment album we both lose and retrieve such an emphasis on touch together with a substitution of one order of actuality for another.

Albums of amateurs

From the 1850s onwards, as the practice of compiling albums of photographs gained popularity, there arose many variants on what we tend to think of as the Victorian album. In addition to those albums displaying carte-de-visite portraits of family members, friends, and collectable images of royalty and eminent Victorians, there were ones which brought together 'likenesses' made by studio photographers with inscriptions, drawings and water-colour paintings. Victorian women, in particular, experimented with the application of the relatively new medium of photography to collage, the technique of putting a work together from assembled fragments.[25] Rather than simply pasting out scraps of paper and other oddments, as had previously characterised the technique, women amateurs began applying such pasting to photographic images. The resulting combinations took a variety of forms; they might be dedicated primarily to a display of the woman's own work in water-colour, punctuated by occasional photographic family portraits or, in the manner of the albums of photographer Lady Mary Filmer

(1840–1903), they might present cut-up photographs affixed to decorative backgrounds painted in water-colour.[26] Naomi Rosenblum has identified Lady Filmer as 'probably the first person to employ photographs' in collages dating from the early 1860s.[27] Her marriage to Sir Edward Filmer, 9th Baronet of East Sutton, whose family were somewhat close to the Royal Family, gave her access to photographing its members, such as the Prince of Wales, and she used her own photographs for collage purposes in her albums. A characteristic page uses the rectangular-cut format of the carte-de-visite to make a decorative flower-type arrangement in which blooms and insects embellish the corners of the composition in a decorative manner.[28]

In the context of combination printing and photographic manipulation that we have so far been exploring, the work of Filmer, along with that of Atkins, provides a locus from which to situate that of a virtually unknown contemporary contributor to women's practice of the 1860s, Lady Charlotte Milles (1835–1927).[29] The little-known loose-leaves of 'the Milles Album' in the Gernsheim Collection at the Harry Ransom Humanities Research Center, comprise a series of photo-collages made from a combination of photographs and hand-coloured images. In many ways distinct from what we might think of as the characteristic contents of Victorian photographic albums, the pages of the Milles's album bring together contemporary nineteenth-century photographic portraits, 'either amateur prints or dismounted carte-de-visite portraits',[30] with frequently incongruous and highly finished water-colours to form not only highly decorative combinations, but ones which strive towards the perspectival and narrative coherence of painted compositions. In some cases they substitute for the customary subject matter of water-colour that of 'grander' academic painting. There is no evidence to suggest that Milles was herself a photographer, but her use of other people's photographs provides an unprecedented intervention both at the level of process and that of aesthetics.

Following her marriage to George Watson Milles (1824–1894), the first Earl of Sondes of Lees Court, Kent, at St George's Church, Hanover Square on 25 January 1859, Lady Charlotte Milles moved into the family estate that year and became an active member of the landed gentry. She used the social position of aristocrat from which to produce what might seem at first glance innocuous photo-collages, many of which juxtapose family members alongside royalty and other dignitaries. The first daughter of Sir Henry Josias Stracey, 5th Baronet, and Charlotte daughter and heir of George Denne of the Paddock, Canterbury, Charlotte herself was one of thirteen children, seven brothers and five sisters. She died in her ninety-second year on 23 June 1927 at Brenley House in Broughton Under Bleam. Charlotte and George had four sons and a daughter: George Edmund, Herbert Frederick, Lewis Arthur, Henry Augustus Milles-Lade; the daughter's name, because she remained unmarried, is not given in records.[31] Piecing together such a biographical skeleton of a forgotten woman from the pages of peerages and baronages involves a recognition of the absence of significant dates for women. They are largely commemorated by their marriage dates only, or recorded simply as unmarried issue without being named. Yet this emphasis upon lineage, with its absolute dependence on the visibility of the male line, is confounded by Milles's images in which women figure as prominently, and frequently more prominently, than men. The particular cutting, arranging and pasting practices characteristic of the album deny precisely such an emphasis on lineage as a process of rendering women invisible apart from when they happen to marry. Moreover, the album demands to be read alongside such legitimate

historical documents and genealogies, not only for its comparative revelations, its different story, but also for the changes it brings to bear upon such histories. The patrilinear family trees of the peerage are curiously shaken by Milles's own family records in the form of the photo-collage, whose crude composition from cut-outs shows no special respect for the forms of great men. The effect of Milles's compositions is to question hierarchy rather than to reinforce it. It is to make us aware of the circumstances through which hierarchies are perpetuated by presenting us with a visual uncanniness which denies a 'straight' referential reading. Thus, for example, the Royal Family is more and less than the sum total of its disparate parts in Milles's representation. It jars the eye in particular ways by the overtly hand-crafted context in which it is set.

Milles's album specifically invites us to consider the legacy of the Victorian photograph album in the earlier sentiment album. Her work straddles the two, or rather negotiates the transformation and loss occurring in the transmutation of one into the other. Milles's collages also gesture towards earlier print-making practices of the eighteenth century. In discussing such eighteenth-century practices, Marcia Pointon has focused, in particular, upon the influence of the work of the Reverend James Granger and his process of binding and mounting 'extraneous but thematically related material both visual and verbal' into a book.[32] Concerned with 'the articulation and ordering of notions of the national past by collecting and mounting engraved portraits,' Pointon has examined the production of specific 'meanings' 'through the construction of particular physical objects – volumes (usually very large in format) containing pasted ensembles of text and image'.[33] Grangerising, which 'sparked' a 'craze' during the nineteenth century, graphically represents the means by which 'the printed book is personalised'.[34] In the transition from sentiment album, or personalised book, to a photograph album, there does not simply occur a loss of such personalisation. Nor is there a straightforward substitution of photographed keepsake, a portrait of a beloved for a lock of hair, for a trace of fabric, or for a pressed flower. Indeed, such a straightforward substitution would signal that somehow or other the photograph could encapsulate unproblematically what it was that distinguished such fetish objects apart from the ability to touch and possess them.

As we have found, the photograph's operation as fetish has been well documented by critics such as Christian Metz who has explored its dual function as both that which has been lost and as a protection against loss.[35] Additionally, we have witnessed the way in which the marvel of the portability of a fixed image of the self, or loved one, was not assimilated without wonderment and philosophical musings. In such a context, Milles's album signals and toys with what is lost here, with that which falls in between a possession of a fragment of an object – a part standing in for a whole when a whole cannot be possessed, or when it is simply absent – and a photograph of an object which constitutes by different means a reduced version of an absent one. For Milles retains those elements of the pre-photographic sentiment album that might be lost in the shift to the photographic album, transforming their relationship to temporality and to space, while at the same time reconstituting their relation to the object as 'pressed'. The precious ribbon that once belonged to the beloved is present as a type of synecdoche (like Ruskin's fragments of architecture which represent taking away St Mark's Cathedral piece by piece) but such a keepsake is only ever a fragment made to stand for a whole.[36] There is always a sense that what is absent in relation to the treasured ribbon is a whole on a greater scale physically as well as metaphorically. The photographic portrait, by

distinction, changes such a figurative relationship significantly. It is a *whole* standing for a whole even though clearly it constitutes an entirety distinct from that of the original referent, not least because of the reduction in size. As a correspondence of some other 'whole' to an absent 'entirety', a photograph produces a metonymic relation disguised as something other in that it functions like a part of a person even though it is not a part in the physical sense. Rather than a synecdoche, a part standing for a whole, a photographic portrait provides a reduced version of an original in which size is everything. Distinct from the length of ribbon, or the lock of hair (which is different again since it is a living part of a person) the photograph does not require the imaginative conjuring of other aspects in order to restore its completeness. Yet, at the same time, such a photographic metonymy with its visual, representational semblance to an original does not restore that which the synecdochic keepsake embodies. In its potential figurative equivalence (encapsulating the whole body of a person) a photograph crystallises an emphatic dissimilarity to its referent.

Of the ribbon Roland Barthes writes: 'sometimes the metonymic object is a presence (engendering joy); sometimes it is an absence (engendering more distress). What does my reading of it depend on? If I believe myself about to be gratified, the object will be favorable; if I see myself as abandoned it will be sinister.'[37] A photograph of an absent loved one operates somewhat in these terms. But, since a photograph often constitutes a 'complete' version of an absent whole, it operates more in a metonymic relation to that entity, while a keepsake sustains more of a synecdochic one. Barthes explores the relation to desire of the 'absence' and 'presence' of the object to question whether desire is not the same regardless of the object's presence.[38] He finds that in 'the discourse of the beloved's absence' 'the other is absent as referent, present as allocutory':

> This singular distortion generates a kind of insupportable present; I am weighed between two tenses, that of the reference and that of the allocution: you have gone (which I lament), you are here (since I am addressing you). Whereupon I know what the present, that difficult tense, is: a pure portion of anxiety.[39]

The photograph makes the presence of the beloved all the more tangible by enabling the subject to address the other as if present. Though the referent is absent, it is oddly doubled by the photographic image which distinctively signals the other as 'absent' as referent by conjuring presence so perfectly. Milles's album pages negotiate this 'difficulty' of the present tense. The refusal of the single photographic take signals this suspension of the subject's position between two tenses (the other absent as referent, present as one who may be addressed) to which Barthes refers as the condition out of which a discourse of absence is sustained. For Barthes, since the subject must 'endure' the persistence of absence, he or she must 'manipulate' it and 'transform the distortion of time into oscillation, produce rhythm, make an entrance onto the stage of language'.[40] Barthes's discourse on absence, the condition from which 'language is born,' finds a paradigm in Freud's theorisation of the significance of the 'fort' 'da' game, in which the infant throws the cotton reel out of the cot and repeatedly retrieves it, rehearsing the departure of the mother.

> This staging of language postpones the other's death: a very short interval, we are told, separates the time during which the child still believes his mother to

be absent and the time during which he believes her to be already dead. To manipulate absence is to extend this interval, to delay as long as possible the moment when the other might topple sharply from absence into death.[41]

His example enables us to reconceptualise the ways in which the photograph album, and the 'personalised' pages of Milles's album, 'manipulate' absence in order precisely to stage an extension of this 'interval', between disappearance and return, to ward off that moment of toppling 'from absence into death'.[42] Crucial to this staging is the way in which a photograph insists upon absence as death in a way different from the keepsake. The latter has touched the absent thing (has been pressed physically); the former has received a chemical impression, unless a contact print (like the cyanotype) which has actually touched the paper and bears, in the image, the fragility of that tactile or pressed relation to the object, which itself stands in for 'a furtive contact with the body (and more precisely the skin) of the desired being'.[43]

In fashioning her images as she does, Milles wants to replace a simple substitution of a part for a whole with that which would stand somewhere between a metonymic and a synecdochic relation. The processes of cutting and the reconstituting of the album pages aspire to such a condition, for the images retain a fetishistic contact with the object in the manner of those attributes that characterised a subject's earlier relationship to the sentiment album. In the uneasy conjunction of paint and photograph, Milles attempts to reconstitute such points of physical contact, preserved as fetishistic fragments of wholes, which are lost in the shift from sentiment to photograph album. Or rather Milles strives to preserve those elements of the sentiment album which appear redundant in the face of the photograph album which appears to promise to contain 'everything'.

Generally speaking, Milles reserves the technique of photography for the treatment of human figures while building up the rest of a composition from water-colour. On the surface of it, we would appear to have an example of an archetypal Victorian leisured woman amateur demonstrating a recognisable proficiency in water-colour, but there is much more to these uncanny images than that. They crystallise some of the larger debates we have been pursuing so far, especially those concerning gendered spaces of production, and the breakdown of a strict dichotomy between 'feminine' private and masculine 'public' spaces. For, while Milles's work has all the hallmarks of the female dabbler displaying her aristocratic accomplishments, such traits are dramatically undercut by formal effects of the medium of photography and by the particular contexts in which she sets it.

Although she may not have at her fingertips the technical means of manipulation available to her male counterparts, nor indeed the basic photographic skills of some of her female contemporaries, Milles manipulates by other methods the limits of the unitary photographic image, and makes 'professional' photographic portraits her own by setting them in imaginatively incongruous settings. Her photo-collages blur distinct boundaries between professional and amateur practice, reminding us that strict demarcations of gender must be read within the distinction between amateur and professional practice, and that the status of amateur could work as an enabling position for women.[44] Characteristic of Milles's practice is a desire to commemorate family members and to photo-create fantasy scenarios. Thus, a portrait of her sister, Fanny Stracey, takes the place of a hand-painted motif on the side of a china teacup, that most English symbol of the leisured classes. Similarly, members of the Royal Family are arranged within the grounds of the ancestral home to form compositions in which a regard for perspective

Fig 17
Lady Charlotte Milles, *Fanny Stracey* (1860s)

and relative proportion is sacrificed to a principle desire to include specific photographic representations of people, inevitably in various studio poses. In such a picture the lure of the medium, that offers likenesses in an unprecedented fashion, overtakes any real sense of compositional propriety. Clearly, Milles is aware of laws of perspective, as is evident in the painted areas of her compositions, but a desire to include photographs or more importantly to build pictures around snippets of photographs overrides a respect for such conventions. There is a sense in which for Milles the photographic studio portrait by itself is incomplete in its failure to suggest a way of life and a social milieu, while at the same time, such a portrait is over-determined in its suggestion of a persona from the codes of dress and pose. The format of Milles's album compensates for this incompleteness, and exposes such over-determination, by tampering with the photographic likeness as discrete image. At a general level, this quality of 'incompleteness' inheres in photography's distance from the body in its apparent substitution of a seamless visual whole for what was once a composite of sensory perceptions and representations. But in more specific terms, Milles is coming to terms with a new order of presence through records, memory traces, in a way that forms of combination printing enabled photographers to do. It is as if the single take is finally *too* present owing to its chemical genesis, and yet not so present as a lock of hair for example, as a tangible part of an absent person. It is precisely this different order of presence (as physical contact) which is in the process of being assimilated in Milles's works.

We witness such a method of assimilation if we consider *Fanny Stracey* (on a Teacup) (figure 17) which situates the woman (here Milles's sister) upon the domestic object in a commemorative fashion. During the period in which Milles worked, the technology existed to transfer images onto china and other ceramic materials. From the

Fig 18
Lady Charlotte Milles, *The Honourable Lewis and Harry Milles* (1860s)

mid 1850s a burnt-in impression of a photograph in the glaze on china could be produced by a number of methods. One of these, carbon transfer printing, used enamel colours as pigments to render photographic images on household crockery.[45] In her photo-collage, Milles combines a photographic portrait with a painted domestic object to produce a novel possibility: the commodification of one of her siblings in the manner of royalty. The oddity of this image's particular visual register derives from the superimposition of a photographic fragment upon a lovingly painted teacup which, rather naïvely located with defining shadows in the centre of the page, bears an ellipse and decorative painting both of which defy perspective. A woman practitioner is positioning photography at the heart of the domestic, rendering familiar commodities novel by the incongruous presence of the medium. Milles's collage displays at once the vivid presence of carefully applied pigment, and a different order of presence in the superimposed photographic fragment. The photographic image here takes on the appearance of a relic as pressed. There is an odd celebration of fetishistic contact which is simultaneously treated with a sense of humour; we are reminded of rituals of tea-drinking and of the 'art' of making the beverage as set out in Isabella Beeton's *Book of Household Management*.[46]

We may also read Milles's creations specifically within the context of women's involvement in the natural sciences. In the collage, *The Honourable Lewis and Harry Milles* (figure 18), photographic portraits of two of Milles's four sons are set as giant pearls in abalone shells.[47] The insides of the shells are tipped to face the viewer, suspended against an arrangement of seaweed and coral which itself rises out of a translucent water-colour rendering of sea. This photo-collage, in particular, brings together contemporary crazes of collecting seaweeds (the reference back to Atkins is striking) and shells with the

place of photography in the domestic context, both as an instrument of recording, and as a magical and scientific pursuit manageable in such a context. We are reminded of the contiguity between photography as science and magic with which we began. In this image, Milles creates a type of primeval scene of birth, of emergence from the sea – the photographic portraits of her children look particularly incongruous in this faithful water-colour transcription of elements of natural history. For they are clothed and posed for a studio context and bring with them that presence of the studio interior. It is an uncanny image in many respects, not least because the composition is marked by a real discrepancy of size. The portraits themselves are on slightly different scales. The right-hand boy, the left side of his face quite heavily shaded, looks out directly at the viewer; while the photograph of his brother, slightly more suggestive of a studio context, shows a portion of his right arm and his face less dramatically lit. In a desire to combine a rendering of the natural, closely observed vegetation, with a particular photographic order of the actual, we have an odd re-conceptualisation of the limits of the photographic medium. Milles directly fashions keepsakes here as if they were inlaid miniatures. Her manipulation of personal photographic portraits alters our understanding of the cultural positioning of the medium in the late 1860s. By taking a subject from botany and creating a water-colour setting of particular seaweeds and shells, popular subjects for women amateurs working in the natural sciences, and then superimposing oval portraits of her two sons cut out from larger photographic images, Milles is literally imprinting the familial upon the fine-art image as a type of authoritative stamp. She is also cutting up precious photographs, in themselves keep-sakes, to violate the entirety of a unitary image in order to form other newly and personally crafted keepsakes. The portraits are set as fetish objects in which a juxtaposition of 'cut-out' with paint is crucial.

In photo-collage, there is always a sense in which such photographs have come from elsewhere, not only since a photograph suggests a 'real' elsewhere but because it registers itself as part of a larger image. Time and again, early subjects of the photographic lens remark upon the artificiality of the studio context. Photo-collage also denotes a tampering with the studio-setting of the portrait – of locating loved ones in the more 'real' representative context of home or in other significant locales. One is reminded of the keepsake's earlier incarnation as the painted miniature which could be worn on the body, and of the innumerable miniaturists who, with the invention of the medium, became professional photographers. For, the photographic element of the composition is miniaturised, or reads on the scale of a miniature's relationship to a larger whole. The effect of Milles's collages is to remind us of those historical precursors with which photography continued to actively interact at this point; a history of the medium which, as Schwarz continually noted, reached 'far beyond its lexicographic date of invention'.[48] We have therefore in Milles a domestication of photography but one which, rather than amplifying its proximity to the medium of painting, generates a further sense of photography's dislocation from, and its ability to redefine, other media.

In a plate showing *Queen Victoria, the Prince and Princess of Wales, and their Children* (figure 19) in a garden by the sea, we confront the characteristic visual and temporal dislocation that Milles's collages create. Three photographic elements mark a closely observed water-colour landscape; Princess Alexandra appears on the left with the Prince of Wales and by herself in the centre. Her double appearance is signalled clearly to the viewer by the inscriptions below the frame. The three elements are entirely self-contained; no attempt is made to have them interact with each other, though Milles

Fig 19
Lady Charlotte Milles, *Queen Victoria, the Prince and Princess of Wales and their Children* (1860s)

makes use of the central figure's raised hand by placing a painted decorative urn near to it to make it look as if she reaches out to pluck a flower. The disjunction between the three groups of figures is enhanced by the fact that they have been variously lit by different studio lighting when sitting for their portraits. Evidence of cropping is particularly apparent around the edges of the photograph of Queen Victoria and her grandchildren who make an incongruous, because tightly bunched, group in the outdoor context. Damage to the photograph of the Prince of Wales on the left, along with water-colour tinting, further impresses the presence of an amateur practitioner. As a whole, the image constitutes a type of voyeuristic view of a private grouping in the sense that no human figures are included other than those of the Royal Family. Milles brings the Royals home (as it were), making them her own by a means far different from that of

assembling them in albums in the collectable format of the carte-de-visite.

A leaf from the album showing a *Collection of Figures in Interior Setting* (figure 20) juxtaposes water-colour elements with photographic portraits taken from carte-de-visite photographs. Again, in this collage, the arrangement of figures (all but one of whom are named by inscriptions appearing in the frame below them) defies conventional laws of perspective and relative scale. Four of the six figures, together with a child, are positioned so as to confront the viewer; bearing the traces of their previous photographic contexts in the light coloured and sharp outlines which fail to anchor them in the decorative drawing-room setting. Perhaps more than in any other of Milles's images, the uses of photography in this collage convey the heterogeneity of the photographic medium, together with variants in tonal relationships in studio portraits. In addition, we cannot fail to be aware of the mutability of the photographic image, especially when confronted

Fig 20
Lady Charlotte Milles, *Collection of Figures in Interior Setting* (1860s)

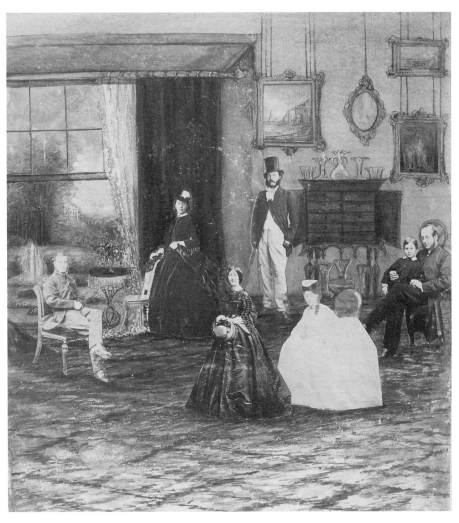

by the seated woman whose faded presence, and failure to appear at one with her chair, creates a kind of white hole in the bottom right of the composition. Visual disjunction is equally but differently signalled by anomalous dress and the convergence of figures turned out for different social occasions and elemental conditions.

A slightly more structurally coherent though, in other respects, an uncanny arrangement of water-colour and photography, appears in the picture which shows *Two Crinolined Women in a Moonlit Landscape*. It is the only image of its kind by Milles that suggests a sense of subtle interaction between the montaged, separately photographed women. Distinguished by the contrasting dark and light gowns, the two unnamed women stand close to the water's edge. One turns her head to confront the viewer; the other in three-quarter profile looks off to the right. By the woman practitioner's sleight of hand the photographic medium makes it possible to situate unchaparoned women in a landscape at night. In the way that painting had always been able realise unlikely imaginative possibilities, and to enable such transgressions of social norms, photography here redefines collage and does so in particular ways for women denied access to 'higher' genres.

In all of her collaged images, Milles is singing the blues for the loss of the keepsake (and by extension for the loss of its variant in the contact print or direct positive image), while simultaneously celebrating its peculiar metamorphosis in the photo-collage. While the two forms of representation, and preservation (keepsake and photo-collage) operate as metonymic, there is a fundamental difference between them. While, on the one hand, a photograph may be seen to embellish an existent relation of a keepsake to a subject, on the other, the so-called 'straight photograph' marks a deficiency that the photo-collage is able to restore. Such perceived deficiency, as belonging to the photograph, is directly proportionate to the degree of personalisation desired by the viewer or the owner of the image. Milles's pages display immense personalisation of fairly impersonal objects and contexts. But in addition, it is crucially a quality of fetishistic contact that is being registered as lost and mourned through its reconstitution in Milles's combined and doctored images.

The peculiar materiality of Milles's pictures emerges from a photographic foundation; she uses scissors and paste freely to enable any type of mixed-media combination. Those discourses we have so far considered in discussing Robinson and Rejlander apply here, but to a much different scenario in which a woman amateur (compositor, not photographer) invents her own bastardised variant of the popular technique of combination printing which, as we have seen, at one level represented a struggle to gain access for photography into a tradition of fine art. Milles is not interested in realism in the sense of securing temporal unity, in the incorporation of multiple portions of photographs, for example. What we think of as photographic authority on time is blatantly denied or frustrated in her work. Nor is Milles intent on using photo-collage simply in order to attempt to simulate a fine-art image. If this were the case, why would she resort to a type of pre-Renaissance understanding of space in presenting the same figure twice in the same image? Rather, her pictures function more in the manner of private records (they constitute an album) and, like the written form of the diary, represent various whims of the author which do not aspire to temporal succession.

In *Amateurs, Photography and the Mid-Victorian Imagination*, Seiberling has begun to unpack intricacies of the role of the amateur photographer in Britain in the 1850s and 1860s, charting the ways in which individual amateur practitioners, and the different

material circumstances in which they worked, significantly affected technical and aesthetic developments in the medium.[49] She locates Cameron and Hawarden, along with Carroll, as amateurs who, predominant in the 1860s once photography was well established, were in a position to 'work against the conventions' and who thus appeal to contemporary late twentieth-century sensibilities.[50] Although Milles is not mentioned in the text her practice falls within the amateur tradition Seiberling identifies with its strong 'class component' in which 'the ability to participate in photography, landscape sketching, microscopy, chemistry, and other amateur occupations implied that a person had education, leisure, and means … Members of the landed gentry and upper-middle classes were more likely to be able to carry on such activities, and their participation gave prestige to the amateur as opposed to the professional practitioner.'[51] At the same time, as Constance Sullivan reminds us with regard to gender, in its first decades 'for everyone photography was the quest of the amateur, a category within which women were immanently comfortable'.[52] Within amateur practice and production, the album constituted the main means of housing and displaying photographic prints. And Seiberling has pointed out the way in which photographic albums arose as replicas of albums or portfolios used to store 'drawings, water-colours, and intaglio prints or lithographs'[53] but the photographic album very quickly became more commonplace than its precedent the portfolio of fine prints:

> During the 1850s the album developed from a general repository for all kinds of specimens, images, and reminders, which typified the outlook of the early amateurs, to a collection of images of a particular type. The early albums derived from and resembled a fixture of the Victorian drawing room, the sentiment album, to which his – or, more likely, her – friends contributed poems and other writings, pictures, and souvenirs of various sorts. Such albums in the 1850s began to include photographs along with drawings, water-colours, and prints. The very format of the album itself, with its multiple contributions, implied social ties, and it was looked at in the company of friends and family members. It was a means of communicating values and tastes.[54]

Seiberling identifies a shift from albums of the mid and late 1850s to those of the 1860s, signalled by a transition from a primary interest in photography as process, as applied to the commemoration of personally significant moments (a variant of the sentiment album which might include 'bits of hair and scraps of ribbon' among its mementoes) to an interest in photography as an unsurpassed means of documentation of scenes and events. In this way, the album ceases to be an all-purpose repository to become instead a 'logically' organised document divided into specialised sections dealing, for example, with categories such as architectural studies, portraits, and topographical views. Chronologically, Milles's album falls within the later category but it resembles the first, that of the scrapbook, more distinctly in its creation of coherent pictorial contexts from multiple sources and from its subordination of 'documentary' interest to a passion for composite fictions.

Milles's photo-collages provide examples of the rootedness of the album in the domestic, both in terms of subject matter and in terms of process. As we have found, with its antecedent in the sentiment album, which brought together visual and verbal representation with physical keepsake, the photograph album remained the domain of

women of the household. Albums constituted a means of forging remembrance or patterns of recollection out of disparate meaningful fragments in the sense of representations and also as synecdoches, talismans and so on. For Milles, photographs are the anchor referents in her album, set up in paint and attributed a mixture of reverence and familiarity.

Milles works from a privileged space within the domestic, a space shared by a photographer such as Hawarden, but she creates a more formal and public playing out of the domestic sphere than does Hawarden. Milles's attempt to reconcile in her album an experience of a new order of presence with earlier forms of remembering, recreating and fixing, comes from a woman who traditionally, as a guardian of the hearth, provided the means for its validation. In mythic narratives women have occupied the legendary position of fashioning the absence of crusading males through the arts, or labours, of spinning and weaving: 'the spinning songs express both immobility (by the hum of the wheel) and absence (far away, rhythms of travel, sea surges, cavalcades)'.[55] One thinks of 'chaste Penelope' waiting for the return of Odysseus or of Lucrece whose very chastity, symbolised by her act of spinning, was praised so highly by Collatine in Shakespeare's poetic narrative of the myth, that his linguistic advertisement of her virtue led to her violation by Tarquin.[56] As Barthes maintains 'it is woman who gives shape to absence, elaborates its fiction, for she has time to do so'.[57]

The Victorian photograph album can be located as part of a discourse of absence in which women fashion, from that state, a form of presence functioning as a type of protection against loss. For in their nineteenth-century roles of creating such pictorial archives within the home, Victorian women deal with absence, both as temporary loss through geographical distance, and as more permanent loss through death. In these terms, a so-called 'feminine' relation to absence is differently inflected not simply when a photograph substitutes for the subject's relation to an earlier 'keepsake', but when photographs from carte-de-visite albums are cut up and combined in other contexts. Milles's intervention in such debates is evident in her transformation of the traditional album. Apart from situating royalty within the grounds of her home, characteristically she puts together ambiguous conversation pieces in which uncannily mismatched representations interact. Mismatched in terms of size and positioning, figures of women trip up awkwardly on their bases while, owing to inaccurate cutting-out from larger photographic images, little bits of bodies are omitted. The rather casual effect of such compositions plays all too easily into the supposedly unproblematic and homogeneous category of amateur photography; a category which, as Grace Seiberling has shown remains to be interrogated.

In another way, Milles's work invites consideration alongside professional experiments with process, particularly as they pertain to modification of the unitary image. We can trace a somewhat unlikely continuity through the work of an amateur such as Milles to those 'fine art' images of Rejlander and Robinson. In each case, the activities of constructing images result from a visualisation and physical assemblage of fragments. But unlike such well-known 'combination' photographers, who lend to their pictures a degree of high finish by re-photographing composite wholes, an amateur like Milles who, magpie-like, collects the photographs of others (both commercial and personal) lacks access to such technology of finish. Her collages retain the feel of assemblages and a quality of superimposition figures dominantly in their effect upon the observer. One is very much drawn to the materiality of the images in a way that one

cannot be to the smooth, continuous surfaces of composite prints. In Milles, the constructedness of the image figures foremost and although one may be very much aware of joins and seams in composite prints one cannot feel their presence in the same way. While composite images, in their desire to deny or obscure their actual materiality, might signal it unwittingly, photo-collages makes us aware of the photograph as surface, as transparency against a background of matte paper. In the photo-collage the absolute material difference of a photograph is signalled by its surface disturbance, at the level of touch as well as that of vision, of the water-colour components of the image. What is more, in photo-collages in which colours figure predominantly, we are returned once again to that inability of early photographic process to reproduce colour and to the fact that, as we found with the cyanotype, such a realisation was not lost upon early practitioners nor upon early commentators on the medium. A woman such as Milles, working as she does with the medium, clearly recognises the inherent abstraction of photography encapsulated in its rendition of widespread monochrome, while realising, in another, that such approximation is countered by the photograph's unsurpassed ability to offer likenesses of family, friends and loved ones.

The combined leaves of the Milles album, like those of earlier sentiment albums, reconstitute an experience from a composite of relics. In their combined form, such photographic images constitute a particular manipulation of time and space. Milles transfers photographic likenesses of people to decorative contexts, stripping them of unnecessary, and what might be to her mind, inappropriate backgrounds, reminding us of that condition of the all-seeing eye of the camera which may always supersede the conscious selectivity of its operator. On discussing Kertész's *Poor Violinist*, Barthes writes:

> it says only that the photographer was there, or else, still more simply, that he could not *not* photograph the partial object at the same time as the total object (how could Kertész have 'separated' the dirt road from the violinist walking on it?). The photographer's 'second sight' does not consist in 'seeing' but in being there.[58]

This deceptively simple truism about the medium's assault on temporality and about a certain inevitable lack of control on the part of the photographer (a point no longer so easily applicable with the growth of computer generated images, for which no actual referent need ever have existed) illuminates the structural tampering that Milles employs. She does not want her photographic subjects immortalised in studio contexts, and so she cuts around their chairs and studio props, and for the most part she fixes them straight, without any sense of their original milieu. Milles thereby makes it possible not only to have 'the violinist without the dirt road' but also to harness a sense of the medium's sovereignty 'in having been there' without at the same time its being subject to indiscriminate capturing. But more than this, the Kertész photograph alerts us to the experience of sight on the part of the viewing subject; to the sense one has of there being elements present in the photograph which might not have been consciously perceived at the time of its taking because the photograph presents a separation of the conscious from the unconscious, so to speak, by capturing an inevitably packed visual field even in those images that appear relatively empty.

It is such an oscillation between fullness and emptiness that the scrapbook-like pages of Milles's album communicate, stripping the rhetorical element from the question:

what would stand in a supplementary relationship to the photograph album? Milles's photo-collages correspond with what Anselm Haverkamp, writing on Barthes and Augustine, has termed the 'souvenir' as 'the self-made photographic picture, which is meant to preserve individual memories from individual moments of an individual life'.[59] In the following chapter I will consider further the relationship of photographic 'presence' as inherent in the single photographic 'take', as against the disruption of the unitary image by combination, or 'double' printing. It is specifically to the problematic of the double, within such debates, that I now wish to turn.

Notes

1 See Larry Schaaf, *Out of the Shadows: Herschel, Talbot and the Invention of Photography* (New Haven and London: Yale University Press, 1992).
2 *Ibid.* p. 128.
3 *Ibid.* p. 130.
4 For a detailed examination of Herschel's experiments in colour in the context of his working relationship with William Henry Fox Talbot, see Schaaf, *Out of the Shadows.*
5 *Ibid.* p. 88.
6 William Henry Fox Talbot, *The Pencil of Nature* first published between 1844–46 in six separate fascicles (New York: Da Capo Press, 1969).
7 A.A. (Anna) Atkins, *Photographs of British Algae: Cyanotype Impressions*, 3 vols (Halstead Place, Sevenoaks: privately published 1843–53). Volume I contains 75 pages of text and 162 illustrations of seaweed by Herschel's cyanotype process, obtained by superimposition in 1843. Volume II contains 151 plates and Volume III has 98 plates. Each volume has a title, preface and list of species in cyanotype, 'printed' from the author's handwriting. According to Gernsheim: 'Mrs Atkins circulated copies of these photographically printed "books" among a small circle of interested persons during the period 1843–53. The dates of the issues are indicated by date stamps in the three vols at the British Museum.' (Helmut Gernsheim, *Incunabula of British Photographic Literature. A Bibliography of British Photographic Literature 1839–75 and British Books illustrated with Original Photographs* (London and Berkeley: Scolar Press, 1984), p. 15. See also the *British Journal of Photography*, 25 October and 29 November, 1889.
8 John George Children, 'Lamarck's Genera of Shells', *The Quarterly Journal of Science, Literature and the Arts*, 16 (1823).
9 Schaaf, *Out of the Shadows*, p. 131.
10 From the preface to her books, quoted in Schaaf, *Out of the Shadows*, p. 131.
11 *Ibid.*
12 *Ibid.*
13 Gernsheim cites another book of botanical specimens as preceding those examples of Atkins as the first photographically illustrated book: *Le Premier livre imprimé par le soleil*, Ibbetson, L.L. Boscawen as: 'an album of contact copies of ferns, grasses and flowers which were made by the independently invented process of Frederick Gerber of Berne, published in January 1839, when Ibbetson was residing in Geneva. It was exhibited by Ibbetson under the above title at the first photographic exhibition held in Great Britain at the Society of Arts, London in December 1852–January 1853'. (*Incunabula of British Photographic Literature*, p. 15).
14 Schaaf, *Out of the Shadows*, Constance Sullivan, *Women Photographers* (London: Virago, 1990).
15 Schaaf, *Out of the Shadows*, p. 131. We might further question in this context the survival of the cyanotype process in the form of the 'blue print' in which there is no correspondence with colour in nature.
16 Johann Wolfgang Von Goethe, *Theory of Colours* (London: John Murray, 1840) trans. Charles Eastlake (Cambridge, Massachusetts: Massachusetts Institute of Technology Press,

1989), p. 311.

17 Ludwig Wittgenstein, *Remarks on Colour*, ed. G.E.M. Anscombe, trans. Linda McAlister and Margarete Schattle (Berkeley and Los Angeles: University of California Press, 1978), section 38, p. 22e.

18 Wittgenstein, *Remarks on Colour*, section 117, p. 31e.

19 *Ibid.* section 271, p. 52e.

20 Stephen Bann, *The True Vine, On Visual Representation and the Western Tradition* (Cambridge: Cambridge University Press, 1989), p. 19.

21 *Ibid.* pp. 19–20.

22 William Henry Fox Talbot, *The Pencil of Nature* (London: Longman, Brown, Green and Longmans, 1844–46).

23 *Ibid.*

24 *Ibid.*

25 See Grace Seiberling, *Amateurs, Photography and the Mid-Victorian Imagination* (Chicago and London: University of Chicago Press, 1986), and Val Williams, *Women Photographers: The Other Observers 1900 to the Present* (London: Virago, 1986), pp. 17–18: 'Side by side with the practice of photography, many British women from the 1850s were attracted to making photograph albums. Some of these albums existed primarily as a means of displaying the women's own work; others were constructions of family photographs, drawings and carte-de-visite studies made by commercial photographers ... The production of these, early, personal presentations, anticipated the popularity of the family album, continuous throughout the next century. The use of collage in these albums, indicated many later developments.'

26 See Lady Filmer, *Untitled* (1864) reproduced (plate 4) in Sullivan, *Women Photographers* p. 13 and in Naomi Rosenblum, *A History of Women Photographers* (New York: Abbeville, 1990), p. 14.

27 Naomi Rosenblum, *A History of Women Photographers*, p. 14.

28 *Ibid.* p. 13.

29 Lady Charlotte Milles married George Watson Milles in 1859 and moved into the Family estate, Lees Court, from where she made the photo-collaged pages of her album. George Watson Milles was educated at Eton (1838–42) and at R.M.C. Sandhurst. He entered the Royal Horseguards in 1845, becoming a Lieutenant in 1846 and then a Captain in 1853, and retiring in 1858. He was later both a magistrate for Kent (1865–75) and a Conservative MP for East Kent, 1868–74. According to G.H. White's *The Complete Peerage*, Lees Court, built 'after the designs of Inigo Jones' was 'burnt to the ground 20 November 1910'.

30 Roy Flukinger, *The Formative Decades: Photography in Great Britain 1839–1920* (Austin, Texas: University of Texas Press, 1985), p. 91.

31 The respective dates for Milles's children are as follows: George Edmund, 2nd Earl (b. 11 May 1861), Herbert Frederick (b. 2 September 1865, d. unmarried 24 October 1894), Lewis Arthur, 3rd Earl (b. 30 October 1866), Henry Augustus Milles-Lade (b. November 1897).

32 Marcia Pointon, *Hanging the Head, Portraiture and Social Formation in Eighteenth Century England* (New Haven and London: Yale University Press, 1993), p. 54.

33 *Ibid.* p. 66.

34 *Ibid.* p. 54.

35 Christian Metz, 'Photography and Fetish', *October* 34 (Fall 1985), pp. 81–90.

36 See John Ruskin, *The Complete Works of John Ruskin* (Library Edn), eds. E.T. Cook and A. Wedderburn, 39 vols (London: George Allen, 1903–12), VII, p.xxiii.

37 Barthes, *A Lover's Discourse: Fragments*, trans. Richard Howard (New York: Hill and Wang, 1984), p. 173.

38 *Ibid.* p. 15.

39 *Ibid.*

40 *Ibid.* p. 16.

41 *Ibid.*

42 *Ibid.*

43 *Ibid.* p. 67.

44 On this topic see, Seiberling, *Amateurs, Photography and the Mid-Victorian Imagination*, pp. 65–70.

45 Brian Coe and Mark Haworth-Booth, *A Guide to Early Photographic Practices* (Victoria and Albert Museum: Hurtwood Press, 1983), p. 18.

46 I. Beeton, *Book of Household Management* (London, 1861), p. 879.

47 Within the context of women's interest in botany, the Botanical Society of London was one of the first scientific organisations to admit women, and botanists very quickly took up the opportunities for recording that photography offered.

48 Schwarz, *Art and Photography: Forerunners and Influences*, ed. William E. Parker (Chicago and London: University of Chicago Press, 1987), p. 98.

49 Seiberling, *Amateurs, Photography and the Mid-Victorian Imagination*, pp. 65–70.

50 *Ibid*. p. 71.

51 *Ibid*. p. 4.

52 Sullivan, *Women Photographers*, p. 102.

53 Seiberling, *Amateurs, Photography and the Mid-Victorian Imagination*, p. 102.

54 *Ibid*. p. 102–3.

55 Barthes, *A Lover's Discourse*, p. 14.

56 William Shakespeare, *The Rape of Lucrece*, in *The Alexander Text of William Shakespeare The Complete Works* (London And Glasgow: Collins, 1979).

57 Barthes, *A Lover's Discourse: Fragments*, p. 14.

58 Roland Barthes, *Camera Lucida: Reflections on Photography* (New York: Hill and Wang, 1981), p. 47.

59 Anselm Haverkamp, 'The Memory of Pictures: Roland Barthes and Augustine on Photography', *Comparative Literature* 45:3 no.3 (Summer 1993), pp. 258–79, p. 258.

4

'Me and My Shadow': the double in nineteenth-century photography

> For the photograph is the advent of myself as other: a cunning
> disassociation of consciousness from identity.
>
> (Roland Barthes, *Camera Lucida*)

> Lacan's writings are literally speculative in the sense that they have
> related the development of language capacity, and of the
> imagination of an ideal and integral self, to the child's dealings
> with mirrors. The image glimpsed there is thought to be perceived
> as the same as the child but different.
>
> (Karl Miller, *Doubles*)

Towards the beginning of *Camera Lucida*, Roland Barthes touches upon the concept of the double in 'pre' and 'post' photographic eras. He finds it curious that prior to the invention of the medium there should exist the greatest interest in the concept. He writes:

> It was *before* photography that men had the most to say about the vision of
> the double. Heautoscopy was compared with an hallucinosis; for centuries this
> was a great mythic theme. But today it is as if we repressed the profound
> madness of Photography, it reminds us of its mythic heritage only by that faint
> uneasiness which seizes me when I look at 'myself' on a piece of paper.[1]

Barthes's remark, slipped into his meditation on photography without elaboration, has always struck me as particularly intriguing. While his reference to the trigger-mechanism of the camera recalls, by its distinction from, the earlier and far different procedure of uncapping and exposing the hole in the lens of the apparatus in order to take a photograph, Barthes's mention of heautoscopy (the seeing of oneself) begs questions about the historical and theoretical relationship of photography to larger concepts of doubling, and to the fundamental role of the double in constructions of identity. Before the existence of photography, he maintains, 'heautoscopy' (from the Greek 'heauto', meaning 'oneself'), was compared with hallucination (with a condition of being deceived

or mistaken). Yet, contrary to what one might expect, the invention of the photographic medium did not generate a proliferation of interest in the vision of the double, rather it marked a waning of such interest. Barthes acknowledges this apparent contradiction precisely in order to suggest that photography is the medium able to restore, in certain ways, such a forgotten hallucinatory relationship to the double. For what he calls the 'profound madness' of the photograph – its root in hallucinosis – inheres in the photograph's ability to manifest a 'disassociation of consciousness from identity' in the 'advent' (arrival) of the self as other.[2]

I want to consider the relation of the photographic medium to doubling, to question what such a comparative loss of interest in the double might imply. In those earlier pre-photographic versions of the double (as referred to by Barthes) the self was experienced as other, but the medium of photography overtly redefines such a split. Since photography's formalisation of a division within the self invokes the mirror stage in psychoanalysis, I will read conditions of photographic doubling (as highlighted in the technique of double printing we have previously explored) alongside the mirror stage specifically in order to consider questions of identification, fantasy and projection in photographers' presentations of their doubles. But I would also like to suggest that it is the invention of photography that allows the psychoanalytic concept of the mirror stage to be thought; and that the mid-nineteenth-century use of the infant or child in particular as a type of double of the photographer may be seen to represent a fantasy of the self (as whole) 'before language restores to it its function as subject'.[3] The adult's identification with the child subject involves a knowledge of the fantasy of such wholeness.

To address these issues, let us begin with that fundamental difference that photography makes plain, that we see ourselves, as if for the first time, as an image distinct from the one given in the mirror. What is the status of that image? We might read it as denying (or replacing) an earlier (hallucinatory) concept of doubling by way of the persistence of the photographic referent; a sense that the photographic image of a person does not constitute a double since it fails to manifest an unproblematic separation between an original and its representation. Or, put more simply, we might propose that a comparative loss of interest in the double, following the advent of photography, stems from the fact that photographs do not 'double' in the manner of mirrors, but differently somehow.[4]

Of course the legacy of photographic discourse in both the actual and the metaphorical mirror is well rehearsed by nineteenth-century commentators on the medium. Perhaps the most popular contemporary Victorian adage, 'the mirror with a memory,' was later transformed in Jean Cocteau's coinage of 'mirror reformant'. As Heinrich Schwarz informs us, the connection between painting and photography, implicit in attitudes to the mirror from the fifteenth to the nineteenth centuries, demonstrates to what extent we need to take into account the status of photographic invention in 'the link between science and art with all its consequences' :

> Leon Battista Alberti, [...] had linked the mirror so closely with the visual arts that in his *Trattato della pittura*, written about 1436, he called Narcissus, who fell in love with himself while viewing his image mirrored in the water, the true inventor of painting, as Leonardo called the reflection in the mirror the true painting and recommended the painter always to carry with him and to consult the mirror.[5]

The recourse to the myth of Narcissus, a reference captured dramatically in Baudelaire's much quoted response to the effects of the invention of photography – 'the foul society rushed, like Narcissus, in order to contemplate its trivial image on the metal' – brings to the fore the accompanying and well-known mythological dependency upon the mirror.[6] In classical myth, Narcissus fell because of his relation to a reflected image of himself, but the occasion of his 'self love' raises the problematic question of agency; of the extent to which we interpret the myth as implying that Narcissus recognised himself in the image he worshipped. It is crucial, with regard to metaphors of mirroring in photography and in the concept of the mirror stage, that we recognise a distinction between Narcissus falling in love with an image which he believes to be that of another, and his attraction to the appearance of his self-reflection upon the water's surface as a superiorly distributed image.[7]

Lewis Carroll's emotive fictional meditation, 'A Photographer's Day Out' published in *The South Shields Amateur Magazine* (1860) plays upon the concept of narcissism as bound up with the perilous technical procedures of taking a photograph.[8] Satirising the consequences of movement during exposure, and wittily demonstrating the process by which an uncapping of the lens exposes the sensitised plate in the camera, Carroll draws attention to the relationship of technical method to duration, reminding us that it is only relatively recently, with instantaneous exposure times, that the act of photographing could have been likened (as Barthes likens it) to that of firing a gun. In the mid-nineteenth-century, to photograph was to capture by exposure, as an invisible emanation from a referent imprinted itself on a recently sensitised plate, and to seal the newly harnessed contents by repositioning the lens cap. The timing of such a photographic event had to be just right, for too long a delay in setting up a composition, or in waiting for a particular expression, would result in a loss of sensitivity of the plate. With developments in the photographic medium the photographer's act of removing the lens cover was replaced by a finger-operated mechanism that activated the 'click' of the shutter; previously, the act of taking the photograph assumed more of the form of an occasion of self-exposure, closer to that of the flasher than that of the shootist.

Carroll is especially interested in the photographer's implication in methods of exhibitionism. By exaggerating processes of identification and idealisation the essay attempts to dispel simplistic notions of the photographer's objectification of his subjects, but at the same time it complicates the relationship of the medium to accepted categories of identification. Carroll puts in place a type of narcissistic relation to the one he desires to photograph:

> August 23, Tues: They say that we Photographers are a blind race at best; that we learn to look at even the prettiest faces as so much light and shade; that we seldom admire and never love. This is a delusion I long to break through – if I could only find a young lady to photograph, realising my ideal of beauty – above all, if her name should be Amelia.[9]

We find a connection between photographic exposure and, with its overt sexual connotations, identification on the part of the photographer. Carroll's emphasis on the visual aspects of the process reminds us that in the early decades of the medium the photographic 'act' primarily signalled itself to the eye rather than the ear; it took on more the form of a silent encounter, or the witnessing of an event, than a noisy registering of a photographer's presence. As the narrator in Carroll's story describes the process: 'I

selected the best point of view for the cottage ... cast one fond look toward the distant villa, and muttering, "Amelia 'tis for thee!" removed the lid of the lens; in a minute and 40 seconds I replaced it: "it is over!" I cried in uncontrollable excitement, "Amelia though art mine."[10] Such self-conscious play upon sexual climax, photographic exposure, and possession here gestures very much towards the derivation and significance of exposure and that which it figures. In the procedure of uncapping and re-capping the lens, Carroll expresses a sentiment of relief at the experience being over. That sentiment is not simply produced by the length of exposure but by a mode of reproduction and representation which entails 'exposure' in the sense of unveiling, of laying forth to view, or unmasking. The relationship of photography to duration is distinctive during this period not simply because of the length of exposure times, which required a stillness on the part of the subject akin to that composure frequently found in a mirror-image of the self, but also owing to that procedure here described by which an image is directly 'taken' by an occasion of depriving a lens of cover.

Reconsidering, in this context, the enigmatic sense of Barthes's 'faint uneasiness' that accompanies the perception of a photograph of the self, it is important to assess the material ways in which, following the advent of photography, the concept of the double invariably acquires different meanings. While the photograph corrects the lateral inversion of the subject in a mirror (and this was one of its startling and immediate revelations), it was Fox Talbot's negative/positive process which enabled such a transposition of the laterally inverted image to occur. Daguerre's direct positive process replicated the subject as laterally inverted in a mirror.[11] Such a factor marks a crucial distinction between these two pioneering photographic processes, a difference further conveyed by the fact that while each daguerreotype was a unique object in itself, requiring the protection of glass and a softly lined case, the Talbotype enabled the mechanical reproduction of multiple copies of a negative. Like the image in a mirror, the daguerreotype read backwards. The uncanny effect of viewing a daguerreotype arises partly because it is a direct positive which can appear as a negative since the shadows reflect light back to the viewer unless the photographic plate is held at an angle to a sufficiently dark surface. When 'the daguerreotype is held at the correct angle for viewing, the shadows appear to recede slightly' for, acting as a mirror, they 'reflect a "virtual image" that appears to come from behind the plane of the reflecting surface', thus giving the image the appearance of 'slight three-dimensional relief'.[12] It is owing to this required positioning that the singular optical qualities of the daguerreotype cannot be illustrated through conventional methods of reproduction. One practice designed to correct the inversion was to place a forty-five degree angled mirror in front of the lens of the camera and to daguerreotype the reflection of the subject, rather than the subject itself. In this way the daguerreotype would harness a shadow of the subject; it would preserve the self as seen in the mirror.

One can see how, in these terms, the mirror functions as an irrefutable anchor point for the photograph. The photographic image gains its identity through a correspondence with, and difference from, the mirror. Possessing a daguerreotype would be like having a fixed and portable double of oneself as seen in a mirror. The photographer Oscar Rejlander's response in viewing the photographic exhibits at the Great Exhibition in Hyde Park in 1851 is most apt in this respect: 'What I saw proved as evanescent as looking at myself in a glass, out of sight out of mind. They were all Daguerreotypes.'[13] Rejlander suggests that daguerreotypes are unremarkable images, that they can aspire to

a permanence in the mind of the viewer no greater than that of an image in a mirror; tangible but only fleetingly so. But the major difference between the two mediums is that the latter renders static those images which (as in those mediated sights of 'the Lady of Shalott'), move through the former. Rejlander's comment further prompts us to conceptualise the effect upon the larger concept of 'doubling' of crucial differences between the processes of Daguerre and of Fox Talbot.

No matter how wondrous the reproductions of the daguerreotype ('they surpass anything I could have conceived as within the bounds of reasonable expectation') as John Herschel so passionately outlined them on first seeing the process and meeting Daguerre in Paris in the May of 1839, it was clear to Herschel that Fox Talbot ultimately had no need to feel that his own experiments had been pre-empted by the French process. He writes to Talbot on 24 June 1839:

> When I wrote to you from Paris I was just warm from the impression of Daguerre's beautiful pictures. After reflection I feel no way disposed to abate in my admiration. However that has not prevented my wishing that the processes which have *paper* for their field of display should be perfected, as I do not see how else the multiplication of copies can take place, a branch of the photographic art which Daguerre's processes do not by his own account admit of.[14]

Larry Schaaf elaborates Herschel's disclosure here in terms of the daguerreotype's improbability as a process, as one whose implications for reproduction were far different from Talbot's and 'whose basis Talbot could not possibly have guessed'.[15] For, as Herschel here realised more tangibly, Talbot's research was very much concerned with the ability to produce multiple copies of the same image. Having first used the camera to secure one picture, writes Talbot, 'the rest are obtainable from this one, by the method of re-transferring, which by a fortunate and beautiful circumstance verifies both of the errors in the first picture *at once*; viz. the inversion of right for left; and that of light for shade'.[16] Not only, therefore, did the negative/positive method of Talbot's process enable the reproduction of multiple copies but, unlike the direct positive process which retained a relatively straightforward legacy of the mirror, Talbot's negative/positive process corrected the 'perverse' image of the mirror and presented the subject to itself the right way round as it were.[17] With this invention the subject's relation to its 'shadow' or 'double' was subsequently radically altered (turned awry in being laterally corrected) and with it so too were the literal and metaphorical connotations of the double.

In a very fundamental sense, then, after photography people had different things to say about doubling because the double could be both conceptualised and represented differently. In one respect, a relation of photography to the mirror-image of the subject (and modifications in that relationship) immediately invokes the concept of the mirror stage in psychoanalysis, and raises a question of the relation of the medium to psychoanalytic formulations of subjectivity. Following the work of Jacques Lacan in the 1930s and his introduction of the concept of the 'mirror stage' a particular account of the mirror's function occupied a central place in theories of subjectivity. Remarking upon a phase in the development of the infant, occurring from about the age of six months, Lacan formulated his theory of the mirror stage with reference to a Gestalt: 'the fact is that the total form of the body by which the subject anticipates in a mirage the maturation of his power is given to him only as a *Gestalt*, ... in an exteriority in which

this form is certainly more constituent than constituted, but in which it appears to him above all in a contrasting size [*un relief de stature*] that fixes it and in a symmetry that inverts it, in contrast with the turbulent movements that the subject feels are animating him.'[18] The image in the mirror thus grants to the child its first sense of coherent identity and self-recognition, a spectre of his developed future power experienced as outside the self as it were, but, the 'image is a fiction' because as Jacqueline Rose has written 'it conceals, or freezes, the infant's lack of motor co-ordination and the fragmentation of its drives'.[19] For Lacan a crucial element of the process is the ability of the child to 'recognise as such his own image in a mirror' at an age when he is lacking comparatively in 'instrumental intelligence'.[20] But the child's relation to the stage is further distinguished by the fact that:

> this act, far from exhausting itself, as in the case of the monkey, once the image has been mastered and found empty, immediately rebounds in the case of the child in a series of gestures in which he experiences in play the relation between the movements assumed in the image and the reflected environment, and between this virtual complex and the reality it reduplicates – the child's own body, and the persons and things, around him.' [21]

The occasion when the subject first recognises itself amounts to a misrecognition; the subject's appearance of totality is a fantasy, 'the very image which places the child divides its identity into two'.[22] For Lacan, the mirror image is 'the model of the ego function itself, the category which enables the subject to operate as 'I'. Lacan posits the mirror as the access point to visibility, to the images of things we see in our daily experience. Moreover, he equates the mirrored image of the subject with the visible counterparts of the self as experienced in dreams and hallucinations – the various doubles one might experience are attributed the dispositions of mirror images.

Photography, as process, can be understood to enable a particular conceptualisation of the mirror stage since the photograph is linked with a fantasy of greater wholeness of the type that the child experiences in relation to its mirror image. One might thus substitute photographs for mirrors in the above quotation by Miller about the child's 'dealings' with such specular objects: 'the image glimpsed [in the photograph] is thought to be perceived as the same as the child but different'.[23] For the perception of a photograph of the self amounts also to an experience of misrecognition; at home with one's 'imago' in the mirror (itself earlier experienced as a misrecognition) one misrecognises oneself (in the sense of a failure to recognise) as a corrected mirror-image in a photograph. Yet it is not simply at the inception of the medium that the photograph disrupts, by naturalising, a perverse (mirrored) image of the self; the photograph performs this function repeatedly. Those familiar refrains 'it doesn't look like me,' and 'that's never me' testify to the persistence with which photographic doubles of the self are encountered over and over again as misrecognitions, failures in recognition.

One might say that the photograph thereby inaugurates a second mirror stage, one for the adult subject. For the inability to recognise oneself immediately in a photograph somewhat reproduces that initial misrecognition in the mirror as experienced by the child. Of course, the adult's relationship to that misrecognition is different from that of the child. The child's pleasure in the mirror stage is said to come from a sense of its reflected motor co-ordination outstripping its actual abilities; the misrecognition inheres in an experience of wholeness in the image. By contrast, the adult encounters the

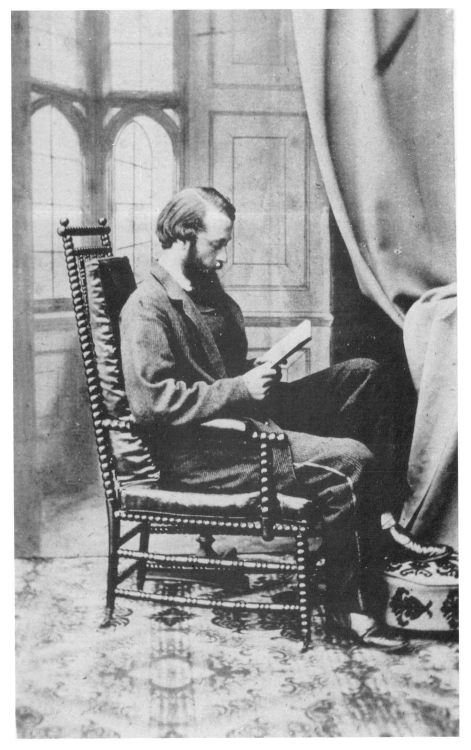

Fig 21
Henry Peach Robinson, *The Photographer Catching Up on His Reading* (1862)

relationship to a photograph of the self as a misrecognition; an inability to recognise (visually) the laterally corrected image in the photograph because of its distance and difference from (sometimes owing to its greater perfection) the one experienced in a mirror; from the originary image of wholeness. In a sense, a reluctance to relinquish that fantasy of perfection still endures in the mirror-image. By extension, it is only post-photographically that a mirror phase can be conceived of as such in the sense that photography offers a representational alternative to the left/right inversion of the mirror. Prior to its photographic correction the mirror-image exclusively represented for the adult, as for the pre-linguistic child, an experience of or a metaphor for a certain wholeness. It is not, of course, that before photography the fiction of the mirror escaped unrecognised but that the invention of photography, by 'correcting' it, dramatised the mirror's fiction for what it was, and enabled a fantasy of wholeness as distinct from that fantasy as given by a mirror. In the nineteenth-century child's credulous relation to photographs (a relation that crops up repeatedly in texts of the period) we can witness psychoanalysis working *avant la lêttre* in this way. In the case of the child subject, unaware of its lateral inversion as a mirror image, the photograph functions as type of mirror, offering a fantasy of a greater wholeness in a way that it simply cannot do for an adult subject. More emphatically, the indirect participation of photography in such a conceptualisation of the mirror stage indicates that the photographic medium shapes the discourse of psychoanalysis in more fundamental ways than by simply lending a monocular model to the psychic apparatus.[24]

An obvious exploration of versions of photographic doubling in the nineteenth century is provided by the many self-portraits by photographers. But photographers specifically interested in developments in process provide notable variations upon the popular genre of self-portraiture in images which play upon the larger concept of doubling characteristic of the medium. Henry Peach Robinson's *The Photographer Catching up on His Reading* (1862) (figure 21) presents a blatant indication of the photographer's profession. By presenting himself as a person at leisure, in the act of reading, Robinson assumes the manufactured persona of one of his studio subjects in a context in which books serve as properties. The interior is clearly that of a photographic studio with its painted backdrop which makes no pretence at credibly representing the recessional space of illusionism, and the photographer sits, himself subjected to the lens. The title of this image, gesturing towards a life of culture for the photographer, and to the photographer as interchangeable with his subject, has the effect of making the viewer reflect not only upon photography as a profession, but upon the practitioner as assuming a professional role, a relatively newly defined role as a contemporary image-maker reliant upon technology. The novelty of photography as reproductive technology is here enhanced by the appearance of the book. As a favourite prop by which photographers could steady posing subjects during long exposures, and as an attribute of learning with which a subject might wish to be pictured, the book allows the viewer to self-consciously double the photographer and photographic subject. In other words, the image stresses that process of substitution or mirroring which photographs perform on a wider scale. An image by Benjamin Robert Dancer, who produced pioneering work on stereoscopic photography (a process by which two photographic images – taken from the position from which each of the two eyes sees – are combined by the brain into a single, highly three-dimensional image) further dramatises the process of 'doubling' as fundamental to all forms of the medium, rather than simply to those that in their title or method refer

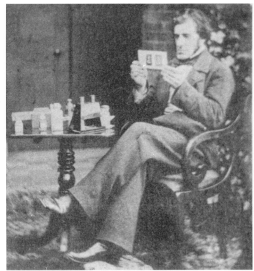

Fig 22
Benjamin Robert Dancer, *Self-Portrait* (1854)

self-consciously to it. In his stereographic *Self-Portrait* (1854) (figure 22), Dancer, seated in the manner of Robinson, shows himself holding up a stereograph to view. Instruments of his trade, such as a stereoscope, are clearly visible on the table. Such an obvious type of self-referentiality is significantly over-determined by the duplication of various doubles within the self-portrait. In a gesture of multiple doubling, Dancer presents to our view a stereograph (which appears to be the head and shoulders of a human figure) while seeming to contemplate its reverse side. The doubles within the photographic double of the portrait assume that disorienting capacity for infinite regress characteristic of the mirror.

In what may be regarded as a simultaneously overt and covert manner, photography *per se* radically plays upon a mirroring of the subject. More than this though, 'double' or more commonly combination printing emphatically brings to the fore that condition of photography so easily effaced by its apparently simple process of transference; that doubling characteristic of photographic processes of reproduction. As I demonstrated in chapter 1, as a medium which allows the photographer to transcend certain technical difficulties such as those of focus and resolution (originally the bleaching-out of skies by early lenses), combination printing or the creation of a single photographic print from more than one negative allows for the juxtaposition of historically and temporally unrelated details. This popular nineteenth-century practice has been read predominantly for its structural and aesthetic impact upon photography, rather than in terms of a psychic one, even though the disturbance that many combination prints produce in the viewer occurs at the psychic level, as suggested, for example, in the bringing together of uncannily mismatched gazes of figures. We only have to consider Henry Peach Robinson's *Photo Sketch for a Holiday in the Wood* (figure 23) (1860) to witness this point. The 'double' print which combines nine women, one man and a dog presents a skewed perspective in which figures appear unrelated to one another. Not only is the viewer struck by the discrepancy in size of objects (the two figures walking in to the

image in relation to the large central basket that almost slips off the bottom) but also by lines of sight between figures which fail to meet. In considering Robinson's *Genre Portrait of a Girl in Country Dress and Sun Bonnet* (1861–62), a preliminary study for a composite photograph, we confront the fragmented quality of the technique first hand. It is an unfinished image, a light albumen print overlaid with water-colour and pencil, displaying the extent to which, as a technique, combination printing brings to the fore photography as surface, as collage, by crystallising its difference from the painted ground with which it is here juxtaposed. Functioning as a study, Robinson's image recalls contemporary anxiety about painting over photographs as a 'crime' among artists that might go undetected in finished works; a charge levelled against the Pre-Raphaelites and for which their work was defended by Ruskin. Moreover, the photo-sketch dramatises the extent to which, rather than co-existing harmoniously with the painted areas of the composition, the photographic portion signals its heightened three-dimensional presence as surface, as that which could not successfully be concealed by layers of applied paint; whose surface difference would be enhanced by such a process of layering.

A more structurally coherent combined photograph by Robinson, which sparked

Fig 23
Henry Peach Robinson, *Photo Sketch for a Holiday in the Wood* (1860)

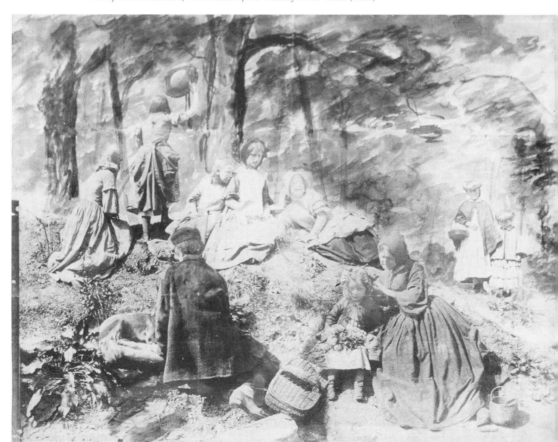

considerable controversy owing to its delicate subject matter, further demonstrates the relationship of combination printing to wider questions of the construction of subject positions. Robinson's *Fading Away* (figure 24) (1858), which shows 'a young consumptive surrounded by her family in her final moments,' was printed from five negatives onto a single sheet of paper. From a technical point of view it would have been impossible for Robinson to have produced such a photograph, featuring a group of figures indoors, with a single exposure. On the one hand, critics attacked Robinson for the presumed indelicacy of having invaded the death chamber at the most private of moments: '"Fading Away" is a subject which I do not like, and I wonder Mr Robinson should have allowed his fancy to fix on it; it is a picture no one could hang up in a room, and revert to with pleasure.'[25] Similarly, those who recognised the scene as having been staged and who understood the nature of the process of combination printing accused him of dishonesty in using a medium the chief virtue of which was considered its truthfulness. On the other hand, critics praised Robinson's aesthetic achievement as approximating that of contemporary painters: 'the conception is such a one as Noel Paton might not disdain to own, and indeed has much in common with that of his famous painting of the *Dead Lady*'.[26] At the same time, however, the pictorial oddity of the image was not lost on contemporary viewers and it is an effect which stems in part from the uniformity of focus across the planes in the interior of the room and the clouds outside the window, coupled with the slightly disjointed perspective. Crawford makes the point that the 'characteristics of simultaneous tonal balance and deep focus must have been as shocking as was the picture's morbid subject,'[27] and certainly the image produces a visual shock. But Crawford's further assertion that such characteristics 'made the photograph look more like normal visual experience or ... the model of normal experience presented in academic painting,' than a unitary image would have done is

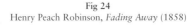

Fig 24
Henry Peach Robinson, *Fading Away* (1858)

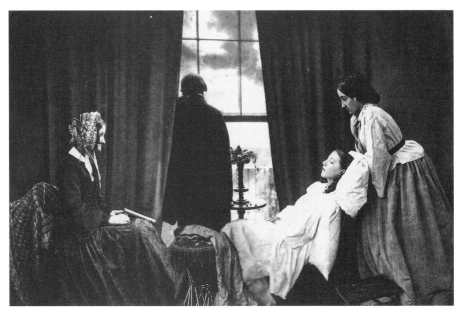

somewhat questionable.[28] I do not think that the public's charge of dishonesty of the medium is simply to do with a sense of an assumed aesthetic violation. It is not only about a supposed integrity of the medium (a sense that what might have appeared more 'normal' to nineteenth-century viewers invariably would seem 'photographically implausible today'), but about the odd structural quality of the image, the manner in which for example those clouds in that unbleached-out sky refuse to recede and thereby to subordinate themselves to the figures within the room. The effect of the photograph upon the viewer is to focus attention on the central portion of the image. Tonally, the figure of the young consumptive, dressed in a white night gown, registers most dramatically along with the light portion of sky outside the window. She, together with the other two women figures, is in profile and, collectively, they are set against the one male figure (father or doctor) who, with his back to the scene facing the window, raises his left arm to his face.

In a gesture of further doubling in relation to *Fading Away*, Robinson's photograph *She Never Told Her Love* (figure 25) (1857) – first exhibited at the Photographic Exhibition at the Crystal Palace, 1858 – subtly articulates the role of the double in mid-century, not only in those debates about truth and imitation we have so far considered, but also more centrally in relation to psychic conditions of doubling. The albumen silver print from a glass negative was exhibited by Robinson as a discrete work but it also served as a study for the central figure in the combination print *Fading Away*. It shows the same female figure propped up by pillows in a chair, her head turned this time in three-quarter profile to the viewer. What is curious about Robinson's creation of this discrete image is that it constitutes a construction of an identity that is itself a fiction created by a cross-dressed character in Shakespeare's comedy *Twelfth Night*. In Act II scene IV of the play, the female character Viola, disguised as Orsino's page Cesario,

Fig 25
Henry Peach Robinson, *She Never Told Her Love* (1857)

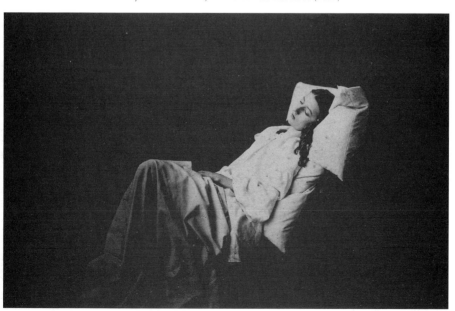

speaks of her emotional predicament from the position of third person narration. But the occasion of cross-dressing significantly complicates such a use of the third person. On the surface of things, what we have in Shakespeare's play is an occasion in which a character, who is secretly in love with the person confiding in and questioning her, must evade personal enquiries in order to preserve her disguise. It is not so much the nature of the evasion (itself a familiar line of deflection) that concerns me, but rather the way in which identification is specifically affected by the process of cross-dressing. Cesario claims he had a sister, and to Orsino's question as to whether that sister died of her unrequited love Cesario replies with his 'She sat like Patience on a monument' speech. Catherine Belsey has read this episode in the play as dramatising the creation of a subject position which is not strictly gendered and not fully unified since the Viola who speaks is not equivalent to the Viola she speaks of.[29] By using a recognisable mode of deviation, 'I have a sister ... ' Viola assuming the persona of Cesario creates a fictional character who is somewhat recognisably the same as the one who speaks but who cannot be strictly identical to it. Shakespeare's text plays further on this point in its use of identical twins; the gender transgressions that occur throughout the drama can only be resolved at the close when Sebastian, the double of Viola, steps in to undo the confusion of gender roles. In terms of Robinson's photographic representation, it is significant that the figure he selects is not an actual character from the play but an identity created from the very transgressions of gender upon which the drama centres. Not only is the relationship of photography to referentiality immediately called into question by such a photograph, but as we confront the image of a 'real' woman, photographically realised as a depiction of a fictional identity (who has no name and is created within another fictional identity) we come face to face with an overt play upon instances of photographic doubling. We glimpse in these instances the interconnectedness of such radical photographic practice with problematics of identification and concepts of subjectivity.

The relationship of 'double' printing to a psychic concept of doubling itself is perhaps most interestingly dramatised in its relation to the persona of the photographer. In the case of Oscar Rejlander's photograph *The Artist Introduces O.G. Rejlander the Volunteer* (figure 26) (1871), we find the photographer presenting his double within the image. In this relatively late combined photograph taken in his studio, Rejlander 'the artist' addresses the viewer, hand on heart, gesturing with the other towards his double who looks on somewhat indignantly. According to Edgar Yoxall Jones in *Father of Art Photography Oscar Rejlander 1813–1875*, Rejlander enjoyed 'drill[ing] and skirmish[ing] with the volunteers and on 7 February 1871 just before Louis Napoleon began his exile in England, [he] signed the muster roll of the Artist's Company, 38th Middlesex Regiment'.[30] In the photograph, Rejlander juxtaposes himself in volunteer regimentals with his double in 'sable suit with clerically cut collar'.[31] The overall concern of the photograph with a repetition of the subject is further, though subtly, strengthened by the partially obscured photograph known as *Ginx's Baby* which rests on the artist's easel. The image was one of the photographic illustrations that Rejlander produced for Charles Darwin's *On the Expression of the Emotions in Man and Animals* (1872), five of which Rejlander himself posed for.[32] Entitled *Mental Distress* and showing an infant crying, the name *Ginx's Baby* was coined by Baden Pritchard after the title of the popular novel. Referring to the recognised portrayal of the passions, based upon Lebrun, an art critic later affirmed that 'they have been finally scattered to the winds by the wonderful photographs of the late O.G. Rejlander, especially noting the illustrations in Dr Darwin's

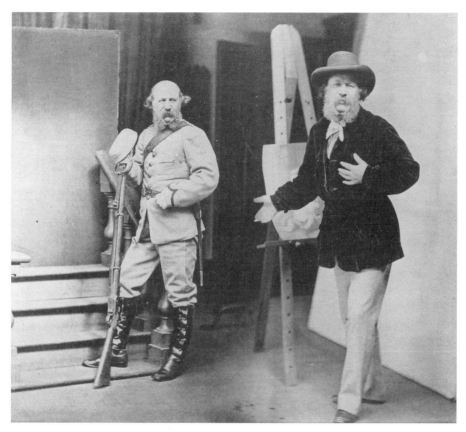

Fig 26
Oscar Gustav Rejlander, *The Artist Introduces O.G. Rejlander the Volunteer* (1860)

work on expression, and *Ginx's Baby* as examples'.[33] The photograph became incredibly popular, resulting in sixty thousand 24 x 30 centimetre prints and a quarter of a million cartes. The appearance of *Ginx's Baby* in *The Artist Introduces O.G. Rejlander the Volunteer* makes the viewer confront the intimate inter-relationship of painting and photography in the period. Leaning against the easel the photographic image buckles, signalling its material difference from the support (either canvas or board) of an oil painting. Rejlander self-consciously plays upon the persona of the artist, undermining its seriousness by his over-earnest gesture of introducing the 'volunteer'. The artist's studio context has here become that of the photographer, and the effect is both one of a playful irreverence and of a visual disjunction between the tools of the artist's trade and those of the photographer as captured in the incongruous positioning upon the easel of the flimsy photographic print.

There are all sorts of coded repetitions visible in *The Artist Introduces O.G. Rejlander the Volunteer*, ones playing both upon questions of truth versus imitation, and of fine art versus technology, as voiced in nineteenth-century contemporary debates within *The British Journal of Photography*, and upon the photographer's relation to his photographic subjects. For the appearance of the image of *Ginx's Baby* in the larger photographic image anticipates an 1872 photograph in which Rejlander as photographer,

mimicking the baby's facial expression, appears behind the photograph of the infant which stands on the easel as before. Yoxall Jones glosses the image as follows: 'Rejlander laughs at himself. Who would have dreamed that 'Ginx's Baby' would have made him solvent'[34] – the implicit irony being that it is an unlikely and seemingly insignificant image of a child that was able to keep him afloat financially.

But which self is Rejlander said to be laughing at in this image? For there occurs within the photograph a fundamental identification between an adult photographic subject, child subject and photographer that is substantially complicated because over-determined by the medium of double printing. As a technique, combination printing makes explicit those questions of identification otherwise understated, or seemingly naturalised by the medium of photography. In other words, double printing undoes the assumed naturalism of the unitary photographic 'take,' drawing attention to the uncanny doubling which all photographs manifest. But the medium also begs us to question what it means for the photographer to include himself (as photographer) in the image when the photograph is a combined one and similarly to consider such a use of the child alongside an image of the photographer. Given the account of doubling I have been pursuing, we may read the appearance of the child subject as a kind of double of the photographer. *Ginx's Baby* becomes a double of Rejlander in the sense of his creation and as a reproducible image. But we may also read the presence of the infant as representing a psychic relation between the photographer and his child subjects. It is as if the adult's fantasy of a return to a pre-linguistic wholeness, as experienced at the mirror stage, can be re-enacted by the photographer's 'setting up' of a child subject to be photographed (as in the case of Lewis Carroll's many examples of little girls) or, as in Rejlander's *The Volunteer*, by blatantly invoking such identification in the image; the infant (*Ginx's Baby*) as Rejlander's progeny and his pre-linguistic self.

Difficulties over mid-nineteenth-century concepts of the child are contemporary with difficulties over the status of the photographic medium. Since, in the period children constitute a much photographed group, the radical involvement of the photographic medium in defining categories of childhood, and its repressed (supernatural) heritage in the vision of the double, means that it requires as its 'natural' double the figure of the child. I say 'requires' because increasingly it seems to me that Victorian photography can be witnessed in the process of engaging that relationship with the figure of the child as a type of naturalised connection while obscuring the reasons for its dependency upon that figure. I'd like to suggest in other words that what Barthes recognises as the 'madness' of the medium is its heritage in such a form of identification, its profound ability to make pre-linguistic subjects of us all. We can further trace the type of identification that Rejlander images in his depiction of his portrait of *Ginx's Baby* within his self portrait *The Artist Introduces O.G. Rejlander the Volunteer*, in more overtly narrative and classical connections of photography with representations of childhood.[35]

Both Rejlander and Cameron made photographs in which photography as a medium is depicted as an infant. We can read Rejlander's *Infant Photography* (1856) alongside Cameron's later *Cupid's Pencil of Light* (figure 27) (1870), to witness the way in which photography, in its infancy still is personified as an infant. In one sense, the use of a literal infant for the beginnings of the medium may be situated within a fine-art tradition which, as Marcia Pointon has pointed out, frequently used children – 'relatives of the putti of Antiquity' – up until 'the middle of the nineteenth century to represent the various arts and the different mechanical skills required to master those arts'.[36] In this

Fig 27
Julia Margaret Cameron, *Cupid's Pencil of Light* (1870)

context Pointon cites the example of an eighteenth-century artists' manual, *Instruction in the Use of Colours*, illustration to *The Artist's Repository and Drawing Magazine* in which praxis is personified as 'either female or child', and she examines the way in which the publication of children's illustrated books in the second half of the eighteenth century 'drew on moralizing and allegorizing visual traditions which represented children without necessarily addressing them'.[37] But, by pursuing a slightly different trajectory, might we not also read the particular personification of photography as an 'infant' as testifying to the link we have so far been tracing between photography and concepts of childhood? For it is an historically specific alliance that testifies to the difficult cultural positioning of the medium at this historical juncture as inseparable from an equally difficult cultural positioning of 'the child'.

A contemporary gloss on Rejlander's *Infant Photography* from the *Photographic News* reads: 'the hand of the artist holds many brushes; young photography – only a child – gives him one more'.[38] In the image, the photographic medium is personified as a child; the hand of the artist is shown on the top left of the composition receiving an additional paint brush in return for a coin. We thus recognise a familiar narrative around the medium's inception – photography as the handmaiden of fine art; photographic representation as another tool of the artist. In such a story, photography is perceived primarily as mediated through painting. The photograph juxtaposes the context of an artist's studio (a sculpted antique figure appears in the foreground together with other properties) with a camera upon which the infant leans to adopt a recumbent pose. A continuity between the mediums of painting and photography is established structurally in the composition by the infant's gesture which connects camera with paintbrush. The angle of the reclining body of the infant dominates the image and is twinned tonally with the antique statue in the left foreground. The figure of the artist is distinguishable only by his sleeve and his hands which hold the paintbrushes. An air of luxury in the studio context, and also of exoticism when read against the dramatically lit bare flesh, is lent by an animal skin upon which the child reclines. The context of the artist's studio, as the domain of the life model, has become here the locus of a new technology of reproduction.

In Cameron's later photograph, by distinction, the child is Cupid, psyche's winged messenger. As Pointon further indicates: 'that Cupid is the most famous child apart from Christ, the child enacting western culture's most intense phantasies from Eros to Agape … suggests moreover that the child possesses a particularly powerful connotative capacity in narrative and myth.'[39] But what especially interests me is the way in which such mythological iconography stops short in Cameron's image in the sense that, featuring a Cupid without wings, the dominant aspect of the suggested narrative is simply that of the photographic medium as divinely given; the pencil of light here substituting for the artist's tool and also for Cupid's arrow which brings to the fore the analogy of the medium of photography with the state of the lover which we considered in the last chapter. In this sense, the use of the infant is not unlike that by Cameron in *My Grandchild* which we discussed in chapter 2; one photograph does not appear to be more mythologically determined than the other. In other words, the line between the use of a child in a portrait and in what appears to be an iconographic image is not easily determined. Furthermore, the direct equation seems to reside more with agency (of the child and of light) rather than with the figure of the child as mythologically manifesting the invention.

Cameron's contemporary – and an exponent of naturalism as opposed to Robinson's pictorialism – Peter Henry Emerson commented upon the dominance of light itself as depicted in *Cupid's Pencil of Light*: 'the descending rays of light are produced by withholding the "cyanide" at the proper moment, and the effect is marvellous'.[40] So additionally arresting is the illuminated tablet in the centre of the composition upon which Cupid writes, together with the glowing outline that it casts upon the child, that one feels that Cameron is concerned to present the medium of photography itself as fundamentally inextricable from the figure of the infant. While there are several other photographs by Cameron in which the reference to Cupid and to *putti* are displayed prominently in the body of the child (I am thinking here of *I Wait* (1872), and of *Venus Chiding Cupid and Removing his Wings* (1873)), in the former, 'the pose and the expression of the child', according to Mike Weaver, 'derive from one of the *putti* in

Raphael's *Sistine Madonna*,[41] and the latter provides a complex compositional arrangement in which feathered wings feature dominantly. The effect of both, therefore, is to draw attention to the attribute of wings as peculiarly signifying divinity. By contrast, a juxtaposition of Cameron's *Cupid's Pencil of Light* with Rejlander's *Infant Photography* shows not that the twinning of the infancy of the medium with an actual infant is especially novel, since we have only to consider the aforementioned tradition in painting of using babies in the forms of cherubs and *putti* to locate the origins of such a usage, but rather that such a general correlation anticipates what will become a highly developed association between photography and nineteenth-century concepts of the child.[42]

Cupid's Pencil of Light represents, as harnessed photographically, the nature of the agency of light itself; the photograph self-referentially alludes to the chemical and physical origins of the medium of photography. What we have is a process, at the mercy of light, conveying light as a blank illuminated space at the centre of the composition. In its suggestion of an irrefutable material presence, as a dazzling space of reflective light, Cameron's photograph recalls the later account by Jacques Lacan in *The Four Fundamental Concepts of Psychoanalysis* of the tin-can incident, where a floating sardine can positioned according to a subject's line of sight manifests the nature of the gaze: 'You see that can?' the author, the dispossessed member of the Brittany fishing crew is asked, 'Do you see it? Well, it doesn't see you'![43] Lacan cites the incident, a 'true story' from his early twenties for its revelation of the way in which objects 'do' 'look' at subjects 'at the level of the point of light, the point at which everything that looks at me is situated'.[44] More emphatically, though, he uses the tale to expose that which is left out 'at the level of the subject' in geometrical accounts of vision, namely the inscrutable depth of field:

> That which is light looks at me, and by means of that light in the depths of my eye, something is painted – something that is not simply a constructed relation, the object on which the philosopher lingers – but something that is an impression, the shimmering of a surface that is not, in advance, situated for me in its distance. This is something that introduces what was elided in the geometral relation – the depth of field, with all its ambiguity and variability, which is in no way mastered by me.[45]

Cameron's photograph works in a related way to make the viewer aware of light by means of its own irrefutable signature, to emphasise depth of field by means of the shimmering surface at the centre of her image as that which is elided in geometrical mappings of space. Lacan further articulates the place of light itself in his account of 'the gaze':

> In what is presented to me as space of light, that which is gaze is always a play of light and opacity. It is always that gleam of light – it lay at the heart of my little story – it is always this which prevents me, at each point, from being a screen, from making the light appear as an iridescence that overflows it. In short, the point of gaze always participates in the ambiguity of the jewel.[46]

The metaphor of the ambiguity of the jewel not only provides a way of further pondering the centrality to Cameron's work of the agency of depth of field, it also enables us to newly read the space of light in *Cupid's Pencil of Light* in relation to larger questions about the depiction of photography itself as an infant.

In Rejlander's *Infant Photography* and Cameron's *Cupid's Pencil of Light*, we are asked to read photographs of the naked infant as a double for photography's immanent status, its latency. In both of these photographs, the troubled and contentious status of photography in relationship to painting is brought to the fore in a conjunction of an image of a naked infant with instruments or manifestations of both human and metaphysical agency. The latency of the photographic medium is represented as implicit in the latency of the infant, who exists as pre-linguistic (as prior to culture) in his or her nakedness. It is a latency in the sense of what the medium will become as it develops technically and also in the sense of photography's subordinate relation to painting. Thus, although Rejlander and Cameron are in some senses picturing a familiar scenario, an infant child imaged as the medium in its infancy, and although metaphors of light as the brush or pencil of the artist abound in literature of the period, there occur very different ramifications when an infant is used stripped of its mythological and iconographical significance. More than this, there is a primary sense in which such photographs, along with Rejlander's *The Volunteer*, emphasise the figure of the child as the most 'natural' double of the photographic medium.

Photography and the child converge around a dominant fantasy of, or investment in, naturalism during the second half of the nineteenth century. We have witnessed to what extent such a convergence is bound up with concepts of the double, and specifically with the impact upon the subject's relation to his or her double of the invention of photography. I now wish to turn to the ways in which this fantasy of naturalism – as conveyed by photographic images of 'the child' – is variously played out both in the individualistic and relatively private amateur pursuits of Lewis Carroll and in the more public photographs of Thomas Barnardo. Just as Carroll's interest in photographing little girls cannot be separated from a concept of minority as evidenced, to his eye, in the physical proportions and 'natural look' of a child, the commodification of the 'Street Arab' in Barnardo's 'before' and 'after' cards cannot be read outside the larger context of a nineteenth-century correlation between the 'naturalism' of the photographic medium and that of the child.

Notes

1 Roland Barthes, *Camera Lucida: Reflections on Photography* (New York: Hill and Wang, 1981), pp. 12–13.
2 *Ibid*. p. 12.
3 Jacques Lacan, 'The Mirror Stage as formative of the function of the I as Revealed in Psychoanalytic Experience', *Écrits: A Selection*, trans. A Sheridan (London: Tavistock, 1977) pp. 1–7, p. 2.
4 This question of the means by which the invention of photography elicits a new conception of the status of the double is crucial to our understanding of the politics of the medium in the nineteenth-century.
5 Heinrich Schwarz, *Art and Photography: Forerunners and Influences*, ed. William E. Parker (Chicago and London: University of Chicago Press, 1987), p. 104. Schwarz continues: 'In any case, the mirror was for centuries an important implement in the artist's studio and is still in use, foremost in England'.
6 In histories of photography Baudelaire's comment generally gets situated alongside the French painter and supporter of Daguerre, Paul Delaroche's much quoted impassioned reaction: 'from today painting is dead', and Turner's equally apocalyptic variant on the subject: 'I am glad I have had my day.'

7 See in particular Arthur Golding's translation of Ovid's *Metamorphoses* 1567, ed. with an
 introduction by Frederick Nims (New York: Macmillan, 1965), Book 3, lines 534–88, in
 which Narcissus moves to a realisation that it is the image of himself and not that of another
 that he desires thus rendering his desire impossible:

> He knowes not what it was he sawe. And yet the foolish elfe
> Doth burne in ardent love thereof. The veric selfsame thing
> That doth bewitch and blinde his eyes, encreaseth all his sting.

> The thing thou seekest is not there. And if aside thou go,
> The thing thou lovest straight is gone. It is none other matter
> That thou doest see, than of thy selfe the shadow in the water.
> The thing is nothing of itselfe: with thee it doth abide,
> With thee it would departe if thou withdrew thy self aside.

> It is my selfe I well perceyve, it is mine image sure,
> That in this sort deluding me, this furie doth procure.
> I am inamored of my selfe, I doe both set on fire
> And am the same that swelleth too, through impotent desire.
> (534–585).

8 Lewis Carroll, 'A Photographer's Day Out', *The South Shields Amateur Magazine Consisting
 of Original Articles, in Prose and Verse, by Amateurs of South Shields and the
 Neighbourhood* (1860), pp. 12–16.
9 *Ibid.* p. 12.
10 *Ibid.*
11 For further details of the invention of the daguerreotype, especially in relationship to
 Talbot's process, see in particular Larry Schaaf, *Out of the Shadows: Herschel, Talbot and
 the Invention of Photography* (New Haven and London: Yale University Press, 1992):

> The manipulatory details of the daguerreotype would not be disclosed until
> the autumn of 1839. It would emerge that Daguerre placed a highly
> polished silvered copper plate in a box filled with the fumes of iodide.
> Exposed in a camera for fifteen minutes or so, an invisible image was
> formed on the silver surface. At this stage, the image, although
> imperceptible, was far from inert. By subjecting the exposed plate to the
> fumes of mercury, a discernible image was formed when tiny globules of
> mercury adhered to the areas struck by light; a wash in common salt
> preserved it. (p. 45)

12 William Crawford, *The Keepers of Light: A History and Working Guide to Early
 Photographic Processes* (Dobbs Ferry, New York: Morgan and Morgan, 1979).
13 Oscar Rejlander, quoted in Edgar Yoxall Jones, *Father of Art Photography 1813–1875*
 (Newton Abbot: David and Charles, 1973), p. 12.
14 Sir John Herschel, Letter to William Henry Fox Talbot, 24 June 1839, quoted in Schaaf, *Out
 of the Shadows*, p. 81.
15 Schaaf, *Out of the Shadows*, p. 45.
16 W.H. Fox Talbot, quoted in Schaaf, *Out of the Shadows*, p. 74.
17 It was Herschel who, drawing upon the field of electricity, coined the formulation negative/
 positive to replace Talbot's term 'photogenic drawing':

> To avoid much circumlocution, it may be allowed me to employ the terms positive and
> negative, to express respectively, pictures in which the lights and shades are as in
> nature, or as in the original model, and in which they are the opposite, i.e. light
> representing shade, and shade light. The terms direct and reversed will also be used to
> express pictures in which objects appear (as regards right and left) as they do in
> nature, or in the original, and to the contrary. (Quoted in Schaaf, *Out of the Shadows*,
> p. 95).

18 Jacques Lacan, 'The Mirror Stage', p. 2.
19 Jacqueline Rose, *Sexuality in the Field of Vision* (London: Verso, 1986), p. 53.
20 Lacan proceeds to describe 'the mirror stage' as 'a drama whose internal thrust is
 precipitated from insufficiency to anticipation – and which manufactures for the subject,
 caught up in the lure of spatial identification, the succession of phantasies that extends from

a fragmented body-image to a form of its totality that I shall call orthopaedic – and, lastly, to the assumption of the armour of an alienating identity, which will mark with its rigid structure the subject's entire mental development' ('The Mirror Stage', p. 2).

21 Lacan, 'The Mirror Stage', p. 1.
22 Jacqueline Rose, *Sexuality in the Field of Vision*, p. 53.
23 Karl Miller, *Doubles, Studies in Literary History* (Oxford: Oxford University Press, 1985) p. ix.
24 It is not my intention here to pursue the ways in which psychoanalysis uses discourses of photography but there exists a vital intersection between them worthy of further consideration.
25 *Journal of the Photographic Society*, 1 January 1859.
26 *Edinburgh Weekly Herald*, 1 January 1859.
27 Crawford, *The Keepers of Light*, p. 59.
28 *Ibid.*
29 Catherine Belsey, 'Disrupting Sexual Difference in Shakespeare's Comedies', *Alternative Shakespeares*, ed. John Drakakis (London, New York: Methuen, 1985), pp. 166–90.
30 Edgar Yoxall Jones, *Father of Art Photography Oscar Rejlander 1813–1875* (Newton Abbot: David and Charles, 1973).
31 *Ibid.*
32 Charles Darwin, *On the Expression of the Emotions in Man and Animals* (London: John Murray, 1872).
33 Yoxall Jones, *Father of Art Photography*.
34 *Ibid.* p. 38.
35 Marcia Pointon, *Hanging the Head, Portraiture and Social Formation in Eighteenth Century England* (New Haven and London: Yale University Press, 1993), p. 179.
36 *Ibid.*
37 In one sense, so obvious is the link between the troubled status of the medium of photography in the nineteenth century with the ambiguous category of childhood, a category so differently demarcated by those agitating for various reforms in age-of-consent legislation for example, that it could almost go unnoticed. I want, however, to assert the link as a crucial element in understanding the numerous photographic images of children in the period.
38 *Photographic News*, 29 October 1875.
39 Pointon, *Hanging the Head*, p. 179.
40 Peter Henry Emerson, 'Mrs Julia Margaret Cameron', *Sun Artists* (1890), p. 42.
41 Mike Weaver, *Julia Margaret Cameron 1815–1879* (John Hansard Gallery: Herbert Press, 1984), p. 44.
42 Cupid, the Greek Eros, as a celebrated deity among the ancients, is the God of love and love itself. Of the different traditions concerning his origins there are, according to the most received opinions, two Cupids: 'one of whom is a lively, ingenious youth, son of Jupiter and Venus'; the other, 'son of Nox and Erebus, is distinguished by his debauchery and riotous disposition'. As a figure of a child winged and naked he appears armed with a bow and a quiver of arrows. 'On gems, and all other pieces of antiquity, he is represented as amusing himself with some childish diversion' for example: 'driving a hoop, throwing a quoit, playing with a nymph, catching a butterfly, or trying to burn with a torch'. The act of writing with a pencil of light does not conform to these childish pursuits but for this reason it makes all the more emphatic the link between the medium of photography and the figure of an unmythological child.
43 Jacques Lacan, *The Four Fundamental Concepts of Psycho-Analysis*, trans. Alan Sheridan (London: Penguin, 1977), p. 95.
44 *Ibid.*
45 *Ibid.* p. 96.
46 *Ibid.*

5

'Take Back Your Mink':
Lewis Carroll, child masquerade and the
age of consent

The history of Lewis Carroll criticism is dominated by questions concerning the nature of his relationship with little girls. Regardless of whether it is his writing or his photographs that they are addressing, critics commonly identify the figure of the little girl as an index either of Carroll's potential sexual 'deviance' or of his irrefutable 'normality'.[1] Those critics who specifically consider Carroll's photographic practices, moreover, tend simply to collapse the author of the *Alice* books into the persona of Dodgson the photographer even though Carroll himself kept his literary persona distinct from his photographic one.[2] They fail to address, as a consequence, complex issues generated by the relationship of that photographic persona to the practice of photographing child subjects. From the 1850s onwards, the critical desire to read Carroll's interest in little girls as residing in the pleasure of their company, their language, the symbolism of their wit, has especially eclipsed the visual emphasis of that 'interest', the visualisation of the little girl as spectacle which, nevertheless, is the strongest, most persistent interest that Carroll exhibits. As a result, the practices of his photographic sessions and his elaborate recordings of them in diaries and notebooks have been downplayed or gone virtually unnoticed, as have the ways in which they draw upon larger conceptions of childhood in the period. Not surprisingly, the particularities of this critical de-emphasis expose what is at stake in Carroll's photographic activities and their textual history, namely a production of the little girl that is inseparable from fantasies of childhood formulated in relation to Victorian concepts of majority and the age of consent.

Marcuse Pfeifer for one exposes this relation. In a review of a collection of essays that seek to recuperate an unproblematic sexuality for Carroll, Pfeifer writes the photographer into a somewhat inappropriate relationship with the Hollywood musical – albeit obliquely – by attributing to him the familiar line 'Thank Heaven for Little Girls' from *Gigi*.[3] In what might seem an initially fitting choice, Pfeifer takes Maurice Chevalier's song as the title of her essay. That title may seem apt, we might say, because the line that follows, 'without them what would little boys do', has assumed a refrain in Carroll criticism with such unmelodic phrases as 'if in fact Lewis Carroll has any claim

to greatness in photography it is with his portraits of little girls'.[4] Yet, given the context of the rest of the song, this assumption about Carroll's dependency could not be further from the truth. For, as we shall see, if Carroll thanked 'heaven for little girls', he did so precisely because they need not 'get *bigger* every day' nor '*grow up* in a most delightful way'. He did so because 'little girls' could enter a substitutive economy, catalogued by their youthfulness and by the point at which it ran out. In this sense then, for Carroll, Chevalier would have had to have been singing the blues.

To remain, for a moment, with 1950s' musicals, but shifting from screen to stage, we might write Carroll more appropriately, and with different ramifications, into a relationship with Broadway. I am thinking in particular of a number by Vivian Blaine and the Hot Box girls from the musical *Guys and Dolls*, entitled 'Take Back Your Mink'. That song records the dressing up which goes too far because it ultimately signals undressing: 'What made you think that I was one of those girls?' This time, however, we could say that the shoe would be on the other foot, the singer no longer Carroll but the object of his affection. For Blaine's retort about her gift of a mink – 'Go shorten the sleeves for somebody else' – takes on particular dimensions beside Carroll's diary entry for 15 June 1880: 'Mrs Hatch brought Evelyn, of whom I took 2 photos in the spotted dress. In the afternoon I took the dress to the Hendersons, to have it reduced to fit Annie'.[5] Indeed, 'the spotted dress' first worn by Evelyn for a photograph, then efficiently retailored to fit Annie as next in line for the lens, is just one example of quasi-bespoke children's tailoring in Carroll. In *Guys and Dolls*, the point about sleeve-shortening establishes the status of the mink as fetishised commodity in consumer capitalism. Mink is the legendary token along with diamonds by which the woman is supposedly best ensnared. But implicit in the knowledge that 'those worn-out pelts' may be easily reduced in size for the next object of affection is the recognition that the act of couturial offering effectively amounts to no more than a *prêt-à-porter*. It is an offering designed by the giver, along with necklace, gloves, shoes and hat, primarily for his pleasure in their removal: 'Last night in his apartment he tried to remove them all'. We find in this phrase, uttered by the recipient, an explicit link between commodity fetish and prostitution.

The couturial games of Carroll are, however, different from those enacted in *Guys and Dolls*. Whereas the latter involve a consenting adult who returns the mink to indicate her contempt for its potential transferability, the former require the dressing of a child to be photographed. The concept of consent thus emerges as a crucial point of differentiation. For Carroll's post-shrunk children's clothes (together with those borrowed from museums and theatres) circulate in an adult economy of exchange. Within that circulation they become, as a rule, garments which no little girl gets to keep, as Carroll maintains the wardrobe to which costumes are repeatedly 'take[n] back'. The little girl, thereby, merely enjoys the pretence of exchanging one exotic garment for another while Carroll stages, in miniature, what we might call a dress rehearsal for an exchange of commodity fetish, literally transporting theatrical spectacle into the context of the photographic studio by means of the wardrobe. In so constructing photographic masquerades, Carroll puts the little girl into a situation in which she can enact a return of the gift, become, so to speak, the consenting subject who, like our Broadway heroine, may return the 'mink' at will. He thereby appears to allow consent but his wardrobe door is, in fact, a revolving one, the clothes only on approval to begin with. Moreover, the child's apparent status of consenting subject is not what it seems, for it is linked by a common deception to the larger paradoxes of what is meant by the 'age of consent' in

terms of power relations in concepts of majority and minority during the second half of the nineteenth century.

By means of such photographic practices, Carroll's formulation of desire assumes a visual enactment of cultural difference across the intricately clothed body of the little girl as object for the photographic lens. His dressing up or dressing down of the child for photography acts in accordance with an intricately formulated rhetoric of consent which, as we shall find, functions in one sense as a ruse. For, repeatedly, Carroll rehearses in his photographs fantasies of racial, cultural and sexual difference through the visual intricacies of costume dramas and child masquerade, intricacies that are in turn underwritten by contemporary issues of children's rights and age-of-consent legislation as negotiated in various cultural spaces. More specifically, Carroll deploys a personal logic of consent through legal and social definitions of the term 'consent' in costume fantasies that register, above all else, an insistence upon height as a barometer of childhood and infantile sexuality.

The medium for Carroll's personal logic is the letter, especially those letters to child friends and their parents in which he negotiates photographic sessions and costumes. Throughout his photographic career, Carroll situates his compulsion to photograph young girls according to contemporary laws of propriety. But he has to rewrite continually the limits of those laws in order for them legitimately to accommodate that compulsion. Consent is crucial to this process, whether it be the consent of a child to walk out with him, to be photographed in his rooms at Christ Church or, as was common in later years, to stay with him at the seaside at Eastbourne. Defined as 'the age at which a person is legally competent' to assent to certain acts, 'especially marriage and sexual intercourse', 'consent' also marks the point at which a recently matured child subject may be legally 'taken'. Derived from *consentir*, 'to be of the same mind; to agree; to give assent to; to yield; to comply', it suggests therefore not so much an equivalence, but rather an imbalance in power relations. For to agree, to give assent, to yield, all suggest capitulation to a more powerful agent, that the person consenting is not by definition occupying the role of initiator but that of yielder or complier.

The vexed issue of consent in Carroll's photographic practices, especially as inscribed in the use of little girls for photography, allows, I want to argue, his (linguistic) narratives of consent to remain detached from, whilst seeming to participate in, Victorian debates around age-of-consent legislation. Indeed, it is in this way that Carroll's concern with historical questions of consent operates, at one level, to deflect attention from the particularities of his psychic investment in the term as manifest in the small girl, the miniature. In such a scheme, the intersection of the psychic and social resonances of 'consent' means that 'size', a desire for the child precisely not to get bigger, produces for Carroll an urgent relation to historical and cultural determinants of the 'age of consent'. The problematical nature of a concept of adolescence is, as a result, displaced to height, and thereby linked to consent in such a way that height, rather than the more obvious signs of puberty, comes to stand in for markers of the psycho-sexual development of the subject.

One incident recorded in Carroll's letters concerning the visit of the young actress Polly Mallalieu to Eastbourne in the summer of 1892 stresses the importance of child-measuring to issues of consent. In a series of letters to Polly's parents, Carroll dwells upon the significance of a discrepancy between the child's professed height and her actual one. In short, when upon measuring Polly he finds that she is '4ft 10$^{1/2}$ins. *without* her shoes',

although she herself claims to be 'only 4ft 10ins. *with* them', and explains that the discrepancy might be owing to her parents' desire 'to secure some engagement she was trying for', Carroll mounts an extended attack upon the motives of what he calls Mr Mallalieu's 'lie'[6] and causes a subsequent break in relations with the family. He reads in(to) the extra half-inch the implication that Polly's father is having her masquerade as more of a child than her height confirms her to be. For Carroll, pretending to be smaller is tantamount to possessing reduced authenticity. Height marks the physiological and psycho-sexual development of the child and occupies the place of visual differentiation that occurs with puberty, but which cannot be articulated as such. At the same time, as we shall find, the concept of consent operates for Carroll in a psychic economy reliant upon a reduction of the figure of woman to that of little girl.[7]

'Return to Sender'

Carroll corresponded with Lord Salisbury, during 1885, about the well-known exposé in the *Pall Mall Gazette* of organised child prostitution and vice by the editor Thomas Stead (1849–1912). His two letters to the Prime Minister on the subject of Stead's revelations to this magazine in the articles entitled 'The Maiden Tribute of Modern Babylon', position historically and culturally Carroll's photographs of children within the sphere of larger issues of children's rights during the period. These letters of 7 July 1885 and 31 August 1885 testify to the fact that it is not viable for critics to read Carroll's photographic activities as in some way divorced from the whole issue of the definition of childhood that was under debate and manifesting itself in various new legal and social structures. For, as I have said, Carroll's photographs of children inevitably engage questions of children's rights as they centre upon the huge and highly topical issue of consent and, moreover, Carroll regarded his literary and photographic practices within a context which included the various movements engaged in agitation for reform. But the question becomes one of precisely how to read this relationship of photographic practice to contemporary definitions of childhood.

The public outcry generated by Stead's articles of 6, 7, 8, and 10 July 1885 appears to have provoked Lord Salisbury's short-lived Conservative government to address seriously in the House of Commons the Criminal Law Amendment Bill, and to restore to public attention the issue of child prostitution which had been obscured by agitation over the Contagious Diseases Acts. The Bill, known as 'Stead's Act' was passed in 1885 and raised the age of consent from thirteen to sixteen for girls. Prior to the Act of 1885, the Offences Against the Person Act of 1861 had deemed it a felony for a man to have sexual intercourse with a child under ten and a misdemeanour if the child were between ten and twelve years of age. The age of twelve in the 1861 Act went back to legislation of the thirteenth century.[8] During the 1870s, however, the Social Purity Movement worked to legislate for a higher age of consent, resulting in 1875 in its raising the age to thirteen. But the Act of 1885 did not represent a consensus; people campaigning for the protection of female children held divergent points of view about the age of consent. And as Deborah Gorham points out, 'Some people in the Social Purity Movement were pressing for an age as high as twenty-one, while many of their opponents still believed that the traditional age of twelve was more suitable.'[9]

Significantly, Carroll's two letters to Lord Salisbury do not directly address either questions of reform or state regulation of prostitution. Instead, Carroll directs his protest

against the sensationalist rhetoric of Stead's articles; his concern is with legislating against the types of material which documented the exposure of prostitution. But he was not the only one to be so worried. As Gorham writes, 'By providing a set of vivid images that caught the public imagination, [Stead] generated a sense of outrage with which a wide spectrum of public opinion found itself in sympathy. In the summer of 1885, Anglican bishops and socialists found themselves working together to protest against the sexual abuse of children.'[10] At the forefront of Carroll's letters to the Prime Minister is his concern that 'the publication, in a daily paper sure to be seen by thousands of boys and young men, of the most loathsome details of prostitution' was likely to increase the problem by informing, and thus inciting to action, those who had previously been unaware of such 'vice'.[11] Carroll's position is clearly on the side of censoring the medium that had led to its exposure. In the second letter he writes: 'It was not the *Pall Mall* that I meant to suggest as a subject for prosecution: it is too late to think of that *now*: but surely the *other* similar publications, which are now flooding the streets, might be checked without any risk of increasing *their* popularity.'[12]

In writing this letter, Carroll implies an unquestioning belief in a direct causal relation between a written account of prostitution and its perpetuation, advocating a straightforward call for censorship as a primary form of protection. But protection for whom? For at the same time that he protests against Stead's exposé, Carroll chooses to situate himself, and by implication his child friendships, within this public debate. In one sense, then, his letters to Lord Salisbury simply confirm other instances in which Carroll shows a marked social awareness of the potential significations of his own interest in female minors. Indeed, Carroll frequently had recourse to the caricatured figure of 'Mrs Grundy', and that recourse suggests, as it off-sets, his repeated evaluation of 'laws' of public decency, together with the invention of new ways to transgress them, while never failing to communicate the fact that in his case there is no 'real' transgression since he regards the child's consent as paramount. In another sense, these letters clearly indicate an anxiety about the ways in which his relations with little girls might be construed at an historical moment when the realities of child abuse were being vividly exposed in the popular press. But this anxiety simultaneously works as a cover for his visual investment in little girls. Indeed, Carroll's interpretation of consent, in relation to the agency of the child, precisely involves the desired construction of the little girl as a diminished consenting subject, accompanied by a desire not to recognise the existence of consent in legal and social structures.

Carroll thus constructs an elaborate epistolary framework in which letters and diaries function in some ways as an exercise in the symbolic logic of consent, the meanings of which are changed when read in relation to the cultural debates around the Criminal Law Amendment Act of 1885.[13] As Carroll is regularly obliged to negotiate the parameters of his child friendships within the context of contemporary constructions of childhood, the letter (he wrote multiples of thousands of them) becomes the main medium by which he juggles the significance of his interest in little girls; friendship is the dominant trope of the narratives of his desire. In much of his correspondence with parents, Carroll is then in an impossible position of (innocent) transgressor (legally and culturally so to speak), and constantly faced with having to account for the peculiarity of that position. This fact explains, to some extent, the frequently authoritative rhetoric of Carroll's letters to parents asking to 'borrow' their children for photography. This is particularly so in the cases of nude studies, where the caution employed to ensure an

absence of 'unhealthy' interest exacerbates the sense of a linguistic cover-up. Social and cultural constraints mean that he has to construct his child friendships as different from illegitimate relationships. But because there is no respectable historical precedent in Victorian culture for Carroll's interest in little girls, the question of how to represent the specificity of his desire and its manifestations becomes an insurmountable task that generates more and more purple-inked prose. In any case, he has to speak about the current state of child abuse against which to measure the respectability he posits for himself; to acknowledge child abuse as a real threat while simultaneously proving that his case requires no parental vigilance.

A transference of his sense of transgression of propriety to an unhealthy suspicion on the part of a child's parents typifies Carroll's epistolary use of consent. This process is evidently the cause of his breaking off relations with Mr and Mrs Anthony Lawson Mayhew in 1879 over the issue of consent to nude photographs.[14] In a first letter on this subject to Mrs Mayhew, 26 May 1879, Carroll goes to great lengths to detail desired photographic poses for her three daughters Ruth, Ethel and Janet, whose respective ages are thirteen, twelve and six: 'I should like to know *exactly* what is the minimum of dress I may take [Janet] in, and I will strictly observe the limits'.[15] In a second letter on the subject, written the next day to Mr Mayhew, Carroll writes:

> As to the photography, I am heartily obliged to Mrs Mayhew for her kind note. It gives more than I had ventured to hope for, and does not extinguish the hope that I may yet get *all* I asked […] If Ruth and Ethel bring Janet, there is really no need for [Mrs Mayhew] to come as well – that is, *if* you can trust me to keep my promise of abiding strictly by the limits laid down. If you *can't* trust my word, then please never bring or send any of the children again![16]

These preferences are followed by a highly detailed elaboration of prospective poses of the children (back and frontal views), and Carroll's subsequent letter to Mrs Mayhew, May 1879, which outlines his regret at the previous one, indicates the offence she had taken to it:

> After my last had gone, I wished to recall it, and take out the sentence in which I had quite gratuitously suggested the possibility that you *might* be unwilling to trust me to photograph the children by themselves in undress. And now I am more than ever sorry I wrote it, as it has accidentally led to your telling me what I would gladly have remained ignorant of […] I should have no pleasure in doing any such pictures, now that I know I am ~~not thought fit for~~ only permitted such a privilege ~~except~~ on condition of being under chaperonage.[17]

The question of chaperonage is, not surprisingly, a difficult one for Carroll to get around without in some way offending or distancing parents. For Mrs Mayhew to insist upon a chaperone is, Carroll writes, to mistrust his 'word' that he will abide by 'the limits [she] has laid down'. By these means, Carroll constructs the request for a chaperone as an unreasonable demand when in fact it is Mrs Mayhew who is merely abiding by convention and he the one asking for a concession to transgress an established social code. Carroll's response to her reply to his first letter on this issue, 'it gives more than I had ventured to hope for, and does not extinguish to hope that I may yet get *all* I asked', seems for a logician more than calculated illogic; the note gives 'more' than Carroll 'had ventured to hope for' but does not preclude the fact that he 'may yet get *all* he asked'.

Thus, Carroll asks for more than he hopes for. Semantically, Carroll's use of the word 'hope', its shift from noun to verb, demonstrates the fact that in order to attempt to gain his desire, he has actively to situate the unnameable desire/hope into the commerce between himself and the parents; Carroll has to verbalise it (both speak it and make it into a verb), and 'more than I had ventured to hope for' becomes '*the hope* that I may yet get all I asked'.

The method of bargaining whereby Carroll plays the parents and successively plays the children against the parents shows to what extent he transgresses contemporary standards of decorum while transferring culpability to the parents. Carroll's strategy necessitates his placing the parents in a position of determining moral standards. He performs a subtle transference of transgression by which agency is delegated to the parents. The method of the letters, therefore, is to make the parents themselves initially define the quality of 'innocence' which, reciprocally, sets the limit of transgression; once the onus is on the parents it becomes difficult for them to raise subsequent qualms.

The crucial point, however, is that such a strategy requires Carroll to allude to sexual transgression through discourse in this way. Not in order 'to conceal sex: a screen discourse' as Foucault has written, but to expose it.[18] Carroll's masked allusions to sex are not attempts to gloss over the issue of sex but ruses to mask the fact that sex – at least as the parents might suspect it – is *not* the point. For Carroll's self-conscious references to the logistics of consent operate in one sense as a cover for his obsession with height; his compulsive interest in smallness as played out in costume fantasy works as a means of disavowing symbolic castration. But so great is the need for this disavowal that he is led to use a ruse of consent that is in some ways more transgressive than the act of photographing female minors that he hopes to perform by using it. However, aware of the risk he takes in constructing this discourse on transgressive sexuality to hide a different transgression, Carroll works continually to prevent the one from being extricable from the other.

Sartor Resartus

Writing to one of his favourite 'child friends' Gertrude Chataway, 2 January 1876, Carroll explains: 'I want to do some better photographs of you … And mind you don't grow a bit older, for I shall want to take you in the same dress again: if anything you'd better grow a *little* younger – go back to your last birthday but one.'[19] Here, a desire for 'the same dress' determines Carroll's characteristic request for a reversal of growth. In another letter of the same year (1 October 1876) written from his annual summer haunt of this period, the Isle of Wight, Carroll similarly requests Gertrude Chataway's help in dressmaking matters, this time pattern-cutting, for he wants to replicate the style of her bathing costume for other girls to wear:

> I have been buying, for photographing children at Oxford, two of those blue jerseys, like what you used to wear, the smallest two sizes, and I'm not sure if I shall want a larger size or not: so I want you to measure yours, and send me the length and width, both of the jersey and the bathing drawers, when they are simply spread out flat, without any stretching. I have lent my two to two little girls here, one 10 years old and one 6, and they look very nice in them.[20]

Such meticulous attention to details of costume is followed, in the same month, by an

invitation to the child to go to Oxford to be photographed in the aforementioned garb: 'You had better bring the blue jersey and the bathing drawers with you. I shall want to take 8 pictures of you, so I send you 8 kisses.'[21]

The effect of these references to dress is in no way to exaggerate the way in which masquerade determines the nature of Carroll's photographic practices.[22] The catwalks of his photographic imagination display a spectacular ethnic sartorial mix: Chinese, Indian and Greek (costumes/models) rub shoulders with Turk, 'native' New Zealander and Dane, together with nationally displaced or indeterminate 'veils', 'rags' and 'primitive' costume. As Beatrice Hatch recalls: 'He kept various costumes and "properties" with which to dress us up ... What child would not thoroughly enjoy personating a Japanese or a beggar child, or a gypsy or an Indian.'[23]

In masquerading little girls before the camera, it is as if Carroll sees himself as offering to a child a place in a sartorial democracy, through a ritualised stripping away of contemporary fashion, a liberation that is equally achieved by encouraging – in the case of Gertrude Chataway, for example – her mother's sanctioning of the girl's wearing 'bathing pants and a fisherman's jersey' on the beach, 'a thing quite unheard of in those days'.[24] By 'freeing' little girls, in social situations, from strictures of propriety, he allows them to personate consenting adults. In the case of another 'child friend' Adelaide Paine, 'gloves' are recalled as the article of clothing about which Carroll offers advice to the parents. They are recommended 'not to make little girls wear gloves at the seaside; they took the advice, and I enjoyed the result'.[25] Such detail is further substantiated by Adelaide Paine's memory (documented originally by Collingwood) of the supply of safety pins that Carroll habitually carried at the seaside to prevent wading girls from spoiling their frocks.

According to the reminiscences of his 'child friends', Carroll apparently always made it plain that children should not be persuaded to do anything that they did not wish to do. Thus, by effectively granting consent to children of all ages (taking all children at their word, giving them the right to decide what they will assent to in terms of photographic poses and costumes), he paradoxically negates the legal status of the term. While such licence might be regarded as a radical liberation of the child subject, and clearly in one sense Carroll rationalised it in this way, it is difficult to separate his attribution of consent to a child of five from that which Carroll clearly wants to gain from it for himself. This is especially the case as he downplays the legal significance of consent, whilst, as we have seen, overdetermining the relevance to the concept of the statistic of height.

At the same time, the links between Carroll's sartorial persona and issues of theatricality and role-playing have crucial connotations for his larger constructions of the realms of fantasy and reality in visual culture – that bipolarity upon which so much of his work hinges. Role-playing, it is important to note, is what Carroll seeks both in the fantasy 'set-ups' of his 'costume' photographs and in his interaction in contemporary social contexts as dramatised by his repeatedly voiced dislike of contemporary styles in children's clothing. Indeed, it has become something of a well-known maxim that Carroll could not 'bear' an unnatural child in real life. However, somewhat paradoxically, the elaborate cultural personae of his costume photographs are conceived by Carroll as proximate to the 'natural' child (as encoded in tousled hair and bare feet, for example), itself a fantasy of the child as exempt from the 'civilising' and regular sartorial characteristics of Victorian culture. That is to say, fantasies of other nationalities share a

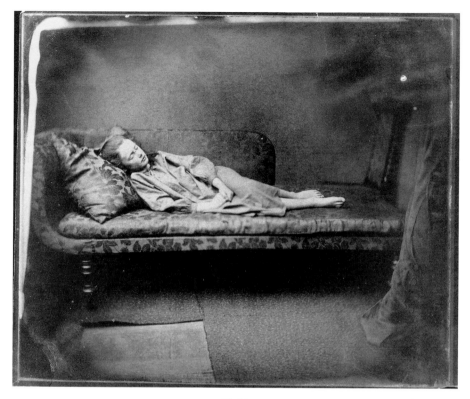

Fig 28
Lewis Carroll (C.L. Dodgson), *Gertrude Chataway Lying on a Sofa* (1870s)

territory of 'naturalness' with photographs of upper-class English girls barefoot in nightdresses. For Carroll forges an equivalence between the unadorned nude (or, as he so tellingly calls it by means of a transference of agency, the child's 'favourite state of nothing on'), or between the child in simple nightgown, and the elaborately clothed and posed subject who is always enacting a fantasy of cultural and/or ethnic difference.

If we compare, for example, two photographic portraits of Gertrude Chataway and Irene MacDonald, we can see how Carroll formulates this equation. The portrait of *Gertrude Chataway Lying on a Sofa* (figure 28) from the 1870s combines the familiar makeshift qualities of Carroll's studio with a centrally placed couch. Taken from an elevated position, the photograph registers a distinctive literal point of view and is quite different, for example, from a photograph of 'child friend' *Xie Kitchin Lying on a Sofa* (figure 12), where the subject appears centred through cropping. The former represents a little girl reclining in a specific but incongruous context, the opulently embossed fabric of sofa and cushions contrasting dramatically with the tatty sections of carpet in the foreground. The figure of the child appears highly lit, deathly pale, eyes tightly closed, hands tensely clasped in front of her, long white feet stretched out, ankle and lower calf exposed. She wears a long-sleeved, high-necked nightgown of a neutral tone rather than white. The figure is stiffly posed, feigning sleep in what seems a vast expanse of interior space. The surrounding blurs and faults give the impression that one is viewing it through an aperture or a partially opaque medium.

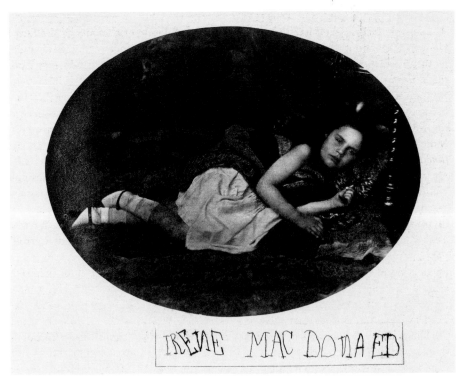

Fig 29
Lewis Carroll (C.L. Dodgson), *Irene MacDonald, Autographed* (July 1863)

Irene MacDonald, Autographed (July 1863) (figure 29), fixes the child in recumbent pose among highly patterned shawls and variously textured animal skins. The rather 'adult' pose is offered alongside the 'authentic' child-writing of the autograph in which the letter 'n' is transposed and the letter 'l' has been substituted by an 'e'. The narrower depth of field in this photograph is exaggerated by the cropped oval formal of the print and the overall effect of the drapery is one of exoticism. What looks to be a tiger or leopard skin lies in the foreground, while the girl's head rests on the base of a table covered by a fur. 'India shawls' are draped over the upper part of her body and, crucially, the composition articulates a contrast between the white skin of bare arms, shoulder and lower legs above the socks, together with brightly lit face, and the clothed areas in between: the nightdress hitched up to reveal crossed legs, ankle-strap shoes alongside oriental signifiers of adornment. The girl looks out, clasping a tuft of fur in the palm of her left hand. In one sense, she assumes the look of an English child who has nestled beneath unfamiliar Oriental drapery, but the image is highly staged, the figure personating a classic recumbent pose of the female nude. What we have is a fantasy of the English child as semi-Eastern, as taking on some but *not all* of the sartorial markers of that other culture. This point is crucial because, in this reduced format, the Oriental does not pose the type of threat that it would in its full form; there are sufficient markers of English childhood in this photograph for us never to lose sight of the fact that the figure is dressed for staged spectacle, that a child masquerades as a reduced form of the Oriental.

Such reduced size is vital, then, to Carroll's formulation of a fantasy of childhood. Herman Rapaport, in 'The Disarticulated Image: Gazing in Wonderland,' has identified in the Alice books and in Carroll's photographs of little girls a dependency upon miniaturisation as representing 'inhibition' in a Freudian sense.[26] In 'Inhibitions, Symptoms and Anxiety' (1926), Freud explains the way in which an activity when it becomes too eroticised is 'subjected to neurotic inhibitions'. That is to say that 'the ego-function of an organ is impaired if its erotogeneity – its sexual significance is increased'.[27] Moreover, Freud defines 'inhibition' as 'the expression of a *restriction* of an *ego function*'.[28] A desire to miniaturise or to infantilise, features in Freud in cases of failed repression in which the instinctual impulse has found a substitute. But it is 'a substitute which is very much reduced, displaced and inhibited and which is no longer recognisable as a satisfaction […] When the substitutive impulse is carried out there is no sensation of pleasure; its carrying out has, instead, the quality of a compulsion.'[29] With an inhibition describing a restriction or lowering of a function, Rapaport reads Carroll's photograph entitled *The Elopement*, which shows Alice Jane Donkin perched upon a upper window ledge, about to descent a ladder (and to which we referred in chapter 2) as an affirmative statement of desire on the part of the photographer, such as 'I want to be with you' that is 'immediately refused or negated by the figure's size and age'. Furthermore, he contends that what occurs in this process is that the distance that articulates desire 'is repeated again by the "inhibition" of the "figure", the reduction of the woman into a little girl'.[30] The disarticulated image of Rapaport's title thus derives from the photographer's simultaneous assertion and denial of the distance between himself and his model.

Although Rapaport does not extend his analysis to Carroll's wider interest in reduced physical proportions, his approach provides a framework which we may apply to a reading of the intervolvement of the psychic and the social in Carroll's photographing of children. A psychic investment in the miniature or 'inhibited' figure of the little girl (as identified by Rapaport) finds its crucial decoy, as we have seen, in the anxieties Carroll expresses around the social determinants of 'the age of consent'. The tiny model ensures a negation of a real sexual union, whilst at the same time staging its possibility. Furthermore, the staged possibility is, we could say, repeatedly upstaged.

In the case of Gertrude Chataway, miniaturisation is achieved by the physical dwarfing of the figure to the surroundings, as somehow incongruous, vulnerable, 'wedged' (to use Carroll's term) into the sofa.[31] In the case of Irene MacDonald, however, the child is transformed into an object of fantasy on the one hand – as viable object of sexual desire – while reciprocally this status is undermined by the signifiers of her size: shoes and socks which, like the bare feet of Gertrude Chataway, remind us that this is a reduced version of an authentic subject. The general subordination of the Oriental is exacerbated in the Other as female child, and correspondingly the Eastern girl can serve more satisfactorily the purposes of disavowal that he seeks. The miniaturisation of the Oriental becomes for Carroll doubly representative of the impossibility of reciprocity with a minor, for the child in Oriental masquerade serves as one with whom it would be culturally impossible to have a sexual relationship.[32] In this sense, the dressing up of little girls to simulate cultural difference constitutes for Carroll the furthest removal from the possibility of reciprocity with a woman.

Carroll's obsession with the fact that little girls grow 'bigger' is not only signified in his photographic preoccupation with the miniature. It is recorded also in the fact that he

charted their growth in mathematical calibrations on the door of his rooms at Christ Church, and in the fact that references to height occur repeatedly in letters to 'child friends' and to their parents. On 17 April 1868, for instance, he writes to Agnes Argles, 'Some children have a most disagreeable way of getting grown-up: I hope you won't do anything of that sort before we meet again.'[33] And in a letter to F.H. Atkinson, written twenty-two years later, 10 April 1890, Carroll remarks '*What* a tall daughter you've got! But I can see the child-face still, on the top of that mountainous maiden!'[34] Particularly noticeable here is the feeling of surprise, as if an increase in height swiftly undermines the matrices of his conception of childhood. At the same time, there is present a drive to find the child subject still, as identifiable in the 'child-face' of the 'maiden', to find her in spite of increased physical proportions. To preserve the little girl, as miniature, prior to puberty is to preserve her prior to the age of consent, as pre-sexual, and reciprocally as sexual. The photographic medium therefore operates to fix childhood in the manner of autographs and letters of child friends in which jokes about expanding maidens invoke variations upon the expanding/shrinking Alice of the books.[35]

'Off With Her Head!'

Carroll's desire to fix height by means of his impersonation of a sartor finds a further manifestation in his interest in tailors' mannequins as potential subjects for photography. Since not any old mannequins will do for his photographic purposes, a lack of available child-size ones – 'they are all adult proportions' – puts a stop to one of his schemes in 1872 to buy a mannequin 4ft 3in high with the measurements of the eight-year-old Julia Arnold so that he might dress it in 'a suit of [her] clothes', and then 'take a picture of it so dressed'.[36] In a letter to Mary Arnold, Julia's sister (later Mrs Humphrey Ward), Carroll, in explaining his plan to 'get an exact duplicate of Julia in papier-mâché', speculates upon the number of people that such a 'duplicate' would 'take in'.[37] His explanation makes it seem as if the photographic process suggests for Carroll new possibilities in deception, in duping the viewer, as defined by masquerade. For he envisages the photograph operating as a sort of theatrical trick, a classic *trômpe-l'œil* staging, the credibility of which might be crafted by meticulous attention to details of pose and costume. 'Of course,' writes Carroll, 'the face must be turned away, and there would be a slight deficiency of hair! But nothing to signify.'[38] If averted face and a lack of hair do not signify in such an instance, then we are left with the question of what would be of consequence?

The mannequin idea would obviously liberate the photographer from the restrictions of photographing live child models, problems of movement during exposures. If, on the other hand, there would be nothing to distinguish a mannequin with averted face from an 'authentic' child, then it suggests that, in some ways, the face is not, for Carroll, the most engaging part of the child model. He desires instead to retain the clothed body in a static form of miniaturisation. Thus, we are back to couture as suggested by the assimilation of tailor's dummy and live model: Julia Arnold and her clothes transformed into 'Miss Julia Arnold duplicate'.[39]

The implications of what became an abortive plan are significant, since they focus upon height, within the larger context of Carroll's elaborate schemes for posing and photographing little girls. Clearly, the plan somewhat dispels the predominant notion that a large part of Carroll's fascination with girls involved the befriending of the

Fig 30
Lewis Carroll, *C.L. Dodgson to Xie Kitchin* (15 February 1880), pen and ink

individual with the photographic session forming a mere adjunct to a friendship. For the mannequin preserves only the height, proportions and clothing of the original model; it salvages precisely those details with which we have been led to believe that Carroll was least concerned. We might then perhaps be surprised to find that where we expected individual character traits we are left instead with a set of 'vital' statistics.

Of those statistics preserved by the mannequin, 'height' is most pressing for Carroll: the one which, or course, the mannequin idea could uniquely solve because it could arrest a child subject at what he considered the optimum height for photography. Both photograph and mannequin therefore function as memorials to a past fantasy. They work as displacements to dupe Carroll himself, for the photographed mannequin (in the permanent and doubly fixed form of a photographed duplicate) offers a means of avowing and denying sexuality in the miniature. We can further understand the function of the little girl as miniature, however, if we consider yet another way in which height operates in Carroll's economy of vital statistics. A reference to proportion in a letter to Alexandra Kitchin brings together the psychic investment in height with particularities of the photographic medium itself and the capacity of photography to impress a unique sense of physical proportion. In this case, the 'off with her head'/castration theme from *Alice* is refigured in relation to photography in a sketch by Carroll (figure 30). This sketch depicts Xie Kitchin as a half-decapitated subject of a carte-de-visite photograph, accompanied by the statement: '*Please* don't grow any taller, if you can help it, till I've had time to photograph you again. Cartes like this (it always happens if people get too tall) never look really nice as a general rule.'[40] On the one hand, Carroll here reiterates a common joke about how the photograph cuts off important bits of a person, but the idea that she will be too big for the frame, that her physical proportions will exceed the limits of the vertical format of the carte, resulting in partial decapitation, would seem to bear out the point that to photograph little girls is a primary method of disavowal. For Carroll's fantasy of the truncated image raises a crucial question of the significance of

that which lies outside the frame and graphically situates the photograph as a means of disavowing castration.

Christian Metz has compared the off-frame in photography and in film and has concluded that it is much more subtle in the former than in the latter. This conclusion arises from the fact that in photography 'the spectator has no empirical knowledge of the contents of the off-frame, but at the same time cannot help imagining some off-frame.'[41] Moreover, he continues: 'The off-frame effect in photography results from a singular and definitive cutting off which figures castration and is figured by the "click" of the shutter.'[42] Metz, however, is theorising that which lies completely outside the frame; Carroll is conversely drawing attention to the crude cropping potential of the photographic medium. But if, as Metz writes, 'the off-frame effect in photography results from a singular and definitive cutting off which figures castration', then Carroll's fantasy about a semi-decapitated Xie represents his anxiety about making the relationship of that which lies outside the frame of the photograph to castration all too evident. Carroll jokingly displaces his fear to a cartoon fantasy of a failed carte-de-visite, failed because half of the head is missing and the format is that of a portrait.

Another important component of the fantasy here is, however, that of size, that a person or thing can become *too* large to be accommodated within the border of the photograph. This is, of course, an impossibility, but it articulates a persistent anxiety that Carroll's photographs work to displace by way of their predominantly wide depth of field and clarity of focus. Thus, anxiety is clearly centred here upon the miniature again. For in projecting Xie's increased size in this way, Carroll forms an equivalence between the proportions of the little girl and the photographic medium. To be too old is to be too big. To be too big is not to be able to function as miniature or inhibition. It is to suggest that which lies outside the frame, thereby making the relationship of the off-frame to castration all too evident.

To be too big is also, however, to be too old, a fact borne out by incidents in Carroll's letters in which he radically underestimates a little girl's age, or literally refuses to believe her height until he *sees* it.[43] The equivalence forged here, in the Xie sketch, brings us back to the importance to Carroll of a simultaneous assertion and denial of reciprocity in his relation to child subjects, that which Rapaport identifies as 'the wish to be recognised by the child as a lover [while] at the same time the demand for such recognition must be dissimulated'.[44] This movement replicates the duality of the photograph's function in relation to the fetish, with its combination of fear and desire, its meaning both of 'loss (symbolic castration) and protection against loss'.[45] For the photograph of the little girl constitutes a double miniature in that it represents a reduced woman and may serve as a keepsake or fetish.

The staging of a desire for reciprocity with a girl below the age of consent therefore operates in Carroll's narratives as a cover for a different compulsion. Like a complex acrostic his voicing of concern over the issue of consent in photographic practices functions as a false allure to deflect attention from his visual compulsion. But because the cover he weaves around questions of consent is potentially so dangerous in itself, it has to produce, as a screen, its own narratives to counteract the problematics it generates. Thus, Carroll toys with a persona (the bachelor with an interest in little girls) the inappropriateness of which, under the circumstances, testifies to just what is at stake in the ruse. Carroll repeatedly voices the affronts he feels, proclaiming the suggestions by parents of 'child friends' that he cannot be trusted. For this he complicates and abandons

several friendships. But such affronts are his own necessary constructions, and they become determinants of his visual fantasies, transgressive covers, we might say, for the fact that he knows he *can* be trusted. For Carroll does not want – as so many critics have suggested – sexual reciprocity with the child. What he does want is the freedom to perform his visual compulsion, through a repeated photographic fixing of the minor; to perform it, that is, in the knowledge that the representation of his desire, in the little girl personating consenting subject (and its dependence upon the medium of photography), is rendered invisible, its visual register readily absorbed by the social and legal discourses on childhood of his day.

Notes

1 Several critics reiterate the claim that there has been excessive interest in Carroll's sexuality, when in fact there have been few attempts to discuss the politics of sexuality in relation to the politics of the medium of photography. Those critics who bemoan a surfeit of interest in sexuality in Carroll studies in order to exempt the author from any 'deviant' tendencies merely enter the fantasy of repetition which characterises Carroll's photographs, letters and diary entries. We find a persistent construction of Carroll as unwilling bachelor. See, for example, Helmut Gernsheim's preface to the revised edition of *Lewis Carroll, Photographer* (New York: Dover, 1969), and Morten N. Cohen (Edward Guiliano, *Lewis Carroll in a Changing World: An Interview with Morten N. Cohen*). Cohen attempts to preserve a normative heterosexuality for Carroll, by shifting his role from that of sexually problematic 'bachelor' to the more comfortable position of unrequited lover. Critics who refute so-called 'Freudian readings' of Carroll produce a psycho-biographical approach, paraded as other than such, in which the preservation of the myth of the transcendence of the nuclear family is inextricable from a notion of Carroll's transcendent appeal.

2 For photography he uses his 'real' name rather than his pseudonym. See, for example, letter to Mary E. Manners, 7 February 1895, *The Letters of Lewis Carroll*, ed. Morten N. Cohen, 2 vols, II (London: Macmillan, 1979), p. 1051, and letters to Catherine Laing, 30 November 1880, *Letters* I, p. 395, 14 June 1881, p. 433, and letter to Coventry Patmore, 6 March 1890, *Letters* II, p. 779. Hereafter cited as *Letters* followed by volume number and page reference.

3 Marcuse Pfeifer, 'Thank Heaven for Little Girls', *Book Forum*, 1979, pp. 504–8.

4 *Ibid.* p. 507.

5 *The Diaries of Lewis Carroll*, ed. Roger Lancelyn Green, 2 vols, II (New York: Oxford University Press, 1954), p. 387.

6 *Letters* II, pp. 918–19.

7 On the issue of determining an 'ideal' age of consent in arguments around age-of-consent legislation during the 1880s see Deborah Gorham, 'The "Maiden Tribute of Modern Babylon" Re-examined: Child Prostitution and the Idea of Childhood in Late Victorian England', *Victorian Studies*, 21 (Spring 1978), p. 369. See also Michael Pearson, *The Age of Consent* (London: David and Charles, 1972).

8 See also Deborah Gorham, *The Victorian Girl and the Feminine Ideal* (Bloomington: Indiana University Press, 1982); Charles Terrot, *The Maiden Tribute: A Study of the White Slave Traffic of the Nineteenth Century* (London: Frederick Muller, 1959).

9 Gorham, 'The "Maiden Tribute of Modern Babylon" Re-examined', p. 364.

10 *Ibid.* p. 354.

11 *Letters* I, pp. 586–7.

12 *Letters* I, pp. 599–600.

13 We should, therefore, question how the status of Carroll's concern (with regard to nude portraits) about the age at which a child should no longer be asked to undress is redefined after 1885 with the change in the age of consent. By definition, it is likely that Carroll was in favour of raising the age; to raise it would mean an increase in girls below the age, an increase in miniaturisation so to speak.

14 Carroll's acquaintance with the Mayhews began in November 1878. The four daughters with whom he became increasingly friendly were: Mary Ruth (1866–1939), Ethel Innes (1867–1919), Janet, who died in 1891, and Margaret Dorothea (1883–1971).

15 *Letters* I, pp. 237–8.

16 *Ibid.* pp. 339–40.

17 *Ibid.* p. 341. Carroll's own deletion.

18 Michel Foucault, *The History of Sexuality Vol I: An Introduction*, trans. (Robert Hurley, New York: Vintage Books, 1978; reprinted 1980), p. 53.

19 *Letters* I, p. 238.

20 *Ibid.* p. 258.

21 *Ibid.* p. 259.

22 Carroll criticism repeatedly side-steps the persistence of costume fantasies to the extent, as we found in chapter 1, that influential photographic historians and collectors like Helmut Gernsheim distinguish Carroll's 'costume pieces' as 'banal' and separate from his more 'serious' and, we are urged to accept, more representative child portraits. Such a separation denies that odd continuum of visual cultural fantasies that hinge upon a particular paradigm of consent, represented especially for Carroll in the intersection of photography with the garb of child actors (especially from pantomime) as a legitimate context for exotic *tableaux vivants*.

23 Reminiscence of Beatrice Hatch from the *Strand Magazine*, London, April 1898, xv, pp. 212–23, quoted by Isa Bowman, *Lewis Carroll as I Knew Him* (New York: Dover, 1972), pp. 16–17.

24 Reminiscence of Gertrude Chataway, *Lewis Carroll, Interviews and Recollections*, ed. Morten N. Cohen (Iowa City: University of Iowa Press, 1989), pp. 138–9.

25 Quoted by Stuart Dodgson Collingwood, *The Life and Letters of Lewis Carroll* (New York: The Century Co., 1898), p. 373.

26 Herman Rapaport, 'The Disarticulated Image: Gazing in Wonderland', *Enclitic*, 6:2 (Fall 1982), pp. 57–77.

27 Sigmund Freud, 'Inhibitions, Symptoms and Anxiety', in *Standard Edition*, vol. 20 (London: Hogarth Press, 1974), p. 89.

28 *Ibid.*

29 *Ibid.* p. 85.

30 Rapaport, 'The Disarticulated Image', pp. 66–7.

31 Letter to E. Gertrude Thomson, artist, 2 October 1892: 'P.S. You don't seem to know how to *fix* a restless child, for photography. I wedge her into the *corner* or a room, if standing; or into the angle of a sofa if lying down.'

32 See chapter 6 for a related discussion of the photographic staging of Orientalism.

33 *Letters* I, p. 117.

34 *Letters* II, p. 785.

35 See Nancy Armstrong, 'The Occidental Alice', *Differences: A Journal of Feminist Cultural Studies*, 2.2 (1990), pp. 3–40; in particular her discussion of appetite and consumption in the Alice books: 'For even though [Alice's] size increases at the story's end, she retains the prepubescent shape distinguishing her from the other women in that story' (p. 18).

36 *Letters*, I, p. 174.

37 *Ibid.*

38 *Ibid.*

39 *Ibid.*

40 *Letters* I, p. 370.

41 Christian Metz, 'Photography and Fetish', originally published in *October*, 34 (Fall 1985), reprinted in *The Critical Image*, ed. Carol Squiers (Seattle: Bay Press), 1990, pp. 155–64, p. 161.

42 *Ibid.*

43 See, for example, *Diaries*, II, p. 385: 'Brought in "Atty" Owen […] to wait in my rooms until Owen was at leisure. She does not look fourteen yet, and when, having kissed her at parting, I learned (from Owen) that she is seventeen, I was astonished.'

44 Rapaport, 'The Disarticulated Image', p. 66.

45 Metz, 'Photography and Fetish', p. 158.

6

The shoe-black to the crossing sweeper: Victorian street Arabs and photography

Cartoons and photographic stereograms of the 1850s and 1860s share a popular joke: the invitation by the shoe-black to the bare-foot crossing sweeper to stop for a shoe-shine. ('Now, Young' un! Just give my wellingtons a good polish, cos I likes to go to business respectable in the morning!' is the line of a *Punch* cartoon of 22 August, 1855.) The joke between shoe-black and crossing sweeper over pedal extremities helps us to re-conceptualise a conjunction of discourses of childhood, photography and colonialism in the period. This common scenario of *Insult Added to Injury* (as one photographic image entitles it, figure 31) draws upon a display of ragged street Arabs which acquires a singular resonance as relatively new discourses of photography intersect with those of colonialism. It is not of course a unique example of such an intersection for, as demonstrated in the last chapter on Lewis Carroll's photographic practices, photography is clearly used to promote specific accounts of childhood inseparable from contemporary debates upon ethnicity. Those accounts, in which discourses of race and class are played out on the homespun scale of the East End of London, rehearse and modify other versions of colonial encounter in the period, and it is in this context that I want first to explore the uses of the child as a reduced form of the ethnic other. However, since the joke between children here (shoe-black and crossing sweeper) as photographically exposed becomes, as we shall find, a joke at their expense in narratives which hinge precisely upon credulous children viewing photographs of child subjects, I want also to question what positioning of the child as viewer occurs when the child is presented as photographic subject, when the child is presented, as it were, on both sides of the camera? What construction of the child as viewer is being set-up when the child is depicted photographically as simulating 'racial' difference, and by what means does the dirt-blackened child become identifiable first and foremost as a street Arab?

The by no means inconsequential coinage of the term 'street Arab' in Thomas Guthrie's 'First Plea for Ragged Schools', first published in pamphlet form in Edinburgh in 1847, makes the correlation between the child and a bestial other, between city and desert: 'These Arabs of the city are wild as those of the desert, and must be broken into

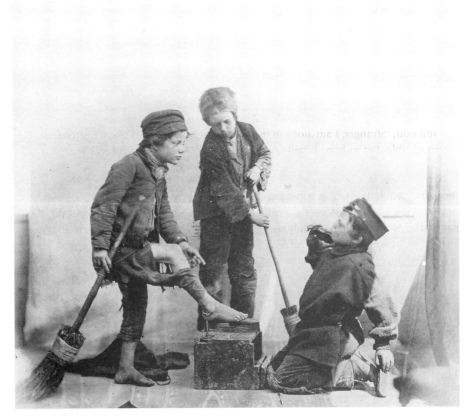

Fig 31
Oscar Gustav Rejlander, *Insult Added to Injury* (1866–68)

three habits, – those of discipline, learning, and industry, not to speak of cleanliness. To accomplish this ... hard words and harder blows are thrown away here. With these, alas! they are too familiar at home, and have learned to be as indifferent to them as the smith's dog to the shower of sparks.'[1] Guthrie's use of the term 'Arab' to refer to the street children of Edinburgh forms part of a larger account of the contagion of the city in which degeneration is attributed the propensity of yeast: 'Around the [infected] you can draw no *Cordon Sanitaire*. The leaven is every day leavening more and more of the lump.'[2]

Founded in 1835 the Ragged School system had expanded by 1861 to one hundred and seventy-six schools throughout England with an average daily attendance of 25,000 pupils. In his 'Second Plea' for the schools published in 1849, two years after the first, Guthrie uses the occasion of a missionary's encounter with an orphaned African boy to parallel the plight of orphans of the East End, the difference being for Guthrie that 'the solitude of a crowd [as experienced in the city] is more painful than the condition of 'savage freedom':

> During the noontide heat of an African sun, the missionary sat with his family
> in the shadow of their wagon ... The sun glowed from a cloudless sky on
> the scorching sand; the lion lay panting in his shady den; ... and all around the
> travellers there was neither sound, nor sight of life ... An object moving in

the distance, and approaching his encampment, at length attracted the eye of the missionary. By and by a boy stood before him, in the grace of savage freedom, scantily attired in the skin of a wild beast, which hung from his bronzed and naked shoulders. He was accompanied by a beautiful springbok, which licked his hand, and trotted lovingly at his heels. The child of parents who had died or deserted him, without brother or sister, kindred, clan, or companion, save the gentle deer, – he told us his story in a single sentence. Fixing his large black eyes on the man of God, he stretched out his naked arm and said, 'Stranger, I am alone in the world.' The appeal was touching, tender, irresistible. Let us hope it will prove as successful with kind hearts at home.[3]

Of course, there is a sense in which such an appeal will not prove irresistible at home when the East End Arab is substituted for the 'authentic' African child in Guthrie's narrative. The passage sets up the exoticism of the black child (savage) by playing it off against the white springbok (submissive, civilised). The boy's humanity is shown in relation to the bestial but it is a condition substantially modified in the spectacle of a reversed relation between human and animal in which the deer functions here more like the human (domesticated, white), while the human (black boy) occupies the position of animal (inscrutable, wild, exotic). Guthrie specifically racialises the 'threat' of the metropolis. His recourse to a discourse of the noble savage is designed to implore the public to realise that even the unknowable alien qualities of an African landscape are nothing compared to those of the city. Anticipating references to inept philanthropy, as later famously satirised by Dickens, Guthrie cites British intervention to abolish infanticide in India as an example of justification for 'interfering [at home] between the rapacity of the parent and the ruin of the child'.[4] His point, a familiar one in the period, is that we ignore the immediate, we are more interested in 'schemes of benevolence which labour under a serious disadvantage of being remote, and far away – objects to us, not of sight, but of faith,' while 'our streets swarm with living evidence of the need of these schools'; proof, he believes, that his own scheme for ragged schools is equally bound up with the 'stability of the Empire', though perhaps not so easily recognised as such.[5]

The use of the term 'street Arab' by Guthrie, for him interchangeable with 'savage' in his 'Pleas for the Ragged Schools', acquires a changed resonance following the popular representation of street Arabs in photography in the 1860s and 1870s. By that time, two key conditions that arise are those of deceit and agency. The later meanings of the term 'street Arab' suggest a knowable other interposed between self and absolute other. More specifically, in the identification of class with ethnicity in the term we find that the adult confers an agency upon the poor child which is coupled with a charge of deceit. That is to say, in uses of the concept 'street Arab' in the period we find both a fantasy of the child as possessing agency, and a castigation of the child for not being authentic, perhaps in the sense that it cannot represent that simultaneous desire and disgust that would be felt in the face of the real thing. Indeed, the correlation between the working-class child and the child as ethnic 'other' gains a specific currency from a structure of deceit – involving the adult knowledge that the East End Arab is not the real thing, that a child is functioning as a displaced form of the other. This is a point that the Latin scholar and humorist Charles Stuart Calverley's parodic, but none the less troubling, poem 'The Arab' of 1872 later makes clear.[6] The text plays upon the accusation that the street Arab is duping the speaker for his skin is not dark but artificially blackened. The poem moves from a sympathy for the child's destitution, his emaciation and 'frequent cough', to a fear of

temptation by the aesthetic qualities of the boy's physical difference, through to an emphasis upon his commercial aspect: (he is peddling newspapers, shining shoes); and finally to a charge of inauthenticity: the Arab cannot offer the viewer that which his appearance promises. The last few lines read:

> But I shrink from thee, Arab! Thou eat'st eel-pie,
> Thou evermore hast at least one black eye;
> There is brass on thy brow, and thy swarthy hues
> Are due not to nature but handling shoes;
> And the bit in thy mouth, I regret to see,
> Is a bit of tobacco-pipe – Flee, child, flee![7]

By 1872, then, the child is clearly set up as possessing agency when in fact he has been constructed by the adult as agential specifically so as to be found wanting; the artifice identified as covering a lack has of course been projected onto the child by the adult. Moreover, occidental superiority is oddly inflected here in a contempt for the inadequate impersonation by the street child of an Arab child. Does the inadequacy of the adult's creation of this colonial image rest with the fact that as a reduced form of the other the child figure cannot adequately serve processes of repression? Or is it not rather the case that in the creation of a reduced form of the other the adult can indulge more covertly particular fantasies and projections?

In the previous chapter I argued that Lewis Carroll's photographic costume fantasies present the English child as semi-Eastern, as taking on some but not all of the sartorial markers of that other culture, *precisely because* in its reduced or miniature version, the oriental does not pose the type of threat that it would in its full form, and that it can therefore more satisfactorily serve processes of disavowal.[8] Above all, in his compulsion to repeatedly photograph his 'child friends,' Carroll is intent upon preserving the minor as a miniature version of the consenting subject, such that as we found in the photograph *Irene MacDonald, Autographed*, there are sufficient markers of Englishness for us never to lose sight of the fact that the figure is dressed to masquerade as a reduced form of the Oriental.

In the case of contemporary photographs of street Arabs, we find the general subordination of the colonial other is exacerbated in the other as child. Correspondingly, therefore, in terms of processes of fantasy and projection, the photographed street Arab can arguably more satisfactorily serve purposes of disavowal than its unblackened counterpart. At one level, what is here being disavowed is a recognition of self in the other (the East End Arab is still human rather than a beast). This is a point that John Barrell explores in 'Death on the Nile' in his reading of Florence Nightingale's letters from Egypt in which she writes: 'the thieves in London, the ragged scholars in Edinburgh are still human beings; but the horror which the misery of Egypt excites cannot be expressed, for these are beasts'.[9] However, rather than a simultaneous assertion and denial of reciprocity that we tend to find in Carroll's costume photographs, in photographs of street Arabs we encounter a complex interaction between concepts of authenticity and deception. Calverley's 'Arab' is shown to violate conditions of naturalness and authenticity: 'thy swarthy hues/ Are due not to nature but handling shoes'.[10] But such conditions do not entirely negate the child's aesthetic attractions for the speaker, since the fascination of the child for the narrator derives from his playing around with this ethnic fiction; toying, that is, with an other that is finally domesticated and

knowable because reducible to the sum of its westernised East End constituent parts: tobacco-pipe, shoe-shine box, eel-pie.

Such categories of deception, agency, and disavowal as they emerge in the inter-relations of nineteenth-century discourses of photography, colonialism and childhood are nowhere more apparent than in the work of the evangelical philanthroper Thomas Barnardo (1845–1905) and in the uses of photography in his aesthetics of abduction. Barnardo refers to his practices of 'saving' children from the appalling conditions of street and lodging house as 'philanthropic abduction pursued as a fine art'.[11] Those practices involve disguise: he dissolves his difference from the 'class' of child he aims to 'rescue' by blacking his face with soot, wearing ragged clothes and, in one instance, by pretending to sleep in the bed of a doss house, subjecting himself to the graphic fantasy of being eaten alive by lice. In an article in *Night and Day* Barnardo's argument in defence of such practices is that 'judicial law' is not always 'coextensive with moral law' and that he must transgress judicial law.[12] Barnardo, with his assumed persona of outlaw, was shocked by Thomas Stead's imprisonment over the well-known Eliza Armstrong case (which Stead delineated in his articles 'The Maiden Tribute of Modern Babylon' in the *Pall Mall Gazette* July 1885)[13] since he himself had bought and abducted children over a long period of time. As he writes in *Night and Day*: 'I [currently] have four children in hiding from their unnatural guardians, and efforts are constantly being made by these people to trace their whereabouts. I am watched and followed sometimes … in order that some clue may be gained to their hiding place.'[14]

There are crucial links between Barnardo's use of disguise in abducting children and the deception he is accused of with regard to the poses and props of his well-known 'before' and 'after' photographs. From about 1870 Barnardo commissioned a photographer to take pictures of children admitted to his homes. About eighty of these were published, some in pamphlets, others pasted onto complementary pairs of cards showing the same boys, purportedly at the point of admittance, and later in the same day (figure 32). The images sold in packs of 20 for 5 shillings or for 6d. each. From 1874, he had his own photographic department in his first boys' home at Stepney Causeway. The published photographs became the object of a particular accusation when Barnardo was charged on several counts for misconduct in the running of the Homes by the Reverend, George Reynolds, a local Baptist Minister.[15] In 1876, Reynolds published a pamphlet entitled *Dr Barnardo's Homes: Startling Revelations* in which he objected to 'the system of taking and making capital of the children's photographs,' but most emphatically to the deception being practised in Barnardo's use of the photographic medium itself.[16] What began as a quarrel among East End mission leaders became a struggle between the leaders of the evangelical movement and the Charity Organisation Society for the right to control the extent of the charitable voluntary movement. Reynolds' pamphlet included the accusations that Barnardo had benefited personally from donations to the homes while claiming that they were self-supporting; that he had no warrant to assume the title of doctor and had refused to state the nature of his diploma; that he was himself the author of letters sent to the *East End Observer* in the name of *Clerical Junius*; that boys entrusted to his care had been imprisoned by him for periods of between three and eighteen days in a filthy cellar; that others had their clothing removed in order to be dressed in rags for the purpose of taking deceptive photographs. Reynolds writes: 'Barnardo is not satisfied with taking [the children] as they really are, but he tears their clothes, so as to make them appear worse than they really are. They are also taken in

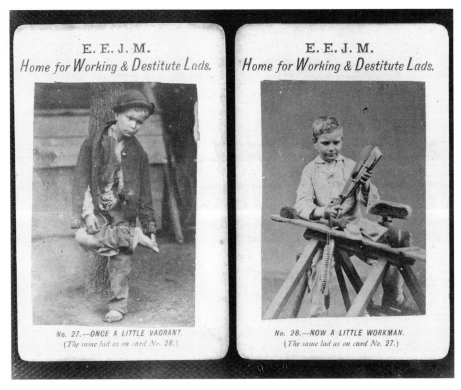

Fig 32
'Before' and 'After' Cards (1870s)

purely fictitious positions. A lad named Fletcher is taken with a shoe black's box upon his back, although he never was a shoe black.'[17]

The questions at issue were submitted to arbitration rather than to a court of law to protect the two prominent Christian workers from the damage of publicity from a criminal prosecution. Of the parents or guardians who gave evidence in the trial, Florence Holder's mother complained that her children had been specially dressed in rags and placed in a variety of poses indicating a state of misery, and had thus been photographed and placarded through Britain for the purposes of obtaining revenue for the home.[18] The photograph of Florence Holder (figure 33) shows her barefoot, with dishevelled hair, selling newspapers, something which her mother claimed she had never done. A deliberate element of staging is irrefutable in this photograph, evident not only in the pose of the figure and the arrangement of her clothing, but also in the disjunction between her expression, the purposeful fixity of her gaze, and her gesture of offering the newspaper. The silk fabric of her dress is soiled and draped in such a way as to communicate a suggestion of tawdriness. William Fletcher, posed as a shoe-black (figure 34) adopts a similar deliberateness of pose which, together with the gesture of pointing to the shoes of an off-stage spectator, while clasping to his chest the blacking brush, suggests more emphatically that powerlessness that is being semi-disguised here. The boy's stance (belying the cumbersome blacking box he carries) along with the expression in his upturned face are further inflected by the images of a male and a female figure which appear in children's line drawing on the wall behind him.

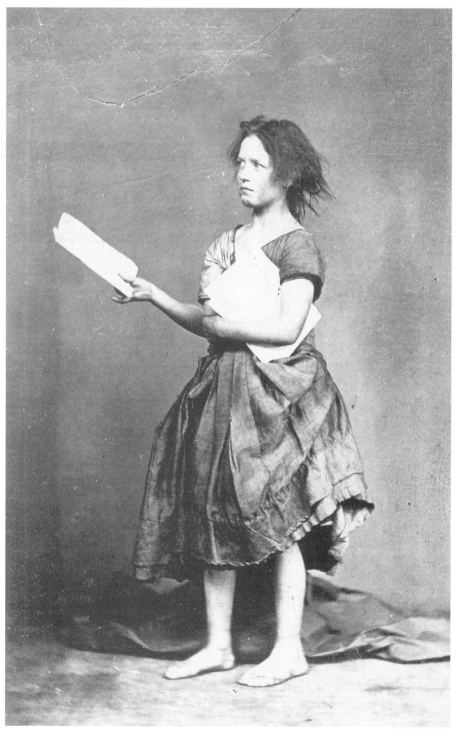

Fig 33
Florence Holder (1870s)

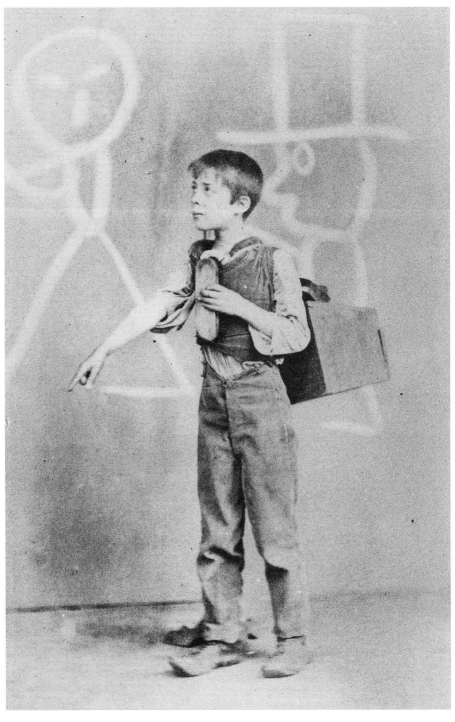

Fig 34
William Fletcher (1870s)

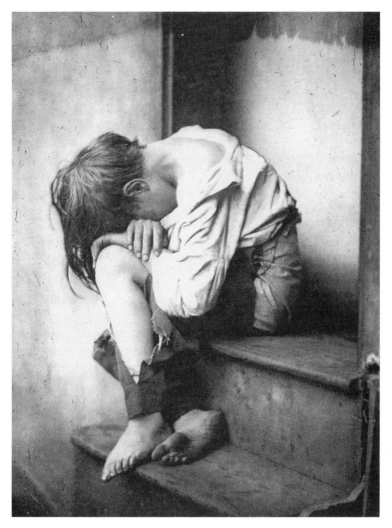

Fig 35
Oscar Gustav Rejlander, *Night in Town* (1860)

In defending his staged photographs Barnardo cited Oscar Gustav Rejlander's art photographs of street Arabs of the 1860s and 1870s, the most famous of which *Night in Town* (1860) (figure 35) was adopted by the Shaftesbury Society for their publicity campaigns. In *Night in Town* a small boy child is posed huddled on what appears to be a doorstep (the mocked-up steps of Rejlander's studio). The figure is lit so as to accentuate the lines of the bare white shoulder, the nape of the neck, and the naked knee and calf protruding through ragged trousers. The hardened and dirt-blackened sole of the boy's right foot is turned to the viewer and is read in contrast with the shiny toe nails of the other foot. In a similar manner, the finger nails of the exposed and relaxed hand serve to stress its soiled fingers. The body of the child is aestheticised in recognisable ways. Not only does the pose itself recall familiar depictions from painting but the arrangement of the folds in the shirt remind us to what extent a strategic partial clothing of a body of a

child is offered for consumption. To this end it is crucial that the child's face is obscured, more clearly consigning the viewer's mode of identification to that of the voyeuristic.

Precedents for Rejlander's work can of course also be found in the earlier daguerreotypes that Richard Beard took as the basis for the engraved illustrations in Henry Mayhew's *London Labour and the London Poor*, but Rejlander's photograph also anticipates a long photographic tradition of documenting the urban poor.[19] Aligning himself directly with Rejlander, though, Barnardo claimed that he was not concerned with the depiction of a particular individual child but with a 'class' of child as being 'typical' of the cases in the home. Yet such an explanation does not square with his reasons for keeping ledgers of children's photographs as records of individual cases including details of colouring and measurements, and sometimes the child's own statement. Barnardo's own impersonation of the street Arab (disguise was a regular feature of his night wandering) suggests the fascination and fear (though a dilute version because it is a child) of experiencing a reciprocal undoing before the 'uncivilised'. Those who are not going to foreign parts in the service of the Empire can experience the wild territories of the East End and its indigenous street Arabs, or those of the Epsom race course which A.E. Williams tells us Barnardo found 'so fruitful a field' that 'one visit alone resulted in upwards of one hundred applications being made at the Boys' home'.[20] The applicants were 'nearly all genuine, bona-fide street-Arabs … the real article; gaunt, woe-begone, desperate; clad in rags, out of luck and out at elbow; down in the mouth and down at heel – in some cases quite barefoot'.[21] The emphasis here is on authenticity, a desire for 'the real article' which cannot be real because the term 'street Arab' is always already a simulation. Barnardo's narratives, Guthrie's sermons and Calverley's poem participate in a discourse of authenticity at a stage removed from the authentic. The above list of 'genuine' 'Arab' attributes is clearly underwritten by Barnardo's perpetual need to justify his actions. It is necessary for Barnardo to establish the nature of the child being saved, but at the same time to ensure that children to be saved are visibly distinguishable from the middle-class children of potential benefactors. A quality of genuineness is part of this process but as we have found the conjunction of class with ethnicity in the term street Arab (not present in the cognate terms, urchin, waif, ragamuffin, foundling) frequently serves as a joke or is used to bring to the fore a larger discourse on authenticity.

It is significant in this respect that a photograph brought to court in Barnardo's defence shows the Williams children (figure 36), whose mother, a West Indian freed slave, had been struggling to keep her children out of the workhouse since being widowed. The photograph is presented as showing the 'real' article, and Mrs Williams was called to the witness box to give evidence on the authenticity of Barnardo's account. It is in this photograph that the racial inflection and charge of deception come together where 'real' black children are made to stand for street Arabs. In this image of naked children huddled under sacks, black skin and dirt-blackened skin come together as an unacknowledged conflation of ethnicity and class in what may be read in those photographs by Barnardo that were condemned as fictitious. The photograph brings to the fore blackening as a racialising and racist typology. Barnardo's narrative of the discovery of the children is important in this context for it encodes ethnic difference in a submissiveness which literally reduces the discovered black children to the level of beasts. Their complete and utter nakedness means they cannot even behave, Barnardo observes, in the customary manner of children or in what we might appropriately read here as the

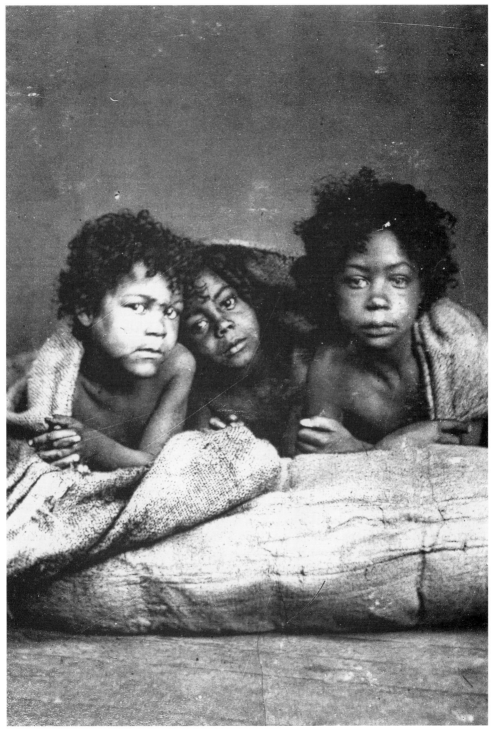

Fig 36
The Williams Children (1870s)

manner of 'real' children:

> No furniture of any kind can be seen – not even a chair nor an apology for a bed. The weary worker speaks, but without raising her head, or leaving off her work for a minute – she sits on an old broken box ... the room is very dirty, dark and close smelling. The occupant of the tenement goes on with her work ... she is not even curious enough or has not the time to ask our business although she must wonder why we have come. She is a negress, and dressed in the poorest rags. Her face is that of a sufferer, and her voice has unutterable weariness in its tone ... Big tears coursed down each swarthy cheek. Greatly moved, we turned to the corner and pulled aside a sack revealing three woolly black heads. Yes, sure enough, there three little black children lay. In a few minutes they were awake, and to our surprise instead of springing out, with the usual vivacity of children, from the heap of sacks, they remained quite still, looking quiet and abashed. 'She ha'nt no clothes for 'em this while back,' explained the landlady in a low voice, 'so they keeps together under the sacks to get warm, till the mother takes her work off to the factory. When she comes back they've a new lot of sacks.'[22]

The narrative of discovery here, with its reported colloquial explanations of the 'landlady,' and which turns upon the substitution of 'sacks' for humanising clothing, outlines a cycle of absolute dependency of the children upon the mother. The mother, herself, however, does not speak but we are told that her suffering is evident in her tone of voice and in the 'big tears' which 'coursed down each swarthy cheek'. Such a presentation of black East End Arabs makes conscious in the viewer the conflation of ethnicity and class that was visible but generally unrealised in the original charge of Barnardo's accusation. In other words, a representation of black children as street Arabs exposes the ethnic prejudice (racism) that informs the perception of the original discredited photographs but is overridden by a greater conscious identification of street Arab as white English child. It is this latter identification, arguably, that prevents the viewer accepting the degree of degradation the photographs of white street Arabs otherwise represent. This observation is relatively straightforward, but it becomes complicated when we consider the probable motives that produce this conflation. Why does Barnardo use the image of the Williams children in his defence?

Is it that he believes ethnic otherness generates a sense of altruism motivated by a contempt toward a cultural inferior that a class other does not? For Barnardo, does it take a conflation with ethnic otherness to make a response to class otherness benevolent? In this sense, blacking would have to stand more for ethnic otherness than for 'dirty' class other. Or is it not rather the inverse of what we would expect: that by literalising the metaphor – by presenting a literal – he effectively breaks the link between the vehicle and tenor of the metaphor and effectively recoups the English child as clearly English. Such a literalisation might make a class other more threatening because blatantly closer to home. In this sense, that recouping might make the degree of poverty (requisite for sympathy) less. The image of the Williams children breaks the metaphorical connection and distances the class other thereby preventing the denial that comes about because of the conflation of class and ethnic otherness in the idiom 'street Arab'. No denial of sameness is required on the part of middle-class white viewers of *The Williams Children*. It is a coherent image which seems to contain elements that remove it from an overt sense of

staging. It is as if the defence are saying to the court: 'so Barnardo is accused of producing fictitious photographs. Perhaps that is a charge that may be justly read off some of his images but why should he have any need for exaggeration when cases of destitution such as that of the Williams family simply presented themselves to him.' But, in fact, the photograph of the Williams children is as highly staged an image as any other manufactured in the studio. Yet it is made to read quite simply as 'natural' ethnic difference.

What is distinctive about this image is its use of 'nakedness', and the literal point of view from which it is taken. If we compare *The Williams Children* with other photographs of children taken in studio settings under Barnardo's instruction, we find the naked body of the child functioning quite differently from the way it does in images of scantily clad white children. In the latter, there is a sense of the transgression of a limit, as expressed in the amount of skin that might be legitimately bared. Thus, we find for example, Florence Holder's skirt interestingly defying laws of gravity, or we recognise the same pair of trousers, with the knees torn out, featuring time and time again on different boys. But in the photographing of black street Arabs ethnic difference is codified *as* nakedness. And nakedness equals authenticity. A comparative lack of clothing, or a substitution of a dehumanising sack for ragged clothing, suggests a stripping down, rather than (a fictitious dressing up) to be photographed. Such a distinction is consolidated by the low vantage point of the camera/ viewer which fixes the children (in the manner of Landseer's celebrated animal paintings) at the level of beasts; a structural effect exacerbated by their framing by sacks.

The photograph is presented in court as if to say 'here is a picture of street Arabs who happen to be black'. But the image breaks open the metaphor 'street Arab' to reveal the surreptitious way in which it works more generally in photographic images of the period. In *The Williams Children* photograph Barnardo has captured, by the inimitable medium of photography, the nature of the product which he believes requires philanthropic intervention. Here, the 'real' article shown 'before' (any 'after' would seem superfluous in this context) is presented in a way different from its white 'artificially' blackened counterpart. The three children signify first and foremost as naked, as submissive. Unlike their white equivalents, they make no pretence at clothing in the form of rags, but cower under dehumanising sacks. Such an image of black children makes it easier for the middle-class viewer to identify ethnic otherness and to produce the 'requisite' philanthropic reaction to the children's state (this is why Mrs Williams was offered money by the opposing counsel, and why one lawyer, so distressed by her testimony had to leave the room).[23]

More difficult for the middle-class viewer, however, is the photographic set-up of a white child as a street Arab, a conjunction in which class and ethnic otherness are mixed together. For the viewer cannot in the face of such an image extricate one from the other and pinpoint a class other as opposed to an ethnic other. In photographs of white children as street Arabs, it is as if the fear of the class other is compounded by the ethnic other, making otherness too close for comfort. Simultaneously, class otherness does not appear to retain its persuasiveness when it is brought together with ethnicity in the same image – such an association makes the separation between self and other less stable. *The Williams Children* can be identified as still entirely other to the white middle-class English observer, in a manner not possible with the blackened white child. Somewhat paradoxically, the notion of artifice built into the concept 'street Arab' makes the white

child as 'Arab' both a safer bet and simultaneously more threatening than its 'real' black counterpart. Furthermore, the metaphor destabilises the process of disavowal that the 'real' black child enables. In photographs of blackened white children, the ragged clothing and signs of menial labour encode the child as emphatically other to the middle-class viewer but, the reading of 'dirt' as racialising, as black skin, simultaneously undermines the surety of the image as one of disavowal, since it reminds the viewer that the imaged child is at a stage removed from an authentic other, thereby bringing with it all sorts of complex resonances in terms of identification and psychic projection.

The effect upon the court of the photograph of the Williams children further prompts us to reconsider the larger questions of deceit and authenticity that operate within Barnardo's work. At one end of the photographic scale, the emergence of 'real' street photography as exemplified by the work of John Thomson might be responsible for making the unacceptability to contemporary nineteenth-century viewers of Barnardo's 'before' and 'after' pictures more tangible.[24] Since undoubtedly contemporary viewers would have been familiar with the studio contexts of portrait photography – the props which constituted the experience of having carte-de-visite photographs made – we might question why they might not simply accept the 'artifice' of 'before' and 'after' on its own terms in Barnardo's representations? The reasons are, first, that the 'before' and 'after' photograph violates a notion of the integrity of the photographic medium as inhering in its unique relationship to temporality, and, second, because the exactly contemporary representation of London street life by Thomson provides an authoritative genre against which to read Barnardo's practices. But there is a further point which concerns the classification of the poor according to their labour as practised most famously by Henry Mayhew. The engraved illustrations to Mayhew's *London Labour and the London Poor*, based upon the photographs of Beard show the labouring classes as representative of particular types of labour. In this way, classification is as much to do with the attribute of labour as with any physical characteristics of the individuals depicted.[25] Critics of Barnardo might well have objected to the fact that his photographs frequently attribute identities to children through labour, a practice of attribution which demands to be read within a long and complex tradition of imaging the labouring poor in Britain. For Barnardo to make the labouring classes 'other' by turning them into commodities (photographs for consumption) is one thing; fixing a sham identity upon a child through attributes of labour which suggest that she had a particular profession on the streets is altogether another. Read in these terms, the charges of deception levelled against Barnardo hinge less on a consideration of the ownership of an individual portrait than on the question of an identity as conferred by labour.

Correlative with these considerations is the further question of whether the unacceptability to contemporary viewers of Barnardo's photographs resides in the fact that they depict children. As we have found, the child as ethnic other can more satisfactorily serve processes of disavowal than its full-grown counterpart but, where a child represents both a class other and an ethnic other, questions of identification become more complex. A key question to arise in this context is whether such complexity is caused by the fact that ethnic otherness overrides class otherness, in the perception of middle-class observers, thereby making class otherness a less stable distinction? In such a scenario, the child would appear to be too close to home, not that different from the white middle-class child in so far as ethnic otherness, as suggested by blacking, would outweigh class otherness, as suggested by torn clothes, and the attributes of labour. By

extension, the appearance of ethnic otherness would then remind the viewer of the undeniable closeness of class otherness in a way that a real ethnic other would not since it would be able to sustain difference more authentically.

While critics have broadly situated Barnardo's before-and-after photographs in the context of Foucault's work on discourses of surveillance and social control, those scientific, technical, legal and political apparatuses in which photography functioned as a means of evidence, they have not considered the potential uses of such photographs of children in transactions with children themselves and how these affect discursive categories of childhood.[26] After 1877, owing to the arbiters ruling that it was morally wrong to use photographic 'artistic fiction' to represent facts, Barnardo never again sold photographs of children. But in Barnardo's evangelical tracts of 1885–86 photographs figure significantly in transactions between children themselves. In these pamphlets, street Arabs are predictably depicted as wild savages, and the suspense of the narratives derives in part from the sense that the desire to tame, to save, might be thwarted by the unknowable alien qualities of the street child. Such uses of photography testify to the ways in which the medium becomes singularly linked in the period with concepts of the 'child'. For while in these pamphlets the photograph is used for its evidential qualities, the fact that it is shown to be read and interpreted by children at once undermines the sense of an absolute evidential truth for photography and reveals a certain sophistication in Barnardo's calculated narrative uses of the medium.

I want now to look at two of the stories from Barnardo pamphlets.[27] The first, *God's Little Girl, a Truthful Narrative of Facts Concerning a poor 'Waif' admitted into 'Dr Barnardo's Village Home'* narrated by Ellice Hopkins, a member of the Association for the Care of Friendless Girls, relates the 'rescue' of two children of a sweep, the buying of a boy for ten shillings and the conversion of an 'unruly, savage girl child Mary in the village home and her death by consumption shortly thereafter'. The account is remarkable for the way in which it uses a photograph, in this instance slipped in to the story to function as the means by which a father, urged by the 'innocence' of his child, incriminates himself. The narrator writes:

> Seeing me stand and still gazing at them, the father stopped and said ironically, 'She's a nice-looking girl, ain't she.' Whilst I was saying a few grave words to him about the child, and receiving the excuse that his wife had left him, and he had no home and no one to take care of her, the child pulled him by the coat, and said, 'Show the lady the pretty picture.' This was at once produced and displayed to me, 'the pretty picture' being a photograph of the father lying dead drunk, the man taking off his cap and displaying his bald head, from which every atom of hair had been singed in some fire, to show how very like it was.[28]

The suggestion is that the 'innocent' child attracted by the visual image is ignorant of the fact that to show it to the woman will further confirm her suspicion of the unsuitability of the child's father to care for her and her brother. The girl cannot tell that it is not at all a "pretty" picture. So the photograph works here as evidence of the man's culpability, thereby confirming the justice of the rescue mission, and as an index of childhood 'innocence' in general, as that state which can perversely endure even such adverse conditions. The little girl here is taken in by the reality of the image. The photograph is used to mock the gullibility of the child, and to point up the differential relationships of

child and adult subjects to knowledge, truth and falsehood. In a narrative difficult for its
narrator to legitimise, because it amounts to the kidnap of children, the photograph
operates as a sort of 'say no more' clause. It is used here emphatically as ocular proof of
the father's unsuitability to care for the child. But it also works to situate the destitute
father as a naïve reader like the child over and above the adult reformer. The narrative
works upon that profound irony produced by the gap between child's and reader's
perception and understanding of the photographic representation – and for what
photographic representation stands in for here (agency) as expressed in class difference.
Throughout, there is an identification of children with savage others. The position of the
civiliser is constructed, with a great deal of self-righteousness, as an impossible and
thankless one, but as a crusade which must go on. More specifically, in references to faces
literally blackened by soot, the prototype of this rescue mission is the full-scale colonial
encounter.

In a second narrative, *A City Waif, How I Fished and Caught Her*, Barnardo fancies
himself as the author of a 'compleat angler' in a tract controlled by fishing metaphors:

> As an old fisherman in the muddy streams of lodging-house life, I knew by
> experience that not only must the hook be often specially baited, but that the
> greatest patience and perseverance must be exhibited if certain kinds of fish
> were to be caught. The drag-net might be successful sometimes in bringing to
> shore large numbers, but very often more skilful and long-continued efforts
> were needed to secure even a single prize.[29]

Barnardo's accounts of meeting children tend to open with rhetorical questions about the
notoriety of English weather: 'gentle reader, have you ever been in London in the month
of November during a *very* wet and inclement season?'[30] In this story, from his position
of safety in a cab, Barnardo surveys empty streets to find "something," perhaps, he
writes, 'I should have said "somebody" the sight of which/whom makes [him] very
uncomfortable indeed.'[31] There follows a detailed description of a drenched raggedly
dressed girl without boots or stockings, and it's only when Barnardo has constructed her
as an object metamorphosing into a human subject that he discloses the unexpected:

> *This*, then, was what met my eye passing the spot in the cab on that drenching
> morning, and this was what made me stop, for I knew Bridget well. She and I
> were not exactly *friends*. For the fact was, Bridget was slow in admitting
> anyone to her friendship.[32]

It turns out to be no less than a tale of recognition (preceded by a virtual misrecognition)
of a lost soul. Explaining how the child had fled from her mother because of her 'ill-usage
and savage temper' to take up lodgings, Barnardo reveals the fact that she has already
resisted his attempts to rescue her, valuing what he maintains she calls her 'freedom'. In
spite of this resistance, he writes that 'it will surprise no one to learn that there came into
my heart a great desire to win this little maid from her unprotected street life and its
perils, and to induce her to enter our Home at Ilford'.[33] The position of the mother is
crucial in Barnardo's narrative. In the manner of Carroll, Barnardo frequently pitches the
child against the parent, and here he constructs Bridget's fear of her mother both as a
legitimate reason to 'rescue' her and as a reason to go easy in his pursuit, to 'bide' his
time and 'seize the first opportunity that would present a favourable opening'.[34] What
occurs is that he takes her to a café, gives her coffee, and once she is warm by the fire he

produces the best way of procuring her. A photograph is the crucial instrument in the kidnapping process; its presence is erotically disclosed:

> By what means could I induce Bridget to come with me to the HOME? I had formerly tried every argument likely to succeed; what new plea could I urge now.
>
> Just then putting my hand in my coat pocket, I felt something stiff against my finger and suddenly recollected that I had there that which might perhaps prove a more powerful argument than any I had previously adduced. But I advanced cautiously, for your true street Arab is often a shy fish, and will not always take even the most alluring bait.[35]

Barnardo regards the photograph as offering a singular form of representation more likely to succeed than words in gaining the desire (which will amount to the confidence) of the child.

> Pulling out suddenly from my pocket the object referred to, I held before Bridget's eyes a photograph of a young girl neatly dressed as a domestic servant, with white wrist bands and collar, with neat white cap and apron, in a print dress, and holding in one hand a house-broom, in the other a dust-pan, in which she was about to gather the dust from the floor which she had been sweeping, her bright smiling face raised from the work and turned full at the spectator, presenting on the whole a very attractive picture.[36]

This passage shows to what extent Barnardo has considered the effects of photographic representation upon the credulous child. He describes in detail the positioning of the child subject in the photograph, and her positioning in relation to the child viewer. The presence of the uniformed domestic servant calls up the photographic examples of Victorian pornography and, in particular, of representations of female labour in the Arthur Munby archive.[37] Although, in one sense, one might read the episode as a fairly simplistic understanding on the part of Barnardo of the cultural power of photography – the notion of a truth exceeding that of other forms of representation in its immediacy. In another, it shows a more sophisticated understanding of the medium in terms of what it can facilitate in relation to the child. The incident crucially raises the issue of the child as naïve reader, and the question as to whether an alternative form of visual representation would elicit or, more crucially, would be thought by the adult, to elicit a similar response from the child. Bridget's reaction suggests that the lure is in the appearance of the neatness of the uniform and unconnected with the social position the imaged child represents, with the context of domestic service. It is in wanting to look like the child in the picture, to be made into an image of perfection.

> 'Oh, my!' was the admiring exclamation that burst from B's lips. 'Ain't she smart.' Having allowed a few minutes for examination of the picture, I asked – 'Wouldn't you wish to be like her? Better, I should think, to be dressed in that way than to wear the things you have on,' pointing to her ragged dress.
> 'I should think it wor,' she replied; 'but I ain't got such luck, you see.'
> … 'That girl, Bridget, was once a poor child without a home or friends, living upon the streets. I received her into our HOME, where she has been trained as a servant … and this is a picture of her engaged at her daily work.'[38]

In Bridget's case the photograph as bait is successful when coupled with the promise that her mother will not be informed of her whereabouts. Barnardo continues:

> The welcome door of our Receiving House was opened wide to admit this poor little waif cast up by the tide of City life almost at my feet, and before whom there now lay the blessed possibilities of an industrious and virtuous career.[39]

The opening fishing metaphor drifts then from that of a deftly baited hook to the random product of an indiscriminate tide. But there is nothing random about this encounter, the outcome of Barnardo's scouring the streets for waifs. The narrative ends with a denial of the agency of the author that controls it. Barnardo erases his agency. The photograph seems to offer a unique and productive object upon which to displace it.

What this story shows, and there are other related examples, is that the child stands alone in such a credulous relation to the photograph. In this sense, the photographic device here functions much in the manner of Carroll's use of child photographs. As we have found, Lewis Carroll shows to new 'child friends' photographs of old ones dressed in costume in order to incite them to dress up and pose for him also. The photograph is a lure for the child in ways that it cannot be for the adult. Such uses of the photograph by Barnardo newly raise the larger question of children viewing photographs of child subjects and their relationship to those representations. As we have found, adults recognise the possible artifice in 'before' and 'after' pictures, the fact, for example, that they might not have been taken on the same day, but the child responds to this artifice differently. Is there a difference for the child between Carroll's elaborate costume fantasies and the uniform of the maid here in what is for the child a desire to be like the one imaged in the photograph? Is the child not seeing both as the same, as they are in the sense of objects of fantasy? In Barnardo's narrative uses of photographic referents we are allowed to get one up on the child reader. We can all be wise to the deceit of photography except the child whose lack of agency the medium singularly exacerbates. The agency seemingly conferred upon the child as unknowable street Arab is through the medium of photography exposed for what it is: a fabrication. Furthermore, in larger terms, the child as street Arab is made to stand in relation to photography as we have been led to believe the Victorians unquestionably did at its inception.

Such a model of a naïve reader is not however simply applicable to nineteenth-century subjects. An article entitled 'Lost and Found the Forgotten Legacy of Dr Barnardo' by Blake Morrison in the review section of the *Independent on Sunday* 11 June 1995, which marked the 150th anniversary of Thomas Barnardo's birth, speculates upon the consequences of the opening up of the charity's archives.[40] Three documentaries which appeared on BBC television during July 1995 reappraise the values of the institutions Barnardo created. As Morrison points out, Barnardo's photographs were crucial to his crusade from the beginning and 'they are crucial now to those former Barnardo children trying to trace their origins'.[41] Certainly, the photographs can be instrumental in helping individuals to trace relatives, but photographs are further crucial to the documentaries in a number of revealing ways. Each programme opens with the highly emotive and somewhat unreconstructed use of anonymous photographs of children propped up on the floorboards of a room. The camera roams from the exterior of one of the homes to the bare interior of a room. It rests fleetingly on one of Barnardo's open ledgers placed on a chair and then pans across haunting unknown faces that look straight out at the viewer. The effect is to suggest that the photographs, wrested from the

album, replace real children who once occupied the room whose door is left suggestively open. The camera progresses to individual close-ups of those Barnardo referred to as nobody's children. The programmes are concerned with identity and the ways in which the identities of Barnardo's' children were concealed from them in the institutions. A sense of the sheer number of photographic images of children has the intended effect of eliciting sympathy and a profound sense of pathos on the part of the audience. But it also has the effect of fixing these images of children as anonymous, thus consigning them to the category of the orphan. The power of the orphan is captured for our consumption in 1995, and it is significant in this respect that the current predominant view of Barnardo's charities, as the programmes remind us on more than one occasion, is that they run orphanages, an image that they have worked hard to change. Yet, the recourse of the documentaries to such a use of Victorian children's portraits testifies to a residual investment in the cultural power of the figure of the orphan. Barnardo understood the unique and powerful impact upon the middle classes of that figure and, as a consequence, referred to the children in the homes as 'nobody's' (when in fact they quite frequently belonged to somebody) and in many instances were taken by Barnardo from natural parents and guardians to be secreted in his institutions. The play upon the senses of 'nobody's' in law (bastard) and 'nobody's' in life as (orphan) is crucial here. Barnardo could read the social construction of the orphan, in the manner of the 'racial' construction of the street Arab, as a *tabula rasa* primed to receive his impressions guided by a moral law overriding judicial law.

While only the first documentary traces the history of Barnardo's institutions and deals briefly with his original uses of photography in record keeping and 'before' and 'after' shots, the second one also focuses upon the importance of photographic records to current attempts by former Barnardo's children to reconstruct their histories. Since in the later parts of this century the charity used film as well as photography to document its work, central to the process of historical reconstruction are the three hundred mostly 16mm films which record different aspects of the charity's involvement with children and which are shown to recent Barnardo's children at their reunions. The programmes are certainly not uncritical of Barnardo's methods of recording and withholding information from families – we are made to experience the anguish of John as he is shown letters from his mother he never knew existed requesting to see her baby – but the relationship of subjects to images retains the type of investment in a naïve child reader that we have so far been tracing. Significantly, the BBC documentaries construct Barnardo's' adults somewhat as naïve readers in the manner that I have shown Barnardo's pamphlets did nineteenth-century child subjects and working-class adult readers.

In the second documentary, former Barnardo children (now middle-aged) are presented to us as faces, in the stark and flickering contrast of cinema lighting, scrutinising footage in attempts to identify themselves and their friends in the films. They reconstruct their pasts from alien, previously unknown images. Such adults are shown delighted at seeing themselves as 'children' for the first time, displaying reactions not unlike the above reaction by Bridget to the photograph of the uniformed domestic servant. And it is in this sense that the opening up to view of the Barnardo archives might somewhat ironically replicate a version of the naïve child reader that Barnardo's own stories perpetuate. Since narratives of the personal histories of these former Barnardo children have been kept from them, they are exploited visually for our pleasure. As we watch adult faces seeing themselves as children, it is as if we are voyeuristically

confronting a dramatisation of the mirror stage, or a reconstitution of it in footage of adults witnessing themselves as 'perfect' little girls and boys.

The third and final programme in the series, part of which considers the plight of rent-boys on the streets of the metropolis, makes an analogy with Victorian London and keeps 'the Doctor's' identity alive by universalising poverty and homelessness. Somewhat ironically, the narrator maintains, Barnardo would have been 'at home' here and now because little has changed: children still sleep rough. Just as Barnardo went on night searches to rescue children, workers from Barnardo's charities are shown, during night wanderings, distributing condoms to rent-boys on the streets. What is highly problematic about a documentary that turns upon such an apparently undeniable analogy is that it leaves the structure of benevolence, as practised by Barnardo, uncontested rather than attempting to theorise it differently. It was a structure, as I hope I have shown, that relied upon a particular construction of 'the child' as naïve. Photography, more than any other medium in the second half of the nineteenth century, facilitated such a version of a naïve reader. That the Barnardo charities' home movies and pictures of children are presented 'straight' in these documentaries, are offered to us as unmediated representations of history and of individual identities, demonstrates the persistence with which such a myth of nineteenth-century photography as somehow innocent pertains in recent accounts of documentary practice. It is by no means accidental that a reliance upon the attribution of a particular type of naïvety to visual practices of the nineteenth century is invested in constructions of the child. The child (as a transhistorical category), it is here maintained, reads photographs as we still wish to believe the Victorians must have done.

Notes

1 Thomas Guthrie, 'First Plea for Ragged Schools', 1847, *Seed Time & Harvest of Ragged Schools or a third Plea with New Editions of the First and Second Pleas* (Edinburgh: Adam and Charles Black, 1860), p. 25.
2 *Ibid.* pp. 20–1.
3 Guthrie, 'Second Plea for Ragged Schools', 1849, pp. 55–6.
4 *Ibid.* p. 75.
5 *Ibid.* p. 94.
6 Charles Stuart Calverley, 'The Arab' 1872, *Flyleaves* (Cambridge: Deighton Bell and Co., 1883), pp. 19–21.
7 *Ibid.* p. 21.
8 Lindsay Smith, '"Take Back Your Mink": Lewis Carroll, Child Masquerade and the Age of Consent', *Art History* 16:3 (September 1993), pp. 369–85.
9 Quoted in John Barrell, 'Death on the Nile: Fantasy and the Literature of Tourism, 1840–1860', *Essays in Criticism* 41:2 (1991) pp. 97–127, pp. 107–8.
10 Calverley, 'The Arab', p. 21.
11 Thomas Barnardo, 'Philanthropic Kidnapping', *Night and Day, A Monthly Record*, ed. T. Barnardo. For a discussion of the politics of this article, and a condemnation (in terms of civil rights) of Barnardo's privileging of 'moral' over 'judicial' law see *The Journal of the Vigilance Association for the Defence of Personal Rights*, 57 (15 February, 1886), p. 1.
12 *Ibid.*
13 For a detailed discussion of Stead's, 'The Maiden Tribute of Modern Babylon', *The Pall Mall Gazette*, July 1885, see Deborah Gorham, 'The "Maiden Tribute of Modern Babylon" Re-examined: Child Prostitution and the Idea of Childhood in Late Victorian England', *Victorian Studies*, 21 (Spring 1978).
14 Barnardo, 'Philanthropic Kidnapping', p. 1.
15 See Gillian Wagner, *Barnardo* (London: Weidenfeld and Nicolson, 1979), pp. 126–34, 136–54.

16 George Reynolds, *Dr Barnardo's Homes: Startling Revelations* (1876), p. 56.

17 Quoted in V. Lloyd and G. Wagner, *The Camera and Dr Barnardo* (Hertford, 1974), p. 14.

18 See Wagner, Barnardo, pp. 140–41.

19 See T. J. Barringer, 'Representations of Labour in British Visual Culture, 1850–1875', 2 vols, unpublished D.Phil. thesis (1994) .

20 A.E. Williams, *Barnardo of Stepney, The Father of Nobody's Children* (1843).

21 *Ibid.*

22 Thomas Barnardo, *Rescue the Perishing, an extended report of the work of the East End Juvenile Mission 1874–5* (1876), pp. LXXIV–LXXV.

23 Reported in 'Touching Scenes and Statements at the Barnardo Arbitration', *The Christian Herald*, 6 September 1877.

24 John Thomson (1837–1921), traveller, photographer and member of the Royal Geographical Society published in 1866 his photographs of his travels in Cambodia. His photographic series *Street Life in London*, published in 1876–77, is exactly contemporary with the Barnardo arbitration. See, *Light From the Dark Room*, ed. Sara Stevenson (Edinburgh: National Galleries of Scotland, 1995).

25 Henry Mayhew, *London Labour and the London Poor: A Cyclopaedia of the Condition and Earnings of those that will Work, those that cannot Work, and those that will not Work*, 4 vols, 2nd edition (1861–62).

26 See especially, John Tagg, *The Burden of Representation: Essays on Photographies and Histories* (Basingstoke: Macmillan, 1988), chapter 3.

27 Barnardo published a number of such undated pamphlets with titles such as: *Never Had a Home, My First Arab, Done to Death* and *Kidnapped*!

28 *God's Little Girl, a Truthful Narrative of Facts Concerning a Poor 'Waif' admitted into 'Dr Barnardo's Village Home'*, narrated by Ellice Hopkins, a member of the Association for the Care of Friendless Girls, p. 4.

29 Thomas Barnardo, *A City Waif, How I Fished and Caught Her*, p. 2.

30 *Ibid.*

31 *Ibid.*

32 *Ibid.* p. 7.

33 *Ibid.* p. 11.

34 *Ibid.*

35 *Ibid.* p. 19.

36 *Ibid.* p. 20.

37 For an account of Arthur Munby's practice of representing the labouring bodies of women miners see Griselda Pollock, '"With My Own Eyes": the Labouring Body and the Colour of its Sex', *Art History*, 17:3 (September 1994).

38 Barnardo, *A City Waif*, p. 21.

39 *Ibid.* p. 22.

40 Blake Morrison, 'Lost and Found the Forgotten Legacy of Dr Barnardo', *Independent on Sunday*, 11 June, 1995.

41 *Ibid.*

Index

Note: 'n.' after a page reference indicates a note number on that page.

age of consent, 96–100

album, 57, 59, 61, 67–9

 see also photography

Armstrong, Nancy, 110n. 35

Arnold, Julia, 106

Arnold, Mary, 106

Atkins, Anna, 10, 53–4, 56–7, 63, 71n. 10,
 11, 12

 Part I of Photographs of British Algae;
 Cyanotype Impressions, 53–4

 see also cyanotype

Atkinson, F.H., 106

Bachelard, Gaston, 3–4

Bann, Stephen, 8, 56

Barnardo, Thomas, 9, 92, 111–31

 and abduction, 115

 'before and after cards', 115–16, 124–5

 A City Waif, How I Fished and Caught Her,
 126–8

 Florence Holder, 116–17

 God's Little Girl, a Truthful Narrative of
 Facts Concerning a Poor 'Waif' admitted
 into 'Dr Barnardo's Village Home',
 narrated by Ellice Hopkins, a member of
 the Association for the Care of Friendless
 Girls, 125–6

 Night and Day, 115

 and photography, 115

 William Fletcher, 116, 118

 The Williams Children 120–4

Barthes, Roland, 3, 5, 13, 88

 Camera Lucida, 6–7, 9, 70, 73n. 58, 74–5

 A Lover's Discourse, 60–70, 69, 72n. 37,
 38, 39, 40, 41, 42, 43, 73n. 55, 57

Bayard, Hippolyte, 18–19, 33n. 13

Belsey, Catherine, 86

Benjamin, Walter, 'A Small History of
 Photography', 2–6

Braddon, Mary Elizabeth, 39

British Journal of Photography, 21, 33n. 14,
 21, 87

Calverley, Charles Stewart, 113–14, 130n. 6, 7,
 10

Cameron, Julia Margaret, 5, 16, 24–7, 30–2,
 33n. 22, 23, 35–7, 45–51

 All Her Paths are Peace, 48

 Annie 'My First Success', 31

 Cupid's Pencil of Light, 88–92

 Daisy, 31–2

 Eleanor Locker, 48–9

 Florence Fisher, 47–8

 My Grandchild Aged 2 Years and 3 Months
 (August 1865), 45–6

 The Red and White Roses, 49–50

Carroll, Lewis *see* Dodgson, C.L.

Cartesian perspectivalism, 18–24

 see also geometrical perspective

Chataway, Gertrude, 101–3, 105

child, the, 4–10, 88–92, 111

 relationship to photographs, 9–10, 125–8,
 130

 see also street Arab

Cohen, Morton N., 34n. 30

combination printing, 18–26, 82–3

 see also photography, focus in

Criminal Law Amendment Act, 99

Crawford, William, 20, 33n. 18, 84–5

Cupid, 88–91, 94n. 42

cyanotype 52–6
 blueness of, 53–5

Dancer, Benjamin, Robert, 81–2
 Self Portrait, 82
daguerreotype, 77–8
 see also photography
Darwin, Charles, *On the Expression of the
 Emotions in Man and Animals*, 86–7
depth of field, 13
 see also photography
Didi-Huberman, Georges, 56
Dodgson, C.L. (Lewis Carroll), 5, 9, 13, 24,
 26–30, 34n. 25, 26, 27, 35, 36–7, 44–5,
 46–7, 88, 92, 95–110, 111, 128
 and age of consent, 96–101
 The Elopement, 47, 105
 Gertrude Chataway Lying on a Sofa, 103,
 105
 Irene MacDonald, Autographed 104–5
 'A Photographer's Day Out', 76–7, 93n. 8,
 9, 10
 preoccupation with height, 9, 95–6, 97–8,
 104–8
 St. George and the Dragon, 47
 Xie Kitchin as Penelope Boothby, 28–9
 Xie Kitchin in Greek Dress, 45
 Xie Kitchin Lying on a Sofa, 47, 103
 Xie Kitchin Playing the Violin, 28–9
 *Xie Kitchin Standing in a Nightdress and
 Crown*, 45–6, 47
Dodier, Virginia, 51n. 6
double, the, 74–5, 81–2, 85–6, 88, 92,
 94n. 33, 34

Emerson, Peter Henry, 90, 94n. 40

Fenton, Roger, 56
Filmer, Lady Mary, 57–8, 72n. 26
focus, 16–21, 24–7
 in Cameron, 24–31
 in Carroll, 26–30
 etymology of, 16–18,
 33n. 10
 gendering of, 25–8, 35–7
Foucault, Michel, 14–15, 110n. 18
Fox Talbot, William Henry, 17, 33n. 11, 53,
 56–7

Freud, Sigmund, 'Fetishism', 30–2, 34n. 32
 'Inhibitions, Symptoms and Anxiety', 105,
 110n. 27, 28, 29

Gernsheim, Helmut, 16, 24–5, 32n. 8
 *Julia Margaret Cameron. Her Life and
 Photographic Work*, 24–5, 33n. 22, 23
 Lewis Carroll, Photographer, 26, 34n. 25,
 26, 27, 28, 29
geometrical perspective, 13, 18–27, 35–6
Goethe, Johann Wolfgang von, *Theory of
 Colours* vi, 52
Gorham, Deborah, 130n. 13
Guthrie, Thomas, 111–13, 130n. 1, 2, 3, 4, 5

Havercamp, Anselm, 71, 73n. 59
Hawarden, Lady Clementina, 10, 37–44, 46–7,
 50–1, 69
 Clementina in Fancy Dress, 43–44
 cross-dressing, 42
hearth, the, 30, 32, 36–7, 39, 50–1
 sanctity of in Hawarden, 42–3
heautoscopy, 74–5
 see also double
Herschel, Sir John, 10, 24–5
 on cyanotype process, 52–4
Hopkinson, Amanda, 31, 34n. 34

Journal of the Photographic Society, 20,
 33n. 17, 19

keepsake, 10, 60–1, 64, 67, 69
Kitchin, Alexandra (Xie), 107–8
 see also Dodgson
Kertész, André, 6, 70
Krauss, Rosalind, 8, 16, 33n. 9

Lacan, Jacques, 32, 34n. 35, 78–81, 93n. 18,
 93–4n. 20, 94n. 21
 see also mirror stage
Le Gray, Gustave, *The Sun at Zenith,
 Normandy*, 18

Mallalieu, Polly, 97–8
Mayhew, Mr and Mrs Anthony Lawson, 120,
 131n. 25

Mayhew, Henry, 120, 131n. 25
Metz, Christian, 30, 34n. 31, 59, 110n. 41
Miller, Karl, 74, 79, 94n. 41
Milles, Lady Charlotte, 10, 58–9, 61–71
 Collection of Figures in Interior Setting, 66
 Fanny Stracey, 61–2
 The Honourable Lewis and Harry Milles, 63
 Queen Victoria, the Prince and Princess of
 Wales and their Children, 64
 Two Crinolined Women in a Moonlit
 Landscape, 67
mirror, the, 41–2, 48, 75–7
 lateral inversion of, 77–9, 80–1
mirror stage, 75, 78–81
Morris, William, 4
Morrison, Blake, 128, 131n. 40
Munby, Arthur, 127, 131n. 37

Narcissus, 75–6
negative/positive process, 77–8
 see also photography

Ovid, *Metamorphoses*, 92–3n. 7
Owen, Atty, 110n. 43

Pfeifer, Marcuse, 95
photo-collage, 59, 61–4, 66–8, 70
photogram, 54
 see also cyanotype
Photographic News 88–9
photography
 and the album, 5, 57–9, 61, 68–9
 carte-de-visite, 58
 child in, 4–5, 87–92, 128–9
 child's relationship to, 4–10, 81
 colour in early, 52–3
 and death, 6–7
 depth of field in, 13, 16–19
 and fetishism, 30–2
 focus in, 4, 13, 16–21, 24–32, 35–6
 and magic, 2–4
 monochrome in, 54–6, 70
 and temporality, 5–7, 21, 23, 70
Pointon, Marcia, 59, 72n. 32, 88–9, 90,
 94n. 35, 36, 38, 39
Pollock, Griselda, 131n. 37
Practical Photography, 20–1, 33n. 20

Pultz, John, 42, 51n. 9

Ragged School system, 111–13
 see also street Arab
Rapaport, Herman, 105, 110n. 26, 30
Rejlander, Oscar Gustav, 19–21, 33n. 15, 16,
 69
 The Artist Introduces O.G. Rejlander the
 Volunteer, 86–8
 Charity, 19
 combination printing, 20–1
 Ginx's Baby, 86–8
 to Henry Peach Robinson, 20–1
 Infant Photography, 88–92
 Insult Added to Injury, 112
 Night in Town, 119–20
 response to the daguerreotype, 77–8
 The Two Ways of Life, 20, 33n. 17
Reynolds, Reverend George, 115, 131n. 18
Robinson, Henry Peach, 19, 221–4, 33n. 21,
 69
 Dawn and Sunset, 23
 Fading Away, 84–5
 Genre Portrait of a Girl in Country Dress
 and Sun Bonnet, 83
 The Photographer Catching up on his
 Reading, 81
 Photo Sketch for a Holiday in the Wood, 82
 She Never Told her Love, 85–6
 Sleep, 23
 When the Day's Work is Done, 23
Rose, Jacqueline, 79, 93n. 19, 94n. 22
Rosenblum, Naomi, 58, 72n. 27
Ruskin, John, 8, 36, 59, 72n. 36, 83

Salisbury, Lord, 98–9
Schaaf, Larry, 53–6, 78
Schwarz, Heinrich, 3, 64, 73n. 48, 75, 92n. 5
Seiberling, Grace, 67–8, 73n. 49, 50, 51, 53,
 54
Sekula, Allan, 14
sentiment album, 61, 68–9
Shakespeare, William
 The Rape of Lucrece, 69
 Twelfth Night, 85–6
Simpson, David, 34n. 33
Smee, Alfred, 52

Solomon-Godeau, Abigail, 32n. 2, 3
Stead, Thomas, 98–9, 115
still life painting, 36–7
street Arab, 92, 111–28
 see also Barnardo
Sullivan, Constance, 68, 73n. 52

tableau vivant, 38
Tagg, John, 14–15, 131n. 26
Thomson, E. Gertrude, 110n. 31
Thomson, John, 124, 131n. 24

Wagner, Gillian, 130n. 15
Weaver, Mike, 90, 94n. 41
Williams, A.E., 120
Wittgenstein, Ludwig, *Remarks on Colour*,
 55–6

Yoxall Jones, Edgar, 33n. 15, 86